RUSKIN AND GANDHI

RUSKIN AND GANDHI

Elizabeth T. McLaughlin

Lewisburg
BUCKNELL UNIVERSITY PRESS
London: ASSOCIATED UNIVERSITY PRESSES

© 1974 by Associated University Presses, Inc.

Associated University Presses, Inc.
Cranbury, New Jersey 08512

Associated University Presses
108 New Bond Street
London W1Y OQX, England

Library of Congress Cataloging in Publication Data

McLaughlin, Elizabeth T 1923-
 Ruskin and Gandhi.

 Bibliography: p.
 1. Gandhi, Mohandas Karamchand, 1869-1948.
2. Ruskin, John, 1819-1900. I. Title.
B5134.G32M25 192 72-3260
ISBN 0-8387-1086-7

CONTENTS

PREFACE

In time of war it is worthwhile to examine the potentialities of nonviolent solutions. In time of sharp economic and racial division it is well to seek means of achieving national harmony through cooperation rather than competition. In time of dearth of leadership it is instructive to investigate the forces that contributed to the development of great men. For all of these reasons, there is deep significance for us today in studying the factors that molded the ideas and the character of Mohandas K. Gandhi.

In reading Gandhi's autobiography some years ago, I was struck by his statement that his discovery of Ruskin's *Unto This Last* had transformed his life, and by his inclusion of Ruskin as the only Westerner among the three moderns who had most deeply influenced him. Thoreau's influence has been misdated (it did not precede the initiation of *satyāgraha*), but Ruskin's earlier impact has never been explored. Further reading led me to a dual awareness of the many remarkable parallels between Ruskin's and Gandhi's ideas and of the difficulty of sharply differentiating Ruskin's influence from those of Carlyle, Plato, and other Western and Eastern thinkers. Hence I have sought to bring into focus the distinctively Ruskinian elements in Gandhian thought against this larger background. In considering Ruskin's effect upon Gandhi's way of life, I came to see similarities and contrasts between the two personalities which led me to the conclusion

that Ruskin's mental illness was closely related to his failure to practice his own preachings and to win their acceptance by society at large. Hence I have reinterpreted his psychosis in the light of a comparison with Gandhi's charismatic sanity. I have added a glossary of definitions and identifications for the benefit of the general reader, the Ruskin scholar who may be unacquainted with some of the Indian terms and allusions, and the Southeast Asian specialist who may not recognize minor Western figures or know Ruskin's less familiar works.

ACKNOWLEDGMENTS

I owe many thanks to a number of my colleagues and others who have been kind enough to read the manuscript in part or in full and sometimes to make suggestions for improvement: Edward Partridge, Wendell Smith, F. David Martin, Kenneth Rothwell, John Wheatcroft, C. Willard Smith, Joseph Fell, William Cooper, Grace Hawk, James King, and Dr. Robert Kvarnes. Brewster Taylor and specialists at the Library of Congress have aided me in my research, and Cynthia Fell in my editing. I am grateful to the Radcliffe Institute for a fellowship during my sabbatical leave, and to Bucknell University for summer fellowships as well as continuing support of many kinds. Finally, I remember here my mother, without whose untiring help this book could never have been written.

RUSKIN AND GANDHI

1

METAMORPHOSIS THROUGH WORDS

The Encounter

"In the beginning was the Word." The ultimate reality of the word, its capacity to metamorphosize personality, and its power to change the course of history no longer seem self-evident to twentieth-century man. If he insists upon his freedom to choose values to live by, if he affirms the necessity of existential commitment and of involvement with society, it is usually not in order to respond to ideals potent and enduring in themselves, not in order to ally himself with truths greater than he; rather it is only to make a personal statement, to create a self over against surrounding chaos. More frequently he sees himself as a mere stimulus-response mechanism or a helpless product of the dark unconscious forces of sexuality and aggression. When he regards society as a whole, he may proclaim that bread for all is the precondition of liberty for anyone. If the historical process is not a totally meaningless juggernaut of destruction, it seems to express only the grim logic of a machine grinding up individual purposes in foreordained interactions of material forces. Consequently, human thought seems a mere superstructure imposed upon basic economic realities, perhaps a tool to understand them but

13

not an influence fundamentally controlling them. To the
practical man, the mind, the book, the university seem no
match for the military-industrial complex. To the intellec-
tual it appears that words must be mistrusted and
analyzed unceasingly; they are deemed reliable only
when they can be confirmed by scientific experiment with
concrete objects. Even that master of words, Jean-Paul
Sartre, has examined the possibility that his own words
have been means of self-deception rooted in the needs and
limitations of his childhood.

Yet in our own century Gandhi put faith in the power of
truthful words and by practical use of this weapon alone
led a nation toward liberty and justice. His struggle was as
much economic as political: it involved the strike, the
boycott, the spinning wheel, the illegal use of salt. To the
materialist he demonstrated the reality of spirit and
thought. To the believer in inevitable historical process he
demonstrated the infinite significance of individual deci-
sion. The theories that he set forth abstractly were exemp-
lified and proved by his own life. It was neither his person-
ality alone nor his convictions alone that gave him the
charismatic power to free his people: it was the indissolu-
ble fusion of the two.

Both Gandhi's character and his opinions owed much to
the influence of John Ruskin. Long before in England,
when it was suffering economic ills not unlike those of
Gandhi's India, Ruskin had enunciated doctrines like
Gandhi's, apparently to little effect. Yet this seemingly
impotent intellectual, through a book, communicated
hard-won insights to Gandhi in Gandhi's time of need and
thereby gave new direction to his thought and to his life.
Carlyle had written in "The Hero as Man of Letters," an
essay well known to both Ruskin and Gandhi: "In books
lies the *soul* of the whole past time. No magic rune is

stronger than a book. . . . Do not books still accomplish *miracles* as *runes* were fabled to do? They persuade man" and thereby modify the practical world. They are a "continuous revelation" of the divine in the terrestrial, Carlyle believed, expressing the "*thought* of man; the true thaumaturgic virtue; by which man works all things whatsoever."[1] Gandhi probably recalled Carlyle's words when he entitled his account of discovering Ruskin's *Unto This Last* "The Magic Spell of a Book." Many ideas helped to shape Gandhi; many experiences led to his fundamental life-choices. Yet his first reading of Ruskin was unquestionably one of the most crucial: "it brought about," he said, "an instantaneous and practical transformation in my life."[2] Ruskin influenced Gandhi's conception of soul-force as a substitute for physical force; he was the chief source of Gandhi's economic ideas; but, above all, he changed Gandhi as a person.

In 1893, seven years before reading Ruskin, Gandhi had left India for South Africa, expelled from his caste and unable to practice law because of a disagreement with the local British political agent and because of his unfitness for the contentiousness of the courtroom, as indicated by his breakdown during his first cross-examination of a witness. In South Africa, however, he had attained modest professional success through his effectiveness in achieving out-of-court settlements and in championing Indian immigrants. There he had found many other Indians, divided by language, caste, and background, most of whom had come to South Africa as indentured laborers, had later found other occupations, but remained the victims of severe prejudice and economic exploitation. In an attempt to unite them with one another and to substitute harmonious cooperation for conflict between European and Indian, he had founded the newspaper *Indian Opin-*

ion, published at first in four languages and later in two,
to discuss public events and political, economic, ethical,
and religious ideas. Only three years later this journal
was to record the historic initiation of *satyāgraha,* a cam-
paign of "truth-force" in disobedience to an act requiring
the registration of all Asiatics in South Africa.
Satyāgraha would probably have been impossible, Gandhi
wrote, without the mutual communication between him
and his subscribers through the editorials and letters of
Indian Opinion.[3] But in 1904 *Indian Opinion* was on the
verge of financial failure, despite Gandhi's steady con-
tributions of practically all his savings. In response to a
letter from its editor informing him of arrears and poor
bookkeeping, Gandhi undertook a train journey from
Johannesburg to Durban, thence to proceed to Natal. An
English friend, H. S. L. Polak, a man who like Gandhi
preferred a relatively simple life and habitually trans-
lated belief into practice, gave him *Unto This Last* to read
on the twenty-four-hour trip. Both Polak's character and,
far more importantly, Gandhi's life situation may help to
explain the immediate impact of the book upon his
thought and action. In later interpreting the experience
he wrote, "I believe that I discovered some of my deepest
convictions reflected in this great book of Ruskin, and that
is why it so captured me. . . . A poet is one who can call
forth the good latent in the human breast. Poets do not
influence all alike, for every one is not evolved in an equal
measure."[4] Gandhi had already become aware of his iden-
tity as a leader of the oppressed and as a mediator between
them and their oppressors. He was now faced with the
possible extinction of the organ by means of which he
sought to effect social justice and reconciliation of class
conflict. The practical problem facing him was an
economic one. It was at this moment that he encountered

an economic theory rooted in love. "The book was impossible to lay aside, once I had begun it," he wrote. "I determined to change my life in accordance with the ideals of the book."

He summarized his understanding of *Unto This Last* in three principles:

1. That the good of the individual is contained in the good of all.
2. That a lawyer's work has the same value as the barber's, inasmuch as all have the same right of earning their livelihood from their work.
3. That a life of labour, i.e. the life of the tiller of the soil and the handicraftsman, is the life worth living.

The first of these I knew. The second I had dimly realized. The third had never occurred to me. *Unto This Last* made it as clear as daylight for me that the second and the third were contained in the first. I arose with the dawn, ready to reduce these principles to practice.[5]

In his enthusiasm Gandhi had drawn sweeping conclusions from brief passages in Ruskin's work. Although Ruskin seems to advocate equality of wages for all, he explains in a footnote in later editions that such is not his intention. His eloquent praise of the laborer's life is not meant as an appeal for renunciation of other occupations. The call to the simple life in his final paragraph expresses not an inherent preference of simplicity for its own sake, but rather a conviction that under existing conditions luxury is sinful: "the kind of existence to which men are now summoned by every plea of pity and claim of right, may, for some time at least, not be a luxurious one; consider whether, even supposing it guiltless, luxury would be desired by any of us, if we saw clearly at our sides the suffering which accompanies it in the world."[6]

This passage at the end of *Unto This Last* altered Gandhi's entire style of life. He immediately founded

Phoenix Farm, an experimental community of Indians and Europeans publishing *Indian Opinion* and providing the model for his Tolstoy Farm of 1910 and his Indian *satyāgraha ashram* (religious community for truth-force). The goal was "the welfare of all"; the means, poverty, equality, and manual labor extending eventually even to the use of the hand press. Settlers were required to promise to follow the teachings of Ruskin and Tolstoy. His friend Polak says unequivocally, "He adopted the 'simple life' as a matter of practice after the influence of Ruskin, . . .[although] he must always have had an inclination that way, especially as a result of his early home life."[7] In Gandhi's autobiography, he not only attributes the settlement at Phoenix to his reading of *Unto This Last,* but also explains that he later disposed of much of his Johannesburg furniture "in the light of Ruskin's teaching" and comments on Polak's reluctance to marry without a financial backlog, "He knew Ruskin much better than I, but his Western surroundings were a bar against his translating Ruskin's teaching. . .immediately into practice."[8] Thus it was from his reading of Ruskin that Gandhi dated his renunciation of money and professional advancement, his choice of a way of life that led him eventually to call himself a farmer and weaver rather than a lawyer, and his definition of the ideals that his disciples as well as he himself should embrace. It was at this time that he adopted the simple life and identified himself with the masses of the poor.

In *Gandhi's Truth,* a book published[9] after the completion of my own studies, Erik Erikson explores a later crisis in Gandhi's life, the strike at Ahmedabad, which marked his first political fast and his emergence into national stature as a leader in his own country. Erikson amply demonstrates the significance of this episode; but its foun-

dations had been laid years before. Gandhi had already become well-known as a leader in South Africa; he had already established the custom of sharing the hardships of the poor, which was logically extended by his fasting to participate in the workers' hunger. All the attitudes and all the theories put into practice at Ahmedabad had been earlier expressed in South Africa, most of them under the influence of John Ruskin. Ahmedabad was chosen as the site of Gandhi's efforts partly because "it was likely to be the most favourable field for the revival of the cottage industry of hand-spinning";[10] his interest in handicrafts dated from his reading of *Unto This Last*. The *ashram* that he founded near Ahmedabad followed the same principles as the farm that he started the day after reading *Unto This Last*. Above all, the economic principles which he applied in his handling of the strike were ideas that Gandhi often explicitly said he derived from Ruskin. He spoke to the workers of the equal value of all occupations, a theory that he considered one of the three principal ideas of *Unto This Last*. He spoke of cooperation rather than of competition, of employers' paternalistic responsibility for the workers, of workers' regard for the employers—all Ruskinian concepts. He found a conflict in which literal family ties between a brother and a sister on opposite sides made real the affection and loyalty that he and Ruskin maintained should always draw capitalists and their employees together in a figurative family group. To the spirit of harmony he added the quest for justice in a Socratic and Ruskinian attempt to discover an abstract principle and relate it to a particular practical problem. As Ruskin had preferred abstract determination of the just wage to reliance on the law of supply and demand, so Gandhi in a concrete conflict did not bargain, but insisted upon the wage that he believed to be just. Although he recognized

his own fallibility and had faith in the pragmatic valida-
tion of truth, he nonetheless, like Ruskin, conceived of
truth and justice not as relative notions, but as eternal
absolutes to be unceasingly pursued.

Gandhi's reading of Ruskin had not only persuaded him
of the principles put into practice at Ahmedabad; it had
effected an earlier and more radical existential transfor-
mation. Erikson recognizes that the Ahmedabad strike
was by no means the only crisis in Gandhi's life, that it
occurred when Gandhi was forty-eight, well after the for-
mation of basic traits of character, and that its interest for
him derived partly from his own visit to the city and partly
from its effect upon the identity crises of younger follow-
ers. In accordance with his theory that the fundamental
life-choice takes place in youth, Erikson places "the" iden-
tity crisis of Gandhi much earlier, when the twenty-four-
year-old lawyer decided to combat racial prejudice be-
cause he had been evicted from a train for insisting upon a
first-class seat.[11] Other experiences also marked sharp
transitions: for instance, the vow of chastity and the initi-
ation of civil disobedience in South Africa. But Gandhi's
maturation was essentially a gradual and consistent
progression toward total identification with the Indian
masses and through them with all humanity. As Erikson
explains, identity is "a process 'located' *in the core of the
individual* and yet also *in the core of his communal cul-
ture,* a process which establishes, in fact, the identity of
these two identities."[12] From this point of view, if one
seeks to focus upon a single turning point in the life of
Gandhi, his decision to become a leader of his people is less
significant than his decision to share without reservation
their experience. At what point did he first reject the
world of privilege and of professional ambition in order to
confirm his solidarity with the oppressed? At what point

did he first existentially proclaim that for him, at least, "the good of the individual. . .[was] contained in the good of all"? The moment is clearly indicated in his autobiography as his encounter with *Unto This Last.*

The voice that spoke to Gandhi across half a century from the nation of India's oppressors had expressed its deep concern for social justice during a far more anguished crisis than that of Gandhi. Born to wealth and luxury, protected by adoring parents, John Ruskin had cultivated a highly refined esthetic sensibility and had become well known as an art critic. He had experienced several depressions, the annulment of his marriage, and some deterioration of his artistic judgment. During the years between 1857 and 1860, he was assailed by religious doubt, love for a child, and, above all, concern for the workers whom he had been trying to teach to enjoy and to create art. His turmoil reflected and focused that of his nation, for 1859 was a year when profound conflict over social and religious questions was coming to a head throughout the English intellectual world. With two lectures that preceded it and a second series of essays that followed it, *Unto This Last* marked a decisive reversal in the direction of Ruskin's intellectual efforts. Through his opinion that beauty could not be valued or produced by exhausted and exploited laborers, he came to give primacy to social over esthetic concerns and to devote much of the rest of his life to the consideration and attempted amelioration of economic problems. In middle age, he suddenly abandoned the work that society accepted and for which his abilities were best fitted, to approach as a pioneer a task of prophecy in a field unfamiliar to him. His message evoked from the influential and the wealthy primarily wrath and scorn. Ruskin himself always regarded *Unto This Last* as the "central book of [his] life," "the truest, rightest-

worded, and most serviceable."[13] His failure to find sup-
port for its ideas precipitated his first serious mental
breakdown and became one of the deepest griefs of his life
and one of the chief causes of his later insanity.

Ruskin wrote *Unto This Last* when he was forty; Gandhi
read it when he was thirty-five. Both found themselves in
the middle of life's road, like Dante when he began his
great narrative of spiritual transformation. Both were
surrounded by poverty and misery and were seeking to
deal with it in a loving and religious way. Both sacrificed
their earlier careers to this effort. Their writings present
largely similar answers to similar economic problems.
Their subsequent lives reveal an inspiring and tragic con-
trast between Gandhi's steel-willed commitment to the
pragmatic realization of convictions and Ruskin's tor-
tured inward division between idealistic thought and
self-indulgent action. Gandhi's discovery of Ruskin's book
was as significant a contribution to his development and
as genuine an encounter between two deeply concerned
human beings as any actual meeting could have been.
Ruskin had told one admirer: "I don't care whether you
have enjoyed. . .[my books] or not. Have they done you any
good?"[14] *Unto This Last* did Gandhi good, and through
him did India good, did the world good.

Gandhi interpreted *Unto This Last* primarily as an ex-
pression of attitude. Little concerned with esthetic merits
or involved arguments, Gandhi selected and evaluated
books according to their moral relevance to his practical
goals. Although he said that his limited reading was
thoroughly digested, his references to Ruskin and other
authors occasionally reveal inaccuracies and misinterpre-
tations, along with a remarkable intuitive faculty for
leaping to the heart of an author's meaning through close
attention to individual passages. Gandhi read Ruskin as

Ruskin longed to be read, as a teacher of virtue stimulating growth through an I-Thou encounter that aided Gandhi to achieve his own identity, to discover his "own deepest convictions," and to fulfill his insight, as he always did, by existential commitment.

Gandhi's Knowledge of Ruskin

The profound inward and outward change in Gandhi's life when he read *Unto This Last* is clearly described in his autobiography. His dependence on Ruskin as the almost exclusive source of his economic opinions is readily demonstrable; for although the practical applications of Gandhian economics reflect traditional Indian ways, the intellectual justifications are consistently Ruskinian. Gandhi listed Ruskin, Tolstoy, and the Indian spiritual leader Raychandbhai as the three moderns who influenced him most deeply. Yet the exact delimitations of this fundamental and far-reaching influence are difficult to mark out.

In the first place, it cannot be determined with certainty how many of Ruskin's books Gandhi knew. He recalls reading "the writings of Tolstoy, Ruskin, and Socrates [sic]" during his first jail experience in 1908 and "the two famous books of Ruskin" during his second, and finding in them "arguments in favor of our fight."[15] Polak states in a letter to the author that apart from *Unto This Last,* "The only other book of Ruskin that I can recall his having the time to read was 'The Crown of Wild Olive.' My books by Ruskin include 'Sesame and Lilies,' 'The Crown of Wild Olive,' 'Fors Clavigera' and 'Frondes Agrestes'; but I cannot now say when I read them or whether I discussed them with him."[16] It is tempting to suppose that whether or not he read *Fors Clavigera,* Gandhi had at least heard of St.

George's Guild and Ruskin's attempts to revive hand-spinning and hand-weaving. Certainly his ideas strongly suggest the influence of *A Joy for Ever,* and perhaps also of *Munera Pulveris.* These works were included in an Everyman volume which Gandhi might have referred to loosely as *Unto This Last,* although its full title was *Unto This Last and Other Essays on Art and Political Economy.*[17] Because this book was not published until 1907, it could not have been the one he read in 1904, but it could have been the one he found in the prison library in 1908. However, because he mentions reading "the writings" of Ruskin, the possibility of his knowing more than two does not depend on the availability of this edition. In any case, *Unto This Last* has been said to contain "in nucleus all the constructive [economic] ideas which Ruskin later developed in detail."[18]

Ruskin also must have influenced Gandhi indirectly through Godfrey Blount, whose six-penny booklet *The New Crusade* was summarized by "a Phoenix Settler" in *Indian Opinion* in 1905.[19] Although Blount does not mention St. George's Guild, he claims the guidance of Ruskin "more than that of any modern prophet"[20] for a very similar movement to purchase land for agriculture and for a handicraft museum. Like Ruskin and Gandhi, Blount emphasizes the priority of individual religious change to political reform, the advantage of practicing ethics over preaching them, the satisfactions of country life and crafts, the nobility of traditional art, and the value of simplicity as against extravagance—a theme stressed in many book reviews and articles in *Indian Opinion.*[21]

Gandhi utilized the first incarceration to work on his Gujarati paraphrase of *Unto This Last,* entitled *Sarvodaya (The Welfare of All),* which was published in pamphlet form in 1908, and again in 1951 in an English

retranslation by Desai, which included a new introduction by Gandhi referring to the influence of Plato and a brief appreciation by Desai of Gandhi's original prophetic conclusion.[22] In 1919, the year when at the Ruskin centenary celebration in London Hobson lauded Ruskin's ideas of social reform as having already been accomplished in some measure in England, Gandhi began the civil disobedience campaign in India by distributing *Sarvodaya* along with another prohibited book, his own *Hind Swaraj (Indian Home Rule)*, and his translation of *The Defence and Death of Socrates*. His purpose, he said, was twofold: to breach the Rowlatt Act and to supply people with clean literature of a high moral value, such as the government might be expected to confiscate. *Sarvodaya* was widely read and remembered. In 1948, after Gandhi's death, the *Sarvodaya Samaj* (Society for the Welfare of All) was started at Wardha to continue his work. Its purposes were explained in 1951 in a brochure, *Sarvodaya,* which was amplified in another volume of the same title in 1954. Beginning with Gandhi's remarks on his discovery of Ruskin, the biblical parable providing Ruskin's title, and extensive quotations from the paraphrase, the volume also includes essays by such Gandhian thinkers as Vinoba Bhave, Mashruwala, and Muzumdar. It clearly establishes Ruskin as the father of Gandhian economic thought.[23]

Gandhi's translation illuminates his interpretation of *Unto This Last.* He follows the original closely until about the middle of the third essay, "Qui Judicatis Terram," or as he calls it "Even-Handed Justice." Most of his changes are deletions, condensations, and simplifications: omissions of such material as the preface, transitional sentences, parenthetical explanations, quotations, allusions to chemistry and the British corn laws, and specifically

Christian elements, like the title, which might be unac-
ceptable to his readers. Ruskin's mention of the slavery
practiced in barbaric nations is transformed by Gandhi
into a reference to England's slaves; his denial of human
equality and his defense against the charges of socialism
and hostility to property rights are dropped. Gandhi is less
concerned with the details of logical economic argument
than with the assertions that justice and humanity form
the only rational basis for economics. His simplicity of
thought and style, in sharp contrast to Ruskin's complex-
ity, and his loose organization are most apparent in his
extremely brief summary of the last chapters. Perhaps he
never found time after the 1908 jail sentence to complete
his translation; more probably he found these chapters too
difficult for the average Indian reader.

The final section of Gandhi's version is primarily a
reiteration of Ruskin's moral axioms. From the last part of
"Qui Judicatis Terram," Gandhi takes only a brief expla-
nation of the just as against the competitive wage; a
statement that "True economics is the economics of jus-
tice"; a general condemnation of competition, which,
Gandhi adds, results in "fraud and rotten goods"; and two
sentences of Ruskin's:

> I know no previous instance in history of a nation's establish-
> ing a systematic disobedience to the first principles of its
> professed religion. The writings which we (verbally) esteem
> as divine, not only denounce the love of money as the source of
> all evil, and as an idolatry abhorred of the *Deity,* but declare
> mammon service to be the accurate and irreconcileable oppo-
> site of God's service: and, whenever they speak of riches
> absolute, and poverty absolute, declare woe to the rich, and
> blessing to the poor.

Of Ruskin's elaborate final essay redefining value and
other concepts, Gandhi preserves only the differentiation

between useful products availing toward human life, those which are nugatory, and those, such as gunpowder, which are destructive. Developing the antithesis between the happiness of the farmer and the material wealth achieved by diminishing the life of the factory worker, Gandhi chooses another brief passage for direct translation:

> THERE IS NO WEALTH BUT LIFE: That country is the richest which nourishes the greatest number of noble and happy human beings; that man is richest who, having perfected the functions of his own life to the utmost, has also the widest helpful influence, both personal, and by means of possessions, over the lives of others.

Asserting that money is an instrument creating misery in the hands of a bad man and happiness in the hands of a good one, Gandhi stresses Ruskin's condemnation of rich men's failure to meet their educational and other responsibilities toward the poor and adds a word of his own on the folly of the poor in allowing envy to reduce them to force or fraud. Gandhi's final sentence summarizes his interpretation of Ruskin's picture of laissez-faire capitalism:

> Employers and employees are at daggers drawn with one another, and men are reduced to the level of beasts.

In a vehement "Conclusion" of his own, which will be more fully summarized later, Gandhi warns his fellow Indians against blind imitation of Western ways. Their present goals of independence and industrialization, he says, have brought no happiness to European nations. The positive side of his thought is expressed in his last paragraph, where in a reference to alchemy he appropriates Ruskin's stress on the development of individual charac-

ter as the precondition of national welfare, and even his Platonic comparison of character to gold:

> India can become a land of gold again only if the base metal of our present national character is transmuted into gold. The philosopher's stone which can effect this transformation is a little word of two syllables—*Satya* [truth]. If every Indian sticks to truth, Swaraj [home rule] will come to us of its own accord.

Satyāgraha (truth-force or soul-force), as Gandhi called his nonviolent civil disobedience, appears on the surface to be alien to Ruskin's constant insistence on the virtues of obedience and loyalty; yet in fact it is intimately related to the content of Ruskin's first essay. Gandhi's retitling of "The Roots of Honour" as "The Roots of Truth" is suggestive; but still more indicative is his treatment of Ruskin's famous refutation of the ethic of self-interest as a basis for economic theory:

> [The servant] being. . .an engine whose motive power is a Soul, the force of this very peculiar agent, as an unknown quantity, enters into all the political economist's equations, without his knowledge, and falsifies every one of their results. The largest quantity of work will not be done by this curious engine for pay, or under pressure, or by help of any kind of fuel which may be applied by the chaldron. It will be done only when the motive force, that is to say, the will or spirit of the creature, is brought to its greatest strength by its own proper fuel; namely, by the affections.

In the English retranslation of Gandhi's paraphrase, "the force of this very peculiar agent" becomes "soul-force." Thus Ruskin anticipates in some part the notion of *satyāgraha*. Gandhi develops the idea further in a significant insertion a few paragraphs later:

[Political economics] imagines that man has a body but no soul to be taken into account and frames its laws accordingly. How can such laws possibly apply to man in whom the soul is the predominant element?

In a Y.M.C.A. report on June 6, 1908, in *Indian Opinion,* Gandhi again refers to this idea:

It never can be that mere intelligence or mere physical strength can ever supersede the heart-strength or, as Ruskin would say, social affections.

Here, too, Gandhi begins his Ruskinian attacks on the doctrines of might as right and the survival of the fittest, and initiates his Ruskinian doctrine of trusteeship with a reference to Kipling's belief that white men should act as trustees for the colored. The concept of soul-force, the dislike of competiton and machinery, and the advocacy of hand-weaving give evidence of Ruskin's influence on *Hind Swaraj (Indian Home Rule),* which was also published in 1908 and outlined many of the ideas that guided Gandhi in later years.

Yet the extent of Gandhi's acquaintance with particular works of Ruskin remains uncertain; and beyond this problem lies the difficulty of disentangling interrelated influences. Gandhi was interested in other authors who influenced or were influenced by Ruskin. Gandhi knew Plato and translated the *Apology* and the *Crito* as *The Story of a Satyāgrahi;* he also began a translation of one of Carlyle's books, and was familiar with Carlyle's lives of Burns, Johnson, and Scott, *Heroes and Hero-Worship,* and *The French Revolution,* where he found "instances of passive resistance."[24]

Many of the attitudes that Gandhi could have derived from the works of Tolstoy[25] belonged also to Ruskin. Tols-

toy had read most of Ruskin's books, beginning with *Unto This Last,* and had translated some of them into Russian. Despite the disharmony between Ruskin's paternalism and Tolstoy's anarchism, the two felt a high mutual regard. Ruskin declared that Tolstoy was "carrying out the work he had hoped to do,"[26] and Tolstoy wrote in 1899 in an introduction to Ruskin's works:

> John Ruskin is one of the most remarkable men not only of England and of our generation, but of all countries and times. He is one of those rare men who think with their hearts ('les grandes pensées viennent du coeur'), and so he thinks and says what he has himself seen and felt, and what everyone will think and say in the future.
>
> Ruskin...is not spoken of as a philosopher, political economist, and Christian moralist....In spite of the ...opposition he still meets with, especially among the orthodox economists...who cannot but attack him since he destroys their teaching at its very roots—his fame grows and his thoughts penetrate among the public.[27]

Tolstoy commented on Brunhès's study of *Ruskin et la Bible,* "There was a man who read his Bible, and to some purpose."[28] He felt akin to Ruskin, too, in their common failure to live wholly in accord with their beliefs.

Gandhi's favorite American authors were Emerson and Thoreau; indeed, he translated part of *Civil Disobedience,* as well as the Reverend William Salter's *Ethical Religion.* Like Tolstoy, the Concord men had been influenced by the Orient; and Emerson, of course, knew the work of Carlyle and Ruskin. An interesting similarity to Ruskin's economic views is to be found in Thoreau's remark that "the cost of a thing is the amount of what I will call life which is required to be exchanged for it immediately or in the long run."[29] Gandhi was probably interested in the

nonviolent hero in Emerson's essay on "Heroism"; the notion of "truth" as the foundation of a peaceful society, which Emerson shared with Carlyle; and the Kantian political ideal of absolute justice in Carlyle and Thoreau.[30] But American influence on Gandhi has been overestimated. Both Gandhi and his close friend Polak denied that they were acquainted with Thoreau's writings until months after the initiation of *satyagraha* on September 11, 1906. The issues of *Indian Opinion* for that year bear out their statement rather than Hendrick's revision of the date to September 11, 1907, and thus invalidate Hendrick's argument that Gandhi derived the idea of civil disobedience from reading Thoreau in 1907.[31]

On the other hand, insufficient attention has been given to Gandhi's affinities with Ruskin and Ruskin's masters, Plato and Carlyle. An investigation of these parallels against the background of Eastern philosophy and Western idealism reveals the validity of some of their religious and economic insights, suggests a redefinition of Ruskin's mental illness, and illuminates the intellectual and ethical development of the greatest spiritual leader of our time. It may be divided into a comparison of fundamental religious, political, esthetic, and educational beliefs, with especial reference to *satyagraha;* a study of attitudes toward scientific progress and of the economic problems following in its wake; and, finally, an attempt to compare and contrast the two men's characters, so closely related to their ideas.

2
THE POWER OF TRUTH

The Unity of All

As Gandhi said, Ruskin's book reflected some of his own deepest convictions: the sources of its appeal to him lay in its verbalization of what Gandhi already believed, in its expression of an attitude toward life similar in many ways to his own. Behind the economic teachings of *Unto This Last* lies a religious world-view, a faith in the primacy of spirit over matter, the faith of a profoundly religious nature intensely aware of a conflict between ancient philosophical wisdom and modern technological orientation. Ruskin's attack on materialism and its psychological and economic corollaries combines elements of Platonism, Christianity, and Carlylean vitalism, with all of which Gandhi was acquainted. Its interpretation of Christianity distantly suggests the Quaker emphasis on ethics, which interested Gandhi, and the Tolstoyan return to primitive Christianity.

Yet Gandhi's interest in Ruskin, in the essential ethical teachings of Christianity (as opposed to its narrowly dogmatic aspects), in Plato, and in such transcendental Western thinkers as Carlyle, Emerson, and Thoreau in no way conflicted with his allegiance to Indian tradition. Some, in

fact, attribute the current Indian renaissance partly to the British government's stimulation of a native cultural revival and partly to Gandhi's study of Western reformers who stirred him to reinterpret Indian thought. Neither Ruskin nor Gandhi made any attempt to evolve a metaphysical system, but their kinship of mind was in the last analysis due partly to similarities between the main body of Indian philosophy and the idealistic side of the Western tradition, especially as represented in Plato and Fichte. Radhakrishnan and Moore list seven tendencies that persist in almost all Indian thought with the exception of the Cārvāka school of hedonistic materialism.[1] Indian philosophy traditionally regards man and the universe as spiritual in nature; it sees philosophy as intimately related to life, with truth a guide to practice rather than practice a test of truth; it resorts to introspection as a means of comprehending the self more than to science as a means of comprehending the material world; it is idealistic, usually monistic; it is synthetic and tolerant, recognizing that there are many ways to worship the same God, tending to view all philosophies as ultimately one, and all aspects of life as parts of a united whole; it stresses the primacy of intuitive over rational knowledge; and it accepts traditional authority. With the partial exception of the last two, these characteristics mark the thinking of both Ruskin and Gandhi. Some of them resemble the four principles of agreement that Toynbee finds among the seven major religions: that "the universe is mysterious"; that "there is a presence in it greater than man or than the sum total of phenomena"; that "knowledge is not an end in itself, but a means to action"; and that communion with the divine spirit requires the conquest of egoism.[2] The last belief is fundamental in the *Upanishads* and most other Indian religious works. It underlies the demand for self-

sacrifice in *Unto This Last* and inspires the entire body of Gandhian thought. The religious beliefs of Ruskin and Gandhi emphasize the essentials common to all religions rather than the distinctive characteristics of Christianity or Hinduism. Neither lays claim to originality of thought. Ruskin says, "No true follower of mine can ever be a Ruskinian. He will follow not me, but the instincts of his own soul and the guidance of his Creator."[3] He recommends adopting St. Paul's "more excellent way" by giving money to the poor rather than maintaining "Ruskinian Preachers for the dissemination of Ruskinian opinions, in a Ruskinian Society, with the especial object of saving Mr. Ruskin's and the Society's souls."[4] Similarly, Tolstoy denies the existence of Tolstoyism, and Gandhi declares, "There is no such thing as 'Gandhism,' and I do not want to leave any sect after me. I do not claim to have originated any new principle or doctrine, I have simply tried in my own way to apply the eternal truths to our daily life and problems."[5] Buddha himself disclaimed any effort to found a sect, advising his followers to rely on themselves and to hold to truth as a lamp.

Perhaps Carlyle contributed to the tolerance and practicality of both Gandhi's and Ruskin's religious views. Gandhi read with sympathy the chapters on nature-worship and Islam in *Heroes and Hero-Worship;* indeed, according to Nanda,[6] he found particularly rewarding the account of Mahomet. He agrees with Carlyle that a man's religion is not what he professes or asserts, but what he "does practically lay to heart and know for certain concerning his vital relations to this mysterious universe, and his duty and destiny therein."[7] This focus upon practical moral commitment suggests the spirit in which Ruskin wrote *Unto This Last,* a spirit easily misinterpreted as purely humanistic. Although Ruskin changed in his at-

titude toward authoritarian religion, toward God as a power commanding obedience, he always retained his conception of a "law of Divine life in the whole of organic nature" and the " justice, self-command, and true thought, which ... dwell in the living powers of the Gods.' "[8] The change of direction in Ruskin's life in 1860 resulted from a widening and deepening of an outlook which was always religious. Although he never achieved the consistent tolerance that would have ended his attacks on Catholicism, he often glimpsed such an attitude, as in his broadly inclusive welcome to men of all faiths as members of St. George's Guild. He was far from disavowing religious faith when he said that "in resolving to work well lay the only foundation of any religion whatsoever"; that "no syllable [of the Bible] was ever yet to be understood but through a deed"; that "the one Divine work. . .is to do justice—justice first before charity can be spoken of"; and that "unless we perform Divine service in every willing act of life, we never perform it at all." A sense of mission animated his work: "It really is. . .important and practical for me to try before I die to lead two or three people to think 'whether there be any Holy Ghost.' "[9] The title of *Unto This Last* and the frequent biblical quotations reveal it as an attempt to apply Christ's ethical teachings to the problems of Victorian society, yet Ruskin regarded it as his first heretical work because it points out the contradiction between Christian doctrine and contemporary practice. Gandhi, who could quote Jesus as well as the religious poet Tulsidas, sympathized with this purpose, although he excised the specifically Christian elements from his paraphrase, perhaps out of deference to the attitudes of other Indians.

Like Carlyle, and like Ruskin after 1858, Gandhi emphasizes deed rather than dogma. His quest of peace and

unity among men begins with a quest of fundamental
religious truth on which men of all faiths might agree.
Hinduism has always assimilated other faiths through its
infinite multiplicity, its assumption that men find differ-
ent paths toward the same truth and even as individuals
need different names for the same God. Gandhi's search
for common elements in the scriptures of the major relig-
ions led him to the historically inaccurate belief that all
were primarily ethical, and that their essence was non-
violence. Besides his Gujarati paraphrases of Plato, Rus-
kin, and Thoreau and his English translation of Indian
poetry, he also produced a Gujarati version of the Rev-
erend William Salter's *Ethical Religion,* which was often
mistakenly accepted as Gandhi's original work. Salter, an
early member of the Ethical Society in America, advo-
cates a religious union among men of goodwill without
regard to their intellectual divisions. Mentioning the in-
adequacy of science to evaluate the facts it investigates
and the contradictions between Christianity and business
morality, Salter argues that duty commands men to make
justice and love prevail in the practical world by summon-
ing others to their "true and proper life," since "the
thought of what *ought* to be is as elemental a part of man's
being as the sense of what is."[10] Despite the differences
between Salter's complete identification of religion with
ethics and Gandhi's worship of a God of truth and love,
Gandhi's interest in the mediocre book reveals his Car-
lylean insistence upon similarities between religions and
upon practical action as a criterion of sincerity. "I do not
know any religion," he said, "apart from human activity.
It provides a moral basis to all other activities which they
would otherwise lack reducing life to a thing of 'sound and
fury signifying nothing.' "[11] Unlike the Western thinkers,
however, Gandhi defines the ethical teaching common to

all religions as nonviolence. In consequence of this conviction he prefers the New Testament to the Old and adopts the questionable interpretation of the Bhagavad-Gītā as representing an allegorical conflict between good and evil rather than a legendary war. It was tragically ironical after Gandhi's lifelong assertion of the unity of all religions that the achievement of Indian freedom was attended by the outbreak of religious conflict as fanatical as the Christian crusades.

The broadly ethical religious orientation of Ruskin and Gandhi is not to be confused with what Collingwood calls the typical Victorian combination of intellectual skepticism with moral dogmatism. Kant's separation of the trustworthy moral faculty from the theoretical faculty that can never determine absolute truth is alien to Ruskin's sense of the organic unity of the human mind. Noting that Ruskin loved Plato and perhaps attempted to read Fichte, Collingwood nevertheless feels that Ruskin's "central core of unconscious ideas"[12] is Hegelian: his respect for facts, growth, and historical causation; his tolerance; his awareness of the interrelationship of morality, art, and political life as expressions of the nature of a given society; and his defense of self-contradiction. Miss Evans argues that Ruskin's inconsistencies and failure to systematize his ideas prove his lack of any synthetic, unifying mental faculty;[13] but her point of view may perhaps be reconciled with Collingwood's by distinguishing between logical and organic unity. While devoting too little attention to the influence of Plato, and indirectly through Carlyle of Fichte, Collingwood rightly stresses Ruskin's dislike of Kant's formalistic anatomy of the mind. It might be added that Ruskin's synthetic approach to philosophy explains his distaste for the analytic methods of science and for the compartmentalization of

mind which created the "economic man" and led Adam
Smith to base *The Wealth of Nations* upon psychological
assumptions quite different from those evolved in his
Theory of the Moral Sentiments. Ruskin's protest against
"modern philosophy... as a great separator" shows an
affinity with Gandhi's belief that "Human life being an
undivided whole, no line could ever be drawn between its
different compartments, nor between ethics and
politics. . . . One's everyday life was never capable of being
separated from one's spiritual being." Gandhi believes
that all aspects of personal and social life interreact, and
that Law and Lawmaker are one; of himself as an indi-
vidual, he says, "My life is one indivisible whole and all
activities run into one another, and they all have their rise
in my insatiable love of mankind."[14] Both Gandhi and
Ruskin seek to establish religion as man's master activity,
controlling his political, economic, and esthetic life; both
refuse to accept the fragmentation of life that can result
from injudicious application of methods intended for the
investigation of laws of matter to the study of man and his
activities.

Behind Gandhi's sense of the unity of religions and of
the human life lies a basically monistic view of the uni-
verse, akin to that of Plato and of Ruskin. According to the
monism of the *Upanishads,* the world of the senses posses-
ses reality only as an aspect or shadow of the world of
spirit, of a God that is Truth; the deepest self of the indi-
vidual is identical with the universal Self or Atman (the
name of God subjectively perceived as Brahman is the
name of God objectively perceived); the *atman* retains an
innate knowledge of truth; it is "apart from the body," "of a
permanent and superior nature"; and the body is merely,
as Gandhi puts it, the prison, the impermanent abode, or
the temporary possession of the soul, which the soul

should use for its own purposes.[15] *Moksha,* self-realization or union with God, is for Gandhi the goal of human life; and truth is God. The Hindu belief that man's real self, as opposed to his external self, is identical with God is akin in some ways to the Quaker doctrine of the "inner light" or the "Christ within" and to the Fichtean identification of the individual ego with the universal ego. The even closer resemblances between this strain of Indian religion and Platonism perhaps help to account for Gandhi's interest in Plato and Plato's disciple Ruskin; but while Hindu thought sometimes tends to advocate withdrawal or to regard *karma yoga* (practical idealism) as primarily a means of personal salvation requiring nonattachment to results and effecting no essential change in the world of *maya* or illusion, Plato sees values as creative powers within the world of sense experience.

Ways toward Truth

The Socratic attempt to define values in order to act wisely is evident in *Unto This Last,* which is an investigation of the nature of truth and justice in the economic sphere, as Gandhi stresses when he retitles "The Roots of Honour" as "The Roots of Truth" and "Qui Judicatis Terram" as "Even-Handed Justice." As Ruskin, who read Plato daily,[16] begins by admitting the impossibility of certain knowledge of Absolute Truth and Absolute Justice, so Gandhi recognizes that "We cannot, through the instrumentality of this ephemeral body, see face to face Truth, which is eternal." Nonetheless, he attributes to his vision of "a republic of every village in India" an "imperishable value" akin to the eternal truth of Euclid's point which can never be actually drawn.[17] Light imagery is associated with these concepts, for instance in the Sun of

Justice in Ruskin's *Unto This Last* and in the Sun of Truth
at the end of Gandhi's autobiography.

Unattainable truth may be approached, both believe,
either through intuition or through deductive reasoning;
their attitude toward induction and experiment will be
discussed later. Ruskin's mind went immediately to the
root of a problem; he rejected meaningless verbiage and
sought knowledge of concrete facts and insight into moral
implications. Though he never thought of himself as a
mystic, he felt with the mystics of every age that his own
intuition took precedence over the Bible and enabled him
to interpret it, that all men's primary task is to "follow
that light which is in them." Often he interpreted his own
work and others' as the expression of divine inspiration.
There is no real incompatibility between his view of the
artist as "Deity or. . .taught by Deity" and his claim to
authority in economics as a "just, wise, and honest man."[18]
Believing that truth lies dormant in the mind of every
individual, he did not hesitate to seek for himself the
"true" meaning of words defined quite differently by con-
temporary society. Just as Carlyle said that in every kind
there is a genuine and a spurious, so in Ruskin's work and
in Gandhi's occur frequent contrasts between the "false"
and the "true"—false economics and true economics, false
wealth and true wealth, false art and true art, false civili-
zation and true civilization. *Unto This Last* expresses not
only condemnation of England's moral corruption, but
also an attempt to refute the faulty thinking that Ruskin
regarded as its cause. That he was not fair to the
economists Fain has amply proved, but his redefinitions
were sorely needed as reminders of human values.

Like Socrates, Ruskin explores the meaning of ideas in
order that men may mend their lives and their institu-
tions. As Gandhi writes in his introduction to *Unto This*

Last, "Ruskin's *Unto This Last* is an expansion of Socrates' ideas; he tells us how men in various walks of life should behave if they intend to translate these ideas into action." Unlike Socrates, Ruskin uses the essay rather than the dialogue. His occasional choice of the dialogue form, as in the *Addenda* to *A Joy for Ever,* reflects no attempt on Ruskin's part to achieve mutual agreement with others. Ruskin preaches *ex cathedra;* he does not teach Socratically. The failure of Carlyle and Ruskin, temperamental egoists as they were, to attain impartiality and appreciate opposing views contrasts with Gandhi's determination to love his antagonists, believe in their sincerity, and understand their ideas, even ideas so alien to him as untouchability.

For Gandhi as well as Ruskin, knowledge of truth is vital to morality; but Gandhi includes self-knowledge, awareness of his own motive, and he seeks always to correct his own moral and intellectual errors through perceiving any truth that lies in his opponents' arguments. His quest of impartiality through investigation of fact and exchange of opinion was constantly evident in his practical life, although like Ruskin he uses the dialogue form in his writings only as a convention. In *Indian Home Rule,* for example, it enables Gandhi as editor to explain his opinions to the misguided reader less in the fashion of *The Republic* than of the Upanishadic dialogues between teacher and pupil. Yet the Socratic tone is evident in his remarks that "what you call *Swaraj* [home rule] is not truly Swaraj"; that "it is as difficult for me to understand the true nature of *Swaraj* as it seems to you to be easy."[19] His own perception of resemblance between himself and Socrates is suggested by his distribution of his *Defence and Death of Socrates* at the beginning of the Indian passive resistance movement. Like Socrates Gandhi heard a

voice within. Once when asked whether he had had any
mystical experience, he replied, "If you mean visions,
no. . . . But I am very sure of the voice which guides me."
His deep sanity resembles Ruskin's madness in the paral-
lel between Ruskin's auditory hallucinations and refusal
of food, and Gandhi's experience of being awakened at
midnight by his voice and twice commanded to go on
fasts.[20] Ruskin's intuitions were far less reliable than
Gandhi's and were far less frequently examined in
dialogue. Yet both men sought to use both intuition and
reason in the quest of absolute truth.

Satyāgraha

Gandhi's prescription for resistance to the injustice of
the state combines the concept "truth" with the concept
"force." Although Gandhi derives his method primarily
from adjurations in the New Testament and the
Bhagavad-Gītā to return good for evil, he also mentions in
this connection Ruskin, Thoreau, and Tolstoy, who had
spoken of soul-force or love-force. It evolved as a practical
mode of action before it was named *satyāgraha,*
"truth-force" or "soul-force," according to Gandhi's revi-
sion of a term submitted in a contest sponsored by his
South African newspaper, *Indian Opinion.* Gandhi de-
fines it as "the Force which is born of Truth and Love or
non-violence"; and derives it from "satyātruth implying
love, and agraha, firmness which engenders and thus is a
synonym for force."[21] Gandhi's nonviolence was in the
tradition of the Jainists and of the Buddhist emperor
Asoka, whose life partially realized the ideal of *ahimsa*
non-violence" and *maitri* (the bond of human relation-
ship), and who had in a famous inscription declared that
the only true conquest is through *dharma* (pious duty).

Indian thought, however, lays little stress on abstractions as practically efficacious causative powers in the material world. German idealism reinterpreted by Carlyle and less obviously by Ruskin may have contributed to Gandhian thought the sense of the influence in history of immanent spirit. The Hindu concept of the incarnation of the *atman* in a succession of avatars is less dynamic and pragmatic than the Fichtean divine idea expressing itself through individuals in the deed. Gandhi, who was familiar with Carlyle's philosophy, was immune to heroic vitalism as the idealization of the life process itself or of the will to power of individuals who sacrificed principle to practical achievement; yet he occasionally uses Carlyle's own term *moral force* for the spiritual power that Carlyle considered the "parent of all other Force," destroyed by undue attention to externals.[22] The abyss between Carlyle and Gandhi results primarily from Gandhi's consistent refusal to transpose the equation "right is might" into "might is right." Nevertheless, Gandhi's concept of the role of soul-force in history has its Carlylean and Ruskinian antecedents.

The French Revolution is founded upon Carlyle's view of man's life as a "Symbolic Representation and making visible, of the Celestial invisible Force that is in him." Man is an "incarnated Word"; thought shapes the world and begins in love; "God is a truth and his world is a truth." The revolution was a strange union of God's message and the devil's; an apocalyptic destruction by fire of the shams and cant of philosophy and Christianity, belied by the people's hunger; a dream of the phoenix's rebirth after death, of a golden age, a fraternal millennium when man's life would rest on truth rather than lies; a hope disappointed because instead of seeking to realize Christianity by changing themselves, the *sans-culottistes* sought

to change the world by means of the guillotine. Without
any power over them and without the guiding power of a
rule of just living within their hearts, they forgot their
true selves to become fanatics. The Revolution, destroying
a set of lies and substituting the rule of violence and the
Evangel of Mammon, existed in the heart and head of
every violent Frenchman. Like every event of history, as
Hegel had said, it was a disruption of the peaceful con-
tinuity of human life; like all battles, it resulted from
misunderstanding.[23]

Heroes and Hero-Worship also reveals Carlyle's convic-
tion that the spiritual determines the material and that
humanity gradually approaches the apprehension of
truth. The idea of the power of truth dominates Carlyle's
portraits of heroes who with childlike simplicity embody
the godlike in man: the hero as man of letters, who expres-
ses the Fichtean divine idea; Mahomet, the hero as
prophet, who especially interested Gandhi; the hero as
priest, who can unite men by a common belief in truth into
"a whole world of Heroes"—as Gokhale said of Gandhi
that he possessed "the marvellous spiritual power to turn
ordinary men around him into heroes and martyrs."[24]
Although some of Carlyle's heroes could never have been
admired by Gandhi, most are portrayed as men of truth,
always aware of God's power and cooperating with justice,
the inner law of the universe:

> Is not every true reformer, by the nature of him, a *priest,* first
> of all? He appeals to heaven's invisible justice against earth's
> visible force; knows that it, the invisible, is strong and alone
> strong. He is a believer in the divine truth of things; a
> seer. . . .[25]

One of the central affirmations of *Unto This Last* as well
is the existence in man of an unseen power as genuine as

the invisible power of steam so vital in modern technology. Even in *Modern Painters* Ruskin points out political scientists' failure to recognize the "truth in man which can be used as a moving or productive power"; now again he denounces economists for having neglected the illimitable "importance—even in a purely productive and material point of view—of mere thought"; "honesty is not a disturbing force, which deranges the orbits of economics; but a consistent and commanding force, by obedience to which. . .these orbits can continue clear of chaos." Experience, he says, can help men recover and prove the faith they have lost in the efficacy of common honesty. Thought can be not only the source but the goal of material productivity, and the "manufacture of Souls of a good quality" in turn might prove "quite leadingly lucrative."[26]

The power of truth is identified with the power of love in *Unto This Last,* where the Christian ethic is dominant. Ruskin prefers Carlyle's view of truth as a means of uniting men to his depiction of life as a battle between truth and falsehood. Like Carlyle, he believes that the power of the governing classes should derive from men's loyalty rather than their self-interest. Combining the two ideas of moral force and human love in *Unto This Last,* he advocates as a basis for economic relationships which might be preferable to self-interest, "justice, meaning, in the term of justice, to include affection,—such affection as one man *owes* to another." Fundamentals of Gandhi's philosophy are foreshadowed in the daring abandonment of the differentiation between justice and charity, the equation of truth with love, and still more the presentation of this identity in dynamic terms. He compares the workman to an engine powered by soul-force, which can be fueled only by the affections. In *The Cestus of Aglaia* he repeats the ironic metaphor with a significant contrast between the

steam-spirit and "that more ancient spiritus or warm
breath, which people used to think they might be 'born
of.' " "The Spirit power," he remarks, "begins in directing
the Animal power to other than egoistic ends."[27]

As Hobson notes, Ruskin's view of history recognized
"the operation of forces which, chiefly economic in their
outward working, are distinctively spiritual in their
natural sources."[28] Although like Plato he would like to
establish a static ideal society, he understands the proces-
ses by which men's varied activities change and develop
and influence one another. Perhaps he overestimates the
role of the individual in history. While Collingwood says
that Ruskin did not admire the style of Carlyle's heroes,[29]
in his definition of the "moral power," the "invisible gold"
of hero and saint, he reasserts the Carlylean might-right
equation: "all true sanctity is saving power, as all true
royalty is ruling power; and injustice is part and parcel of
the denial of such power." Elsewhere he interprets this
power as Gandhi does: "All great men. . .have a curious
under-sense of powerlessness, feeling that the greatness is
not *in* them, but *through* them; that they could not do or
be anything else than God made them. And they see some-
thing Divine and God-made in every other man they meet,
and are endlessly, foolishly, incredibly merciful." The
"God-given supremacy" of great men rests upon their abil-
ity to rule out of love, with love, and by means of men's
love. But the use of physical force in addition to love is
suggested in a passage on the impossibility of equality—a
section which Gandhi omits from his paraphrase: "My
continual aim has been to show the eternal superiority of
some men to others, sometimes even of one man to all
others; and to show the advisability of appointing such
persons or person to guide, to lead, or on occasion even to
compel and subdue, their inferiors, according to their own

better knowledge and wiser will."[30]

Adopting wholeheartedly the Western emphasis on the pragmatic power of the ideal, Gandhi offers a crucial redefinition of soul-force that eliminates glorification of the self-assertive individual and with it compulsive physical force. Like Ruskin, he identifies truth with love, justice with generosity; but since he deduces from man's incapacity to know absolute truth his incompetence to punish, justice for him is based on self-sacrifice. Aware that "mere appeal to reason" does not convince the irrational man, Gandhi argues that voluntary "suffering opens the eyes of understanding" and that "therefore there must be no trace of compulsion in our acts." *Ahimsā* is more than loyalty or social affection; like Christian charity, it is an ideal beyond the polarities of personal hate and love, an ideal of identification with all that lives. In Gandhi's view nonviolence requires the conquest of the body. He adopts the *advaita* belief that the body is not only a apprehension of truth, as in Plato, but also a barrier to the union with universal life. He believes that many religions match soul-force against physical force and teach that we should limit worldly but not religious ambition; he speaks of attaining soul-force by renouncing body-force, of counting the body "as nothing in comparison. . .to [the] soul," of recognizing with the poet Tulsīdas that "Love is the root of religion or sacrifice and this perishable body is the root of self or irreligion." One may come to know the deepest self, the *ātman,* only through reduction of the personal self to zero, through purification and acceptance of the last place among one's fellows[31]—a process that Gandhi can describe in Christian terms as a surrender to the grace of God.

Subordination of self to truth is the source of soul-force as Gandhi defines it. He calls thought "the power and the

life" behind nonviolence: "Needless to say that here I am
referring to the living thought which awaits translation
into speech and action. Thoughts without potency are airy
nothings and end in smoke." Such a comment is atypical
in its apparent denial of the reality of ideas in themselves
but characteristic in its demand that thought be practi-
cally utilized. For him "the might of religious force" in
personal, political, and economic life is "the most potent
force as yet known to mankind and on which its very
existence is dependent.[32] One of his followers rings an
infelicitous change on Ruskin's original technological
metaphor. Substituting for Ruskin's comparison of man
and engine a parallel between State and powerhouse, he
declares that Gandhi "is creating with his dynamo of
Non-violence and Truth endless, electro-motor power
which would move mountains and uproot empires."[33]
With it, Gandhi believes, "you can bring the world to your
feet"; through it India can rule the world. Such a rule
would require avoidance of the pitfalls of modern civiliza-
tion; it would be a rule of service and humility, since for
Gandhi the leader is above all selfless. As Jesus said that
he who would be great should be a servant, so Gandhi
believed that "Leaders are leaders because they are the
leading servants of their masses' esteem." He tended to
regard himself as an interpreter between governors and
simple men and considered the throngs pressing him for
darshan or blessing as one of the trials of a mahatma.
Although he admired the "Prophet's greatness, bravery,
and austere living" in Carlyle's portrait of Mahomet, he
later joked, "In America I suffer from the well-known
malady called hero-worship." As the individual's influ-
ence depends on self-sacrifice for the group, so, he thought,
the nation's influence depends on service to the world:
"the individual sacrifices himself for the community, the

community for the district, the district for the province, the province for the nation, and the nation for the world":

> Life will not be a pyramid with the apex sustained by the bottom. But it will be an oceanic circle whose centre will be the individual always ready to perish for the village, the latter ready to perish for the circle of villages, till at last the whole becomes one life composed of individuals, never aggressive in their arrogance but ever humble, sharing the majesty of the oceanic circle of which they are integral units. Therefore, the outermost circumference will not wield power to crush the inner circle but will give strength to all within and derive its own strength from it.[34]

As did John Ruskin, Gandhi subordinated nationalism to worldwide humanitarianism.

Gandhi's concept of history develops naturally from his idealistic philosophy and his reading of Carlyle. The order of the universe is preserved by a personal God representing a rule of truth and love governing all life, an "indefinable mysterious Power that pervades everything," changes all else without itself changing, and produces an "unbroken line of prophets and sages." The lives of these men and the sacred writings "constitute the history of India in its sublimer aspect."[35] Much history, however, as Carlyle points out, is only a record of wars interrupting the influence of soul-force, which dominates in times of peace and can become a weapon in conflict. Carlyle's dualistic interpretation of history as a celestial-infernal conflict between truth and falsehood is reflected in Gandhi's explanation of his own battle as "a terribly true struggle. . .with no room for sham or humbug in it"; a conflict in which *satyagraha* "can easily conquer hate by love, untruth by truth, violence by self-suffering." "I am not anti-any Government," he said, "but I am anti-untruth—anti-humbug and anti-injustice." Undoubtedly

The French Revolution was partly responsible for Gandhi's warnings to Indian nationalists against the materialism and violence of modern civilization, the imminent ruin of which he prophesied in 1908 with the apocalyptic accents of Carlyle and Tolstoy. He attributed to the violence of the French and Russian revolutions their failure to realize the democratic ideal.[36] No more than Carlyle or Ruskin does Gandhi celebrate history as a record of scientific progress, of man's gradual conquest of nature; or of the slow improvement of his lot through the interaction of materialistic motives. Faith in the gradual revelation of truth in history appears inconsistent with primitivistic tendencies; yet for all the two Victorians' nostalgia for organic medieval society—for all Ruskin's sense of inner kinship with Rousseau—for all his agreement with Plato that virtue and affection were once valued more highly than gold[37]—for all Gandhi's harking back to India's golden age of village communities—they viewed the ideal society more as a vision for the future than as a past perfection. Gandhi's definition of evolution suggests the contrasts between animal and human life in *Unto This Last*[38] and Huxley's view, which Gandhi encountered in *Evolution and Ethics,* that social progress substitutes for the survival of the fittest the survival of the *ethically* fit: "Man's triumph will consist in substituting the struggle for existence by the struggle for mutual service. The law of the brute will be replaced by the law of man."[39]

It is in Gandhi's total rejection of physical force and his insistence upon essential human equality that his concept of moral force profoundly differs from that of Ruskin and Carlyle. All three see beyond the hedonism that inevitably resulted from the materialistic view of man as merely an animal, and that, as the Stoics long ago realized, could

logically lead to suicide in a world where pain predominates over pleasure. As Ruskin saw, the pleasure-pain theory of human motivation could not account even for men's interest in amassing wealth beyond their needs; their drive was not for gold, but for power over other men for good or evil[40]—power that, he pointed out, could be attained equally well by means of soul-force. Toynbee believes that the fundamental error of the unconverted is the worship of human power, collective and physical or individual and psychic; that the quest of this illusory goal prevents the understanding of suffering, a permanent fact of human life that religion seeks to interpret. Nehru quotes Einstein to the effect that the modern predicament requires of men the renunciation of power as well as profit.[41] But Gandhi is concerned with the power neither of the state nor of the individual man, but of the ideal. Gandhi finds the third alternative to the two that Weber presents[42] for the religious man who finds himself in conflict with society: Gandhi neither imposes the commandments of God by violence, like the Puritan, nor withdraws from the pragma of violence like the escapist mystic, but combines the vocational asceticism of the Puritan with the pacifism of the mystic. Although Gandhi admits the presence of violence in every earthly act, he seeks strenuously to keep it to a minimum, instead of adopting Carlyle's tolerance of evil on the grounds of the necessity of action and the inevitable element of sin in every action. Ruskin stand midway between the two in his definition of *holy* as *helpful* or *life-giving* rather than *innocent, sinless*.[43] Gandhi's faith in the all-sufficiency of spiritual qualities carries to the extreme Carlyle's belief that right is might, just as Nietzsche reverses the emphasis to suggest that might is right. Gandhi effects a synthesis between the Christian ethic of humility and suffering and

the idealization of courage and power that led Nietzsche to
reject it. In Gandhian thought self-suffering, as a positive
act of love, requires the ultimate in courage, gives power,
and leads to triumph in conflict.

Society as an Organism

The religious assumptions of Ruskin and Gandhi de-
termine in large part their social, esthetic, and educa-
tional beliefs. Gandhi's retitling of *Unto This Last* as
Sarvodaya (The Welfare of All) emphasizes the first of the
three ideas he found there—one which he "already knew":
that "the good of the individual is contained in the good of
all." The view of society as a family or an organism is
common to Plato, Carlyle, and Ruskin, and accounts
partly for the interest of the latter two in the medieval
period. The organismic view implies the interrelationship
of all the activities of a society, a single life permeating the
whole, and the mutual interdependence of the individual
members of the society. In Plato's thought, in the *Rig
Veda* and the Indian caste tradition, such a concept sug-
gests a rigid classification into occupational and social
groups, which falsifies the analogy, since cells are dif-
ferentiated according to function, while men are not. Yet
the comparison is valid insofar as humanity is a living
whole, no part of which can suffer without affecting the
rest.

Ruskin's parallel between family and state is echoed by
Gandhi, who advocated the same conduct in politics as in
the bosom of the family. Like Ruskin, he points out that a
conflict of interest between hungry mother and hungry
child need not mean hostility between them. As Ruskin
requires the merchant to treat every worker like a son,
Gandhi recommends that even in discharging a persistent

thief, an employer should treat him like a brother. The idea must have been appealing to a Hindu familiar with similar teachings of Buddha and with the ancient joint family system, in which labor was divided among 200 or 250 members. Vinoba Bhave, Gandhi's follower, sees the self-sufficient cooperative village as a family, and indeed the whole national economy planned in the same way.

The Christian view of the Church as the mystical body of Christ can be extended to include all mankind. In a letter of 1860 Ruskin's phrasing recalls the biblical "I am the vine and ye are the branches": "It may be. . .much less selfish to look upon one's self merely as a leaf on a tree than as an independent spirit, but it is much less pleasant. . . .All my work bears in that direction."[44] His concept of society, parallelling his view of nature's ordered unity,[45] reflects the Platonic notion of harmony producing the greatest happiness of the whole rather than of individuals; and the medieval attitude toward society as a "spiritual organism, not an economic machine,. . .[with] economic activity,. . .one subordinate element within a vast and complex unity, requir[ing] to be controlled and repressed by reference to the moral ends for which it supplies the material means."[46]

There need be no conflict between such values and the concept of "the greatest good of the greatest number," which was considered by Mill a Christian ideal, and is in one sense, as Hobson points out, the goal of Ruskin's economics. The phrase displeases both him and Gandhi, however, seeming to them to represent the antithesis of all their principles. At first glance Gandhi's insistent differentiation between the greatest good of the greatest number and the greatest good of all seems to represent less a rational distinction than a hypostasis of the community. There appears to be little reason why "A votary of

Ahimsa cannot subscribe to the utilitarian formula (of the greatest good of the greatest number)" or why Vinoba Bhave, his disciple, disapprovingly contrasts "the Western mind. . .trained to think in terms of the greatest good of the greatest number. . .[with] the Indian mind, from its very childhood. . .taught to think in terms of the good of all." Their mistaken identification of the formula with the economics of competitive self-interest is clarified, however, in Gandhi's statement that the greatest good of the greatest number is "a heartless doctrine" because "in order to achieve the supposed good of 51 per cent the interest of 49 per cent may be. . . sacrificed."[47] Even a small minority should never be forgotten.

In *A Joy for Ever* Ruskin points out that wise men have a responsibility to help fools, that we are bound to our lame and must drag them as a dead weight if we cannot heal them, that the "whole nation is, in fact, bound together, as men are by ropes on a glacier." He believes that the reason for war itself is the ignorance of thieves and fools "who fail to understand that their neighbors' prosperity or poverty is their own."[48] Forgetting that this assertion of human solidarity is accompanied by a denial of human equality, Gandhi believed that it was his discovery of Ruskin's interpretation of the biblical parable of the vineyard that made him see "clearly that if mankind was to progress and to realize the ideal of equality and brotherhood, it must adopt and act on the principle of *Unto This Last;* it must take along with it even the dumb, the halt and the lame." Again in 1946 he declares:

> I stand by what is implied in the phrase, 'unto this last.' We must do even unto this last as we would have the world do by us. All must have equal opportunity. Given the opportunity, every human being has the same possibility for spiritual growth. That is what the spinning wheel symbolizes.

He reiterates, "My Socialism means 'even unto this last.' I do not want to rise on the ashes of the blind, the deaf, and the dumb." For him the suffering or the crime of any Indian is the concern of every Indian. "Not killing competition, but life-giving cooperation, is the law of the human being. Ignoring the emotion is to forget that man has feelings. Not the good of the few, not even good of the many, but it is the good of all that we are made to promote, if we are 'made in His own image.'" Gandhi's stress on the community rather than the individual is extended to the international level: "If [my mission] succeeds—as it will—history will record it as a movement designed to knit all people in the world together, not as hostile to one another but as parts of one whole"[49]

Concern for collective welfare is not incompatible with interest in the conservation of individual creative impulse, which Roe considers a basic principle with Carlyle and Ruskin. "All effectual advancement," says Ruskin, "must be by individual, not public effort." Plato argues that the good of the state is the good of the individual, that justice and injustice arise in the interrelationship of citizens, that the community helps to create the human being and the citizen. Aware that the self is a social self and that the structure of personality and the structure of society influence each other, Carlyle and Ruskin consider inner moral change rather than alteration of external arrangements the best means of improving the social order. Carlyle's emphasis on justice and truth in individual character as the foundation of social justice, an idea reminiscent of the *Republic,* is reflected in Ruskin's insistence on the necessity of individual honesty achieved through voluntary self-reformation and on the choice of just means toward economic ends.[50] Gandhi similarly defines "true home rule" as implying individual self-control,

and much later declares that nonviolence is an attribute of society. *Moksha* or true self-fulfillment is achieved by becoming one with God's creation through service of all; self-realization is identical with the realization of *sarvodaya*.[51] Gandhi does not undervalue individuality, which he considers the source of all progress; but he would agree with Eduard Heimann that "What makes the individual a person and the collective a community is the power of love which transcends the cleavage and possible conflict between them by creating the person as a loving and loved person and the community as a community of persons rather than of atoms."[52] Social interdependence, for Gandhi, is compatible with the independence of every social unit; "willing submission to social restraint for the sake of well being of the whole society enriches both the individual and the society of which one is a member."[53] *Willing* is a key word differentiating his thought from that of Carlyle and Ruskin in their more arbitrary moods.

The Platonic view of man as a participant in the common life of the state, the Hegelian idea that man's deepest need is to be an organ of purposes larger than his private self-interest easily develop into the demand for a morality of perpetual self-sacrifice. As Smart points out, Plato and Ruskin agree both in their emphasis on the welfare of all, and in ". . .a theory of Life, the central thought of which is, the realization of the individual only by the loss of his separate interests in the larger life of the State. What is more than this in Ruskin's theory belongs to the Christian ideal. . . .The true Self Realization of spiritual beings is through Self Sacrifice. 'Whoever shall lose his life shall save it.' "[54] Although Carlyle's ethic is one of strong-willed self-assertion, he and Ruskin alike give duties precedence over rights and criticize the economists for putting rights before duties. The selfish pursuit of happiness to them

appears foolish and useless, though Ruskin mentions the possibility of a higher happiness. In his chapter on "The Roots of Honour," with its emphasis on the sacrificial aspect of vocation, is implicit an idea he occasionally voices quite explicitly: the view that men should strive to do "God's will, not their own," to "live, and *Die*—totally—in obedience to a Spiritual Power, above them *infinitely*." His argument that the merchant should be as ready as the soldier, the physician, the pastor, or the lawyer to die for an ideal must have appealed to one familiar with the moral laws ruling the four Hindu castes of teachers, warriors, commercial men, and untouchables. Gandhi declares that renunciation, "the highest form of religion," "should rule all the activities of life"—the householder's and the merchant's among them. In accord with Ruskin's remark that "the man who does not know how to die, does not know how to live" and with the *Gītā*'s teaching that "it is better to die performing one's duty" he maintains that "the art of dying follows as a corollary from the art of living." Like the individual, "that nation is great which sets its head upon death as its pillow."[55]

Here is the explanation of that glorification of the soldier which at first seems so inconsistent with Gandhi's pacifism and with the condemnations of war often found in Carlyle and Ruskin. Even the early Christians admired the soldier's devotion and discipline, though not his violence. Convinced that "the brave man has somehow or other to give his life away," Carlyle seeks a moral equivalent of war in the notion of soldiers of industry, like Ruskin's "Soldiers of the Ploughshare"[56]—a phrase suggesting regimentation, which is nowhere adopted by Gandhi.

As for war itself, Ruskin recommends avoiding battle for selfish gain but never remaining passive through fear.

He advocated British intervention on behalf of the Italians, the Poles, and the Danes, although he opposed the Opium War. For all his ironic anti-militarism in *The Crown of Wild Olive,* for all his association of war with profiteering, he is little more a pacifist than Carlyle. It is surprising to find him writing in *Munera Pulveris,* "All disputes may be peaceably settled, if a sufficient number of persons have been trained to submit to the principles of justice, while the necessity for war is in direct ratio to the number of unjust persons who are incapable of determining a quarrel except by violence."[57] If Ruskin's notion that in every struggle one side is just involves an inconsistency, Gandhi was far more inconsistent in leading an ambulance corps in the Boer War and recruiting on behalf of the British during the First World War. These moves resulted from his Ruskinian insistence on commitment, his preference for involvement of some kind even when issues were not absolutely clear-cut.

At times Ruskin even regarded war as morally beneficial. The gentle, honest character of some of his military acquaintances contributed to his conviction that war ends materialistic preoccupations and serves as a "foundation of all high virtues and faculties of men," "for the soldier's trade, verily and essentially, is not slaying, but being slain." The unintentional implications of such a definition were illustrated by the disciplined, nonviolent armies of the Pathan *satyagrahi,* who gave a practical answer to Gandhi's rhetorical question, "Wherein is courage required—in blowing others to pieces from behind a cannon or with a smiling face to approach a cannon and be blown to pieces? Who is the true warrior—he who keeps death always as a bosom-friend or he who controls the death of others?" *Satyagraha* "consists in meeting death in the insistence on Truth"; true home rule is "not a result

of the murder of others but a voluntary act of continuous self-sacrifice." Preferring even violence to cowardice implicating the victim in the violence of the oppressor, Gandhi admired the bravery of Carlyle's heroes and pointed out that "Mahāvira and Buddha were soldiers, and so was Tolstoy."[58]

According to Carlyle and Ruskin, the soldierly self-sacrifice of inferior members of society should be directed by leaders whose self-sacrifice is spontaneous. They believe in the Platonic tyranny of the wisest. Gandhi misinterpreted Ruskin's attitude toward freedom when he declared that reading *Unto This Last* had made it impossible for him to approve Nazism, "whose cult is suppression of the individual and his liberty."[59] As Ruskin puts it, "The essential thing for all creatures is to be made to do right; how. . .is. . .immaterial"; "the notion of Discipline and Interference" lies "at the very root of all human progress or power." Complete confidence in the wisdom of the planners and administrators of his ideal state leads to the conclusion that the highest welfare of each individual lies in submission; that violent enforcement benefits the victim. Ruskin approves of Carlyle's teaching of "the eternity of good law, and the need of obedience to it" without making any distinction between obedience to law and obedience to the man of true moral power. Advising workers to "find [their] true superiors. . .and stick to [their] task," he considers two principles inseparably united: "Radical, everyman his chance; Tory, everyman in his rank." His insistence on the necessity of strict governmental control is inconsistent with his assertion that affection and honesty are primary human motives, since naturally virtuous men do not require severe discipline. The key lies in his inability to conceive of brotherhood without earthly fatherhood. To him affection is insepara-

ble from reverence on the one hand and paternal condes-
cension on the other—"the ruler's loyalty to his men." As
he himself long remained dependent on his dictatorial
parents and as he sought to preach at his other compan-
ions, so he envisages the social group as a family subordi-
nate to the parents, a concept the fallacy of which Aristo-
tle long ago exposed. For all the talk of Carlyle and Ruskin
about cooperation as against competition, they actually
often advocate subordination rather than cooperation. For
the cash-nexus they would substitute not simply mutual
helpfulness, but also obedience. The premise that the wel-
fare of all citizens is united leads them to conclude the
necessity of commanding those in difficulty. Ruskin tends
to regard the poor as "disobedient children, or careless
cripples" and the rich as "wise and strong."[60] Despite the
contrast in their estimates of human nature, his prescrip-
tion is curiously similar to that of Freud, who believes that
man's natural aggressiveness can be curbed not by an
enlightened concept of self-interest, but by providing
leaders to whom men are emotionally tied.[61] It is paradox-
ical indeed that those who believed man a covetous
machine advocated laissez-faire and those who conceived
of him as a loving, sacrificial soul believed in strict gov-
ernmental regulation.

Gandhi does not share this inconsistency. His pater-
nalism is of a different stamp, involving more respect for
the poor. "There is no such thing as the humble duty of the
ryots to pay respectful obedience to their masters." He
would never have agreed with Ruskin that "all anarchy is
the forerunner of poverty, and all prosperity begins in
obedience." He distinguishes between "compulsory obedi-
ence to a master [which] is a state of slavery, [and] willing
obedience to one's father [which] is the glory of sonship."[62]
Although he himself received such obedience as a virtual

dictator during passive resistance, he refused political office when home rule was achieved. For him, obedience to God and to good law is the only obedience of the virtuous man; his movement is one of civil disobedience.

Although Carlyle admits the right of revolt if "a just man" "recognize in the powers set over him no longer anything that is divine," both he and Ruskin tend to minimize the possibility of governmental oppression and exploitation. Democracy, or "revolution trying to govern," he regards as productive of social disorder and lengthy, futile arguments; equivalent in the political sphere to the anarchy of laissez-faire in the economic sphere. He objects to democracy on Plato's ground as well: that it is attended by moral and intellectual disintegration and that it does not bring the best men to the fore. His attitude toward voters, like Ruskin's, shows curious inconsistencies resulting from deep inner conflicts. For all Carlyle's belief in the worth of every individual soul, for all his refusal to make distinctions based on rank or creed, he insists on the inherent inferiority of most men and in the inability of the masses to govern. For him profound changes in the workers must take place before Parliament can cease to represent the "condensed folly" of the nation. No more does Ruskin trust the common man. Although he accepts universal suffrage with votes proportionate to position, he opposes popular government because he considers voters fools and would "prefer to keep the common people from thinking about government." He makes a weak attempt to reconcile his self-contradictions by asserting that "The feelings of the mob are on the whole generous and right, but they have no foundation for them."[63]

Logically the view that man's innermost nature seeks charity and truth rather than pleasure and power implies the possibility of anarchy with the perfected individual

ruled only by his own clear perceptions. Plato believes
that only man's unregeneracy makes the state necessary;
Tolstoy, that Christianity and the legal use of force are
incompatible. Gandhi likewise dreams of the eventual
establishment of the kingdom of God on earth, "a
sovereignty of the people based on pure moral
authority."[64] He believes with Tolstoy that the state is
often organized violence, a soulless machine, but not that
it is necessarily based on violence. His faith in individual
potentiality for change explains his combining rejection of
economic and political competition with acceptance of
Thoreau's version of laissez-faire: "That government is
best which governs the least." Like Marx, Gandhi looks
forward to a classless, stateless society; but as an attain-
able intermediary phase he advocates a basically nonviol-
ent state, permitting freedom of speech, religion, and
press, with citizens eternally prepared for nonviolent re-
sistance to any unjust law. Possibly an anticipation of this
view occurs in *Munera Pulveris,* where Ruskin distin-
guished between visible government and the invisible
government exercised by all the citizens, through the na-
tional character. Gandhi envisages no armies and only
nonviolent police, organized in small, local "Peace
Brigades" ready to sacrifice their lives. In contrast to
Carlyle and Ruskin, who urge the punishment of crime,
Gandhi would seek out its cause and attempt to remedy it
through teaching a vocation, as he considers criminals not
different from himself. Since the state is not to seek
wealth, industrial power, or armaments, it can keep its
functioning to a minimum. Gandhi is opposed to any in-
crease in the power of the state because although he
thinks it might minimize exploitation, it would destroy
individuality.

While Carlyle and Ruskin concern themselves more

with bread than with liberty, Gandhi struggles for both. Although on occasion he can point out that the hunger for food comes first, he can also declare, "we do not want bread made of wheat, but we want bread of liberty." Liberty means to him national home rule and the establishment of the four freedoms, as well as the individual's capacity to control himself. His jealous protection of minority rights accounts for his occasional criticisms of majority rule, as well as his contrast between the greatest good of the greatest number and the welfare of all on the basis that "the utilitarian will never sacrifice himself [while] the absolutist will." In practice it might be difficult to reconcile the refusal to coerce even a small minority with the demand for total selflessness from all. Gandhi occasionally makes the Carlylean identification of democracy with laissez-faire, arguing that it must mean a spirit of conflict rather than of mutual service. He defines "true democracy" as the "art and science of mobilizing the entire physical, economic, and spiritual resources of all the various sections of the people in the service of the common good of all"; Ruskin had somewhat similarly defined economy as the "art of managing labor." His *Sarvodaya* organization strove for "a society based on truth and nonviolence in which there will be no distinction of caste or creed, no opportunity for exploitation and full scope for development for individuals as well as groups." Although, unlike Carlyle and Ruskin, he strongly advocated indiscriminate universal adult franchise, he wished to reduce the number of representatives in Congress and to persuade them to serve without pay; he once even declared that Congress had "outlived its usefulness." Proclaiming the unchristian, corrupt nature of the British Parliament, he quotes Carlyle as calling it the "talking-shop of the world" and considers it preferable that "a few good men"

be entrusted with power.[65] The government he envisaged for India was a federation of decentralized democratic rural communities ruled in the ancient tradition by *panchayats,* or elected boards of five workers. Like the overseers of Ruskin's theocracy, the members of the *panchayat* were to be well acquainted with the lives of those they governed.

Thus, in his political opinions, Gandhi agreed with Plato, Carlyle, and Ruskin in comparing the state to a family or an organism with interdependent parts; with Carlyle and Ruskin in rejecting "the greatest good of the greatest number" and in advocating self-sacrificial individualism. Although he saw his egalitarianism, too, as Ruskinian, this attitude as well as his total nonviolence distinguished him from the earlier thinkers.

Truth and Humanity in Art

For Ruskin and Gandhi, morality, politics, and esthetics are interrelated; in their esthetics, too, the influence of Plato and Carlyle is evident. Both stress truth in art, although Ruskin clearly distinguishes truth from beauty, as Gandhi does not; both think of art as an expression of man's life. Ruskin's theory of truthfulness as the chief value of art combines the Platonic doctrine of ideas with an interest in factual accuracy. The influence of Carlyle upon his use of truth as a criterion of art is recognized in his own comparison of his "Reaction for Veracity in Art. . .to Carlyle's and. . .Froude's work in History." The discussion in *Heroes and Hero-Worship* of truth as inspiration for action was the spur that set him to work on the first volume of *Modern Painters,* with its attack on falsehood and quest of truth in art. Like Carlyle, Ruskin includes both fact and intuitive knowledge in his concept of

truth. He believes that the artist should express natural
law through the portrayal of fact and should be judged
according to the critic's observation of the external world
and subjective perception of the inner. The same stan-
dards are evident in his literary criticism, as in his discus-
sion of the pathetic fallacy and his praise of Byron as true,
just, and factual. Such a view implies the superiority of
direct to artistic experience; Ruskin values his memories
of the Alps even more highly than the Turner pictures
that evoke them. Because landscape art can convey such
experiences he believes it might be an agent of "gigantic
moral power"[66]—a concept strange to the Western mind
but not unlike the Far Eastern view of landscape painting
as a religious act.

As his purpose in the first volume of *Modern Painters*
was to study truth in art, so Ruskin sought in the second
volume "to explain. . .the nature of that quality of beauty
which I now saw to exist through all the happy conditions
of living organism"—Vital Beauty—emerging from the
"joyful and right exertion of perfect life."[67] Art is a revela-
tion of universal life in nature, animal, and man. Because
it is the expression of the inner feelings of its creator, it is
related to the painter's nobility of character and the
craftsman's happiness. Ruskin is with Carlyle in thinking
that truth gives moral power—with Plato and Tolstoy in
recognizing the relationship of art to character—and with
them all in esteeming the good and the true above the
beautiful when forced to make choices. One of the central
conflicts in his life as in his thought was the eternal
dilemma of the esthetically sensitive moralist who seeks
to reconcile the two sides of his idealism. For years he
pondered the definition of the artist's character and the
relative evaluation of religious and secular art. Although
he proclaimed the ultimate harmony between esthetic

and social purposes, he recognized the intellectual prob-
lems posed by such a position, often demanded of himself
total dedication to social justice and peace, and envisaged
this as the first goal in the education of youth.

Like Ruskin, Gandhi saw God indirectly through or-
ganic life, loved the beauty of nature itself above that of
art, and conceived of art as emerging from the moral
condition of its creator. Gandhi, however, being endowed
with less esthetic sensibility and intellectual complexity,
oversimplified the connection between art and morality,
as in his dialogue with Ramachandran:

> Ramachandran: Can you see Truth through outward
> Beauty? Gandhi: I would reverse the order. I see and find
> Beauty in Truth. All truths—not merely true ideas, but
> truthful faces, truthful pictures, or songs—are highly
> beautiful. . . .

To the *true* artist, Gandhi continued, the only beautiful
face is one revealing the truth of the spirit. Socrates to his
mind was beautiful because "all his life was a striving
after Truth." Gandhi contrasts "true art. . .the expression
of the soul" with that of Oscar Wilde, who "saw the highest
art simply in outward forms and therefore succeeded in
beautifying immorality." As there is no evidence that
Gandhi read his friend Polak's copy of *Frondes Agrestes,*
he probably knew nothing of *Modern Painters*. But in *A
Joy for Ever* he had read "Noble art is nothing less than
the expression of a great soul"; "the picture which most
truly deserves the name of an art-treasure is that which
has been painted by a good man," and can consequently
"exalt and refine" human character—the "chief and final
value [of art], to any nation."[68]

As Ruskin there asserted men's duty to the dead to
preserve the national heritage of architectural monu-
ments, so Gandhi, Nehru, and others were interested in
the rediscovery and care of ancient Indian architecture.

Ruskin's love of handicrafts accorded well with the traditional Indian view of craft as a sacrament demanding of the worker holiness and self-control. As in these lectures for the opening of the Manchester exhibition Ruskin had pointed out the possible local educational influence of *true* goldsmith's work drawn from the heart and soul of its creators, so Gandhi in opening a crafts exhibition at Lucknow declared that it was intended to contain only objects of educational value: "We have tried to make the Exhibition a sacred and holy place, a feast for your eyes and ears, a spiritual feast capable of purifying the senses. . .the soul of man even in an impoverished body can breathe life into lifeless horns and metal."[69]

Although Gandhi thus admits the possibility of the artistic spirit's triumph over the suffering body, he accepts in his advice to consumers Plato's belief that excesses of wealth and poverty cause deterioration of the arts and Ruskin's theory of the influence of the artist's economic well-being upon his creativity. Identifying self-realization with self-sacrifice, he believes that true art appreciation must be compatible with contribution to the welfare of others. Thus his "Appeal to the Women of India" to give up their lovely saris for the native-spun white *khadi* recalls Ruskin's concepts of wealth and "illth," of consumer responsibility, and of value as that which avails toward life:

> . . .what we today regard as artistic is only falsely so, and. . .true art takes note not merely of form but also of what lies behind. There is an art that kills and an art that gives life. The fine fabric that we have imported. . .has literally killed millions of our brothers and sisters and delivered thousands of our dear sisters to a life of shame. True art must be evidence of happiness, contentment, and purity of its authors. And if you will have such art revived in our midst, the

use of khadi is obligatory on the best of you at the present moment.

The same compassionate note is struck in his remark that while the poet sings of soaring birds, the human birds of India cannot even flutter and long for one poem, food.[70]

The view of art as a means of expressing the soul implies its inferiority to the moral act. As Plato thinks the creation of a state the best dramatic work, as the later Carlyle considers history the only poetry, so Gandhi accepts this corollary without hesitation, declaring that "A life of sacrifice is the pinnacle of art"; "Purity of life is the highest and truest art": "I find that I can do entirely without external forms in my soul's realization. I can claim, therefore, that there is truly sufficient art in my life, though you might not see what you call works of art about me."[71] Ruskin, who could never restrain his craving to possess objects of beauty, did not master as Gandhi did the art of living.

Utter simplicity of oratorical manner and literary style as well as of dress was the natural consequence of Gandhian esthetics In the *Symposium* and the *Phaedrus* Socrates had expressed his indifference to rhetorical art not grounded in an understanding of truth; Gandhi agreed. Quiet, motionless, and simple in addressing groups, Gandhi declared that a *satyāgrahi* "must avoid any trace of untruth and exaggeration and must not seek to arouse in the audience violent feelings of anger or hatred." Although Ruskin was ever ready to waken indignation, and never wrote with the utter plainness of Gandhi, *Unto This Last* and some of his other economic works are considerably purer and more lucid in style than the relatively florid art criticism. Even as late as 1868, however, he felt his pride in his own style was punished by his "finding

that many people thought of the words only, and cared nothing for their meaning. Happily, therefore, the power of using such pleasant language. . .is passing away from me; and whatever I am now able to say at all, I find myself forced to say with great plainness. For my thoughts have changed also, as my words have."[72]

Ruskin was of course far more fundamentally concerned and far more sophisticated about artistic values than was Gandhi. Yet both believed that the central worth of art lay in its truthfulness and in its expression of the character and the well-being of its creator. Gandhi's reiteration of the latter principle must have owed something to his acquaintance with Ruskin.

The Education of Character

The educational theories of Ruskin and Gandhi are more alike than their esthetic views, although Gandhi does not believe with Ruskin that different kinds of education should be provided for students of differing levels of ability. Both consider the primary purpose of education to be character formation, rather than learning from books. Ruskin declares that the object of education is to contribute to the development of a new kind of humanity —courageous, loving, and internationally minded. Sensing a certain affinity with Rousseau, Ruskin adopts his views on the importance of firsthand experience in learning and the value of combining physical and manual with intellectual training. Ruskin's students, however, are not to have moral training postponed until the age of fifteen, as did the isolated Emile.

Although Ruskin criticizes Plato's ideas of education on several counts, he follows them in fundamental ways. He agrees that knowledge is harmful unless used for virtuous

ends. Like Socrates he seeks not to tell the student what he knew not, but to make him what he was not—the perfect individual and the perfect citizen. The specific qualities to be developed by the free compulsory education he advocated are defined in the books Gandhi knew as "admiration, hope, and love," "perfect exercise and kingly continence of bodies and souls"; later he also mentions honor, truth, humility, compassion, health, cleanliness, reverence, and obedience! Instead of cultivating pride in intellectual possessions, he would train students in vocations to make them "practically serviceable to other creatures." He abjures competition and clearly implies some sacrifice of individuality to social goals.[73]

Similarly, Gandhi's schools are to be dedicated to education for *ahimsā*, "not as a personal advantage over. . .[one's] fellowmen, . . .[but as] a personal opportunity for serving them"—an opportunity to develop self-sufficiency, cleanliness, "courage, strength, virtue, the ability to forget oneself in working toward great aims." Adult education is to help men and women recognize the village as their home, see India as a whole, and understand its relation to the world. Gandhi quotes Huxley's definition of a liberal education only to point out how rarely academic studies actually do contribute to the mind's control over the body. His follower Vinoba Bhave also looks for the "graduate in self-regulation" who can differentiate between body and soul and control his senses in order to serve the world. Like Ruskin, they advocate not religious indoctrination but moral teaching along the lines common to all religious ethics—and in Gandhi's case the study of all religious faiths as well. Like Ruskin, they stress the development of the whole child, body and mind, and in particular the mutual interdependence of hand and head. "By education," said Gandhi, "I mean an all-around

drawing out of the best in child and man—body, mind and spirit" an indivisible whole; "education of the heart" and education of the intellect through education of the "bodily organs, e. g. hands, feet, eyes, ears, nose, etc."—his physical education to include even drilling to music, as in Plato and Carlyle. Plato had recommended weaving and other crafts for students in the *Republic;* Xenophon, Ruskin's economic mentor, and Froebel were among the many who recognized the relationship of manual skill in craftsmanship to intellectual development and emotional therapy. Human happiness in work as in consumption was a central objective of Gandhian and Ruskinian education. Ruskin, like Plato and Aristotle, hoped that students would become "capable of honesty and capable of delight," would learn "not only to *do* the right things but to *enjoy* the right things." For Gandhi, too, "Joy. . .is a matter of individual and national education. We shall relish things which we have been taught to relish as children."[74]

Both men seek to avoid creating discontent with lower callings in those not capable of professional work or unable to obtain it—a very real problem in India today. Both denounce over-emphasis on the three R's, although Gandhi changed his mind about 1943. Both point out that textbooks sometimes deal with matters remote from children's everyday life and consequently lacking in reality for them. "An academic grasp without practice behind it is like an embalmed corpse, perhaps lovely to look at, but nothing to inspire or ennoble." Gandhi advocates progressive methods, with the craft as the central project, to be taught "not merely mechanically. . .but scientifically." Gandhian education "combines art with utility and weaves the former into every implement and vessel that the latter requires."[75] The child is to understand the reasons for every process, express artistic ability in

craftsmanship, and relate many fields of knowledge to his craft—for example, progress from an interest in cotton to the study of arithmetic and geography. Gandhi shares the dislike of specialization and the conviction of the interrelationship of all fields of human thought which revealed themselves in lectures where Ruskin mixed art with literature, science, and morals. Along with the craft, the school itself and its surroundings are to aid in the study of science and other subjects, as in Ruskin's scheme.

Manual work, according to Ruskin, also is to give a sense of the dignity of labor and to provide both preparation for the minimal "bread labor" required of every citizen in the ideal state, and a means of physical experience of the material environment. Valuing all of these aspects, Gandhi points out in addition the social advantage of crafts in all primary education as a means of uniting city and country, rich and poor. For him the preparation for a trade is the dominant motif of a child's education. As Ruskin suggests that commodities for the poor be provided by the work of state-supported school pupils, Gandhi advocates the sale of cloth spun by children to pay for their education. They are to learn a useful craft at the very beginning and eventually to study hand-weaving, agriculture, the laws of sanitation, the use of tools, and the building of walls. Practical experience is perhaps overvalued in comparison to academic study by both men, although such an emphasis is more appropriate to India than to Britain.

The notable similarities between the ideas of Ruskin and Gandhi in so many different fields spring from the conviction of both that religion, broadly defined, should be the foundation of every aspect of man's life, and that the essence of religion is truthfulness and love practically expressed. Gandhi's thought fused Eastern with Western

idealism; his concept of truth-force, influenced by Hinduism, Christianity, Tolstoy, and Thoreau, had also significant antecedents in the thought of Carlyle and Ruskin. Sharing their idealistic, nostalgic vision of a society of truthful and dedicated rather than dishonest and self-seeking individuals, he agreed with Ruskin's Socratic identification of ends with means, but differed from him in considering violence always an unjust means. Like Socrates Gandhi sought truth through dialogue, thinking less in Hegelian terms of thesis and antithesis than in Socratic—and Ruskinian—terms of absolute truth and human opinion. The notion of an immanent spirit manifesting itself in history through family-nations and intuitive heroes originated in nineteenth-century German philosophy. Fichte's insistence on the autonomy of the individual's moral will, with the world merely the material of man's duty, contrasted with Hegel's belief that while the individual's efforts to achieve justice are usually thwarted, reason realizes itself inevitably, independently of man's will, through the historical dialectic, with one nation at a time acting as bearer of the *Weltgeist*.[76] Gandhi, who was never one to use philosophical terms with precision, and who knew Fichte and Hegel only through their influence on the equally casual Carlyle and Ruskin, made no distinction between subjective and objective idealism; but his thought, like Carlyle's, is more Fichtean than Hegelian. Founded on belief in freedom of the will, it shows little of the determinism that renders paradoxical any demand that men assist the purposes of providence. Gandhi saw the individual moral act as at once the means of expressing and knowing the self, and the source of all progress. Yet, himself a Carlylean hero who rejected hero worship and never found his own *guru,* he ignored Carlyle's and Ruskin's insistence on the differences of

human abilities and preferred their perception of the heroic potentialities of every man to Carlyle's preoccupation with the unique personalities of particular men. In Gandhi's view, individual action could make truth prevail in local and national history, national action in world history; but he associated its victory with self-purification and self-sacrifice rather than with physical force. In Carlyle's view, the "truth" of the state was "the truth which lies in power"; Gandhi spoke rather of the power that lies in truth.

3
THE WELFARE OF ALL

In recent centuries man has been confronted with the necessity of interpreting in the light of his ancient metaphysical and ethical beliefs the innovations of science and the consequent alterations in the structure of society. The inductive method of investigating natural law has posed its challenges to deduction and intuition; and the goals of the technologist and the modern economist—leisure, material comfort, and the accumulation of things—differ widely from those of the traditional seer. Hedonism and materialistic determinism, as ancient as idealism, have no necessary affinity with modern science, as Einstein's faith amply demonstrates; but they are frequently associated with it. Nominally scientific approaches to the understanding of human activities usually imply some theory of being. Materialistic, mechanical, and quantitative assumptions lead in the study of man's mind to associational pleasure-pain psychology; in the study of society, to the notion of a welter of conflicting selfish interests; in the study of ways of producing and using things, to standards of value related to the interchangeability of material "realities" rather than to their utility in terms of human life. The classical economists and Marx have much in common: both assume that mater-

ial objects are more real than the human spirit, that the course of human events is determined by the interaction of calculable forces of human greed, and that this interaction necessarily takes the form of conflict, whether between competing individuals or between classes with mutually antagonistic material interests. Such a view of human life leads either to the magnificent illogic of the comfortable belief that through an unscientifically conceived "invisible hand" the ultimate in conflict produces the ultimate in well-being; or to the attitude that ruthless violence to body and soul is a legitimate means of obtaining theoretical equality in that material well-being which is regarded as the primary component of human felicity. (Actually, of course, as Djilas has proved,[1] no such equality ensues; Marxism leads inevitably to the establishment of a new class of exploiters.) It is not really science, but rather the materialistic determinism that lies behind both laissez-faire economic theory and Marxism, which Carlyle, Ruskin, and Gandhi attack.

Science, Progress, and Human Values

Science as the experimental study of purely material phenomena interests Ruskin, an amateur crystallographer, geologist, and botanist—but not Gandhi. Neither often conceives of it as the quest of one kind of truth that can unite men. In the fifties Ruskin even resents the contrast between men's universal uncritical acceptance of scientific authority and their unwillingness to accept in an equally unquestioning spirit his pronouncements on the laws of painting. His irrational attacks on scientists and notions that they were persecuting him are inextricably mixed with defensible arguments, such as the complaint that biology represents woman as "charcoal and

water" rather than "goddess." Gandhi prefers to this reductive process the pan-psychism of J. C. Bose, who attempts to prove that the laws of living matter govern all matter. Gandhi's indifference to genuine scientific knowledge is suggested in his remark that modern civilization investigates the laws of matter in order to destroy, while Indians explore spiritual laws; thus, he says, "modern civilization represents forces of evil and darkness, whereas the ancient, i.e. Indian civilization, represents in its essence the divine force."[2]

Science as a means of achieving control over nature and increasing man's pleasure and power holds limited appeal for those who question the value of such objectives and sometimes ignore the contribution of science to the essentials of human welfare. Their feelings are related to a reverence for nature that creates reservations about human attempts to conquer her. They think of the four elements in their natural state as pure and health-giving; Gandhi used them in conjunction with the name of God in his nature healing. As Zoroastrians believe it a sin to pollute the four elements, so Carlyle, Ruskin, and Gandhi complain of industrial pollution of air and rivers. Although Ruskin's attitude was partly esthetic and partly related to his mental illness, it foreshadowed modern efforts toward water and air purification. Not only the fatalities from smog, but more importantly the hazards of radioactive fallout are contemporary illustrations of the significance of a problem that science has created and that optimists hope science wisely used can solve.

The sentimental return to nature also plays some part in the attitudes of Carlyle, Ruskin, and Gandhi toward the machine. They innately prefer more "natural" methods of production and the appearance of the handmade product. Ruskin ranges the sources of power in order of preference

as human and animal muscle; "natural" mechanical power next, including wind, water, and electricity; and finally "artificial" mechanical power. The effect on the life of the producer, however, is the fundamental question for him as for Gandhi: he values the creativity, the freedom, and the rural environment of the artisan more highly than the efficient organization of work achieved by automatizing man. His objections to the use of machinery relate primarily to its social and economic results; he never rejects it in principle, and indeed specifically approves it in major projects such as irrigation. Carlyle, Ruskin, and Gandhi all admit that machines facilitate the production of material necessities; but Ruskin associates avarice with the desire for progress, as Gandhi condemns the use of scientific truths as "instruments of greed." For Gandhi, buttons to press and guns to shoot represent not true civilization, but "irreligion" making "bodily welfare the object of life." "Real" civilization, he thinks, consists in dutiful conduct, "not in the multiplication, but in the deliberate and voluntary reduction of wants."[3]

Ruskin's attitude toward medical science as a whole is not hostile; but Gandhi's is particularly difficult for Westerners to reconcile with his humanitarianism. For all his love of nursing and his work with a hospital corps during the Boer War, he abjures modern medicine in favor of Bose's nature cure. One aspect of his hostility to medicine—his anti-vivisectionism—like his vegetarianism, is easily understood in the light of the Eastern religious tradition of reverence for all life. Ruskin's resignation from Oxford was partly caused by his anti-vivisectionism, supported by few Western precedents other than the tenderness to animals of St. Francis of Assisi, with whom he identified himself.

As believers in the solidarity of mankind, Ruskin and

Gandhi might well praise modern methods of transporta-
tion and communication; instead, disliking haste and
undue busy-ness with superficialities, they are concerned
as to the purposes of men's messages and voyages. When a
cable to India was opened, Ruskin asked, "What do you
have to say to India?" Both men criticized but used rail-
roads. Gandhi denies them any power of uniting men and
feels that they propagate evil more rapidly than good:

> It is not possible to conceive God's inhabiting a land which is
> made hideous by the smoke and the din of mill chimneys and
> factories and whose roadways are traversed by rushing en-
> gines, dragging numerous cars crowded with men who know
> not for the most part what they are after, who are often
> absent-minded, and whose tempers do not improve by being
> uncomfortably packed like sardines in boxes and finding
> themselves in the midst of utter strangers, who would oust
> them if they could and whom they would, in their turn, oust
> similarly.

We recall a similar passage in Ruskin:

> There was a rocky valley between Buxton and
> Bakewell. . .you might have seen the gods there morning and
> evening. . . .You enterprised a railroad. . .you blasted its
> rocks away. . . .And now, every fool in Buxton can be at
> Bakewell in half-an-hour, and every fool in Bakewell at
> Buxton.[4]

"Science" as an attempt to apply laws of causality and
probability to human affairs—an attempt that churches
had opposed in its beginning—Ruskin and Gandhi tend to
consider misleading, inhuman, and unscientific; yet their
attitude is curiously inconsistent. On the one hand Ruskin
echoes Carlyle's denunciations of the "dismal science" of
classical economics and declares that science cannot set
men at one. On the other hand the emphasis of Ruskin and

Gandhi upon the unity of human knowledge and the pragmatic efficacy of the ideal leads them to regard their own economic theories as "scientific" as well as "religious." In view of their high valuation of fact and act they are inconsistent in refusing to recognize the utility of attempted objective observation of the world they hope to change; but they are keenly perceptive in seeing the hidden biases that distort accounts of human and social facts, and they rightly sense that he who investigates only the "is" or the efficiency of means may confuse the "is" with the "should-be" or forget the ends entirely. Pointing out that in fact man is more than an animal seeking only selfish pleasure, more than an ego in quest of power, Ruskin proceeds to mingle with his own "is" a "should-be." Claiming his theory to be the true science of political economics and accepting membership in a National Association for the Promotion of Social Sciences, he nonetheless specifically disavows the scientific method: "In a science dealing with so subtle elements as those of human nature, it is only possible to answer for the final truth of principles, not for the direct success of plans: and. . .in the best of these last, what can be immediately accomplished is always questionable, and what can be finally accomplished, inconceivable."[5] With similar inconsistency, Gandhi declares that political economics is no science at all, yet refers to *satyagraha* as a scientific experiment.

His conception of philosophical truth is somewhat more scientific than Ruskin's. Relying on subjective intuition and individual capacity to perceive facts, Ruskin lacked not only the scientist's determination to test hypotheses through practical experiment (for Ruskin's few experiments failed), but also his desire for consensual validation of his conclusions, his readiness to respect and explore

attitudes alien to his own. Gandhi, on the other hand, was ready to admit the possibility of error in himself; and he put into practice the conviction of Carlyle and Ruskin that genuine religion is understood and expressed through life experience—that is, through relating it to the sense-world of shadows. *Satyagraha* emerged as a practical technique before it was named or explained. Gandhi's search for truth was allied to the careful investigation of fact in every situation he encountered. It is only through accurate knowledge of the world of appearances that one can contribute to the realization of the ideal. When Gandhi had arrived at an opinion as to how the laws of truth and love applied to a particular problem, he retained an open mind but meanwhile acted to make his view prevail. While Carlyle and Ruskin eulogized the deed from the comfort of their study armchairs, Gandhi leapt with startling promptness to put into action every insight he gained. In one sense, his life is accurately described by the title of his autobiography, *The Story of My Experiments with Truth*. "We experiment ignorantly and wonderingly with Ahimsa," he once said, "as we do not yet know all the wondrous properties of water." Whether or not he wished, he "must involve in. . .[his] experiment the whole of. . .[his] kind": he could not detach himself from the most wicked or the most virtuous, because humanity has one soul, like refracted sunlight.[6] Humbly aware of the incompleteness of his apprehension of truth, he seemed often to regard existential commitment as a means of testing hypotheses. He admitted a "Himalayan miscalculation" (a surprisingly quantitative term) in his estimate of India's readiness for *satyagraha*—essentially an error in his usually astute judgment of political facts; but his fundamental beliefs were a matter of faith independent of the success or failure of his efforts to put them into prac-

tice. Since *satyāgraha* is thus rooted in intuitive value
judgments, we cannot accept the verdict of such scholars
as Dhawan, who inaccurately terms it "a science in the
making" and declares that "the victories of physical sci-
ence would be nothing against the victory of the Science of
Life, which is summed up in love which is the law of our
being."[7] Anjaria, who calls Gandhi's economics "a mix-
ture, perhaps a queer mixture, of science and
philosophy,"[8] is as mistaken as the sociologists who agree
with Ruskin that *Unto This Last* is a "scientific" work.
Although it is true that "sentiments are essential to any
orderly interpretation of economic phenomena,"[9] human
sentiments cannot be studied with pure objectivity; the
term "science" is not accurately applied to any social
studies, least of all to those which begin where the study of
man should begin, with value judgments.

The Religious Approach to Economics

The religious approach to economics in *Unto This Last*
was completely congenial to Gandhi. Deeply impressed by
Ruskin's contrasts between "mercantile" and "true"
economy, he adopted even his phrases and analogies, op-
posing "the economics of getting rich" to his own *khadi*
economics:

> An economics that inculcates Mammon worship, and enables
> the strong to amass wealth at the expense of the weak, is a
> false and dismal science. It spells death. True economics, on
> the other hand, stands for social justice, it promotes the good
> of all equally, including the weakest.

Ruskin's belief that classical economics "founds an os-
sifiant theory of progress on. . .negation of a soul" becomes
in Gandhi a far more sweeping condemnation of "modern
civilization" as "a negation of the divine in man." Ruskin's

comparison of political economics ignoring the soul to a
science of gymnastics ignoring all but the skeleton
perhaps influences Gandhi's statement that "politics di-
vorced from religion" is "a corpse only fit to be buried."
Ruskin's attempt to relate religion to economics was in
harmony with the ideas of Gandhi's beloved "political
Guru," Gokhale, who taught him to seek to spiritualize
the political life of India. Gandhi often affirmed the indi-
visibility of politics and religion. In struggling to abolish
indentured labor in South Africa and in halting Indian
civil disobedience after the Chauri Chaura mob violence,
he distinguished between political soundness and moral
soundess, in both cases choosing the latter. More often,
however, he asserted the identity of practical and religi-
ous wisdom:

> That economics is untrue which ignores or disregards moral
> values.

> Politics bereft of religion are a death-trap because they kill
> the soul.

> Let us seek first the kingdom of God and His righteousness,
> and the irrevocable promise is that everything will be added
> unto us. These are real economics.

> Satyāgraha contains the observance of the manifest laws of
> economics, that is love force against distrust.[10]

As Sitaramayya summarizes it, with perhaps too rosy a
view of the Indian Congress Party:

> Congress has, in fact, founded a new religion—the religion of
> Politics. . . .For religion stands not for any particular dogma
> or method of worship but for a higher life, a spirit of sacrifice,
> and a scheme of self-dedication. And when we speak of the
> Religion of Politics we merely make the sordid politics of the

day sacred, the compartmental politics of the day comprehensive, the competitive politics of the day cooperative.[11]

Even Ruskin's constant use of biblical allusion and quotation in economic discussion is parallelled by Gandhi and his followers, like Sitaramayya, who continually quotes the Bible, Aquinas, Ambrose, and others. In A Joy for Ever Ruskin advocates the literal economic application of parables without perceiving the varied possibilities of interpretation or such contradictions as that between reward according to service in the parable of the talents and equal reward for all in the parable of the vineyard from which is derived the title of Unto This Last. Indeed, he feels free enough to disagree with the dictum that "to him that hath, shall more be given." Not the particular passages they cite, but the central meaning of the Bible justifies his and Gandhi's belief that "the scriptures of the world are far safer and sounder treatises on laws of economics than many of the modern text-books."[12]

The pitfalls of the religious as against the scientific approach to social studies are in some measure obviated by a universalistic ethical definition of religion and by Gandhi's refusal to impose any ideas by force. Ruskin never envisaged the enforcement of credal conformity by a sectarian group; but even ethical values may be dogmatic; and a Utopia so conceived might compel austere conduct through severe discipline. Plato points out that the deliverance of cities and of mankind depends on the union of philosophy with political power; Gandhi remarks that even power so controlled should be kept to a minimum.

Simplicity and Work

The goals of human development envisaged in the

economic theories of Ruskin and Gandhi were not unlimited luxury and leisure, for simplicity and hard work appeared to them in a measure desirable. In the *Sarvodaya* volume, one of Gandhi's followers, Mashruwala, condemns the wish for comfort and freedom from physical work, which he regards as the root of both capitalism and communism. The idealization of poverty may rest on a basis of ascetic mortification of the body or on one of selfless, purposeful identification with human misery, the criterion of differentiation being the aim for society as a whole. It is primarily for the latter reason that Ruskin advocates the simple life. Sometimes he appears to believe that luxury corrupts; he declares that "The ideal of human life is a union of Spartan simplicity of manners with Athenian sensibility and imagination"; that "Emperors, Kings, Doges, and republics have risen and reigned by simplicity of life; fallen and perished by luxury of life." "The entirely merciful, just, and godly person" is listed among the poor in *Unto This Last,* because material wealth can destroy manly character.[13] Believing that the work itself rather than its payment should be the chief object, he condemns Mammon worship with Carlyle, and knows that Zeus gives a crown of wild olive rather than of gold.

Ruskin often expresses hesitation, however, between advocacy of the simple life for its own sake and recommendation of the traditional Christian concept of the stewardship of wealth, which he interprets severely. "It is not at all clear to me how far the mighty work of the Beggar and Pauper Saint Bernard . . . was owing to his vow of poverty, or diminished by it," he muses. Wealth, he agrees with Hobbes and Smith, means power over men —power for good or evil. "Riches are a form of strength; and a strong man does not injure others by keeping his

strength; but by using it injuriously." Wesley commands, "Gain all you can. Save all you can. Give all you can." Ruskin, who attacks Mill's doctrine of parsimony or the usefulness of saving, eliminates the second injunction, but believes we should work hard, "live on as little as we can," and do "all the sure good we can." His feeling that what one uses is taken from another contradicts the modern view that consumption helps the economy whenever there is unemployment. New wants, he argues in *A Joy for Ever,* do not contribute to progress if they set men to work making useless things rather than necessities. "Luxuries. . .must be paid for by labour withdrawn from useful things; and no nation has a right to indulge in them until all its poor are comfortably housed and fed." He points out that a consumer employs as many people by ordering plain clothes for the poor as by ordering rich dresses and jewels for his wife. Unlike Gandhi, however, he hopes for a future of luxury for all.[14]

Gandhi often refers to Ruskin in his advocacy of poverty, for example in his depiction of the ideal Indian governor who should be a citizen of the world, a teetotaller, and a hand-spinner, owning an accessible cottage and also a

> somewhat pretentious building for receiving princes and ambassadors of the world. For these, being guests of the Governor should constitute an education in what "Even Unto This Last"—equality of all—should mean in concrete terms. For him, no expensive furniture, foreign or indigenous. Plain living and high thinking must be his motto, not to adorn his entrance but to be exemplified in daily life.[15]

Recommending Emerson's formula to the whole nation, Gandhi agrees with Plato and many Hindu and Christian teachers that the reduction of material wants is conducive

to human happiness. Although he admits that "pauperism. . .[must] lead to. . .moral degradation," and distinguishes sharply between voluntary and involuntary poverty, he calls wealth evil, considers economic progress the antithesis of moral progress, and believes that riches and virtue are usually although not always incompatible. "The art of amassing riches becomes a degrading and despicable art if it is not accompanied by the nobler art of how to spend wealth usefully,"[16] he says, echoing Ruskin's remarks on the difficult art of wise consumption. As for himself, simplicity was a means of controlling the flesh in order to use it as an instrument of service, and a way of identifying himself with the impoverished masses of India. Ever mindful of the poverty of such avatars as Jesus and Buddha, he frequently quoted, "Give all ye have to the poor" and "It is easier for a camel to pass through the eye of a needle than for a rich man to enter the kingdom of heaven." He felt that he had no right to luxuries until all the hungry millions could eat.

Anyone who uses more than the bare necessities of life while others are in want is a thief, according to Ruskin and Gandhi, as well as Tolstoy and some ancient Hindu teachers. Their broad definition of stealing includes any dishonesty such as plagiarism; for Ruskin, sometimes, the taking of interest; for Gandhi, insurance and saving. According to Ruskin, it is only through power given by God that men earn their money; according to Gandhi, landlords should read the "signs of the times," revise their notions of "God-given right to all they possess," and help the poor.[17] Neither, however, would dispossess property owners by force. Their definition of stealing also includes eating without working. Both would put beggars to work if possible, but in any case would feed every hungry man, giving him barely enough to satisfy his natural needs.

Deprivation of work is as injurious as deprivation of food. Carlyle insists on the importance of constant employment; Ruskin considers inactivity rather than hunger the worst of the woes of the unemployed. Seeing "depression of idleness and penury" as sinful, Gandhi notes that eighty percent of the Indian people are "thieves" by necessity during the winter. Attributing their misfortune to the superseding of handweaving by British mill goods, he establishes handspinning as a sacrament to avoid the sin of eating without working: "To a people famishing and idle, the only acceptable form in which God can dare appear is work and promise of food as wages."[18]

"Bread labour" was a favorite notion of Gandhi's, which he felt was exemplified by the Village Industries Association. Although, with typical inaccuracy, he attributes to the influence of *Unto This Last* his acceptance of "the divine law, that man must earn his bread by labouring with his own hands," the concept is not elaborated in the condemnation of idleness there. In *The Crown of Wild Olive* Ruskin quotes Genesis 3:19, "In the sweat of thy face thou shalt eat bread"—but only to prove hard labor a curse and a calamity. It is in *Fors Clavigera* that he enunciates enthusiastically the law of bread labour—a fact which suggests that Gandhi may have been acquainted with that work. The law, as Bondarev, Tolstoy, Gandhi, and his followers interpret the biblical passage, means that the needs of the body are to be supplied by the body, not by mental labor. Every man must daily perform enough manual labor to provide for his own food. Gandhi would also make each man his own spinner and weaver and scavenger, relying as little as possible on the labor of others. In his view even the labor-saving machinery of Western middle-class families is undesirable because it prevents them from being completely self-reliant. Thus he

denies in his attitude toward accepting other men's service the solidarity of mankind that he affirms in his wish to relieve their suffering.[19]

While Ruskin's economic theory emphasizes satisfying, wise, well-distributed consumption as the goal of production, he does not regard labor as merely an undesirable means to this end. Although he grieves over workers' lack of leisure to enjoy art, and makes the proper distribution of effort and suffering one of his human criteria of labor cost, he considers complete leisure as harmful as overwork. Ruskin's and Carlyle's gospel of work agrees with the teachings of the *Gita*. Ruskin's concept of the joyful union of hand and soul, mind and labor, is akin to Gandhi's complaint of the "divorce between intelligence and labor" and his insistence on the balance between muscular and mental work as a means to health. Ruskin recommended plowing, sailing, and forestry as suitable occupations for Oxford students' vacations; he suggested the substitution of physical labor for the destructive field sports of the aristocracy. Carlyle and Ruskin advise "cleanliness and order enforced with our own hands and eyes," as Gandhi with the Vaishnava emphasis on cleanliness fought the prejudice against removing filth, a task traditionally reserved for the untouchable scavengers.[20]

Ruskin, however, considers that "*simply* or *totally* manual work" degrades man "to the condition of a serf, or unthinking worker, the proper state of an animal, but more or less unworthy of men." Such work is to be assigned to an inferior class, as in Plato's republic and the Indian caste system; or alternatively to criminals and idlers. Elsewhere he contradicts himself and approaches Gandhi's point of view by affirming the nobility of any necessary work and again by arguing "with cunning irony yet with an undercurrent of serious intention. . . that ser-

vile work if undertaken in a serious spirit might be the holiest of all and that therefore evangelicals and ritualists might perform such work as evidence of the sincerity of their Christianity." Consistently viewing all work as holy, Gandhi makes no distinction in his emphasis on the dignity of labor. His followers similarly condemn the desire for comfort and power rather than work, the view of "work as an infliction instead of as a privilege," and the wish to fill the mouth rather than the hands.[21]

The Mammon of Industrialism

According to Gandhi, it was *Unto This Last* that first made clear to him an idea that "had never occurred to him": the idea "that a life of labour, i.e. the life of the tiller of the soil and the handicraftsman, is the life worth living." Ruskin, however, had not said exactly this: he had merely drawn an eloquent contrast between factory and farm, remarking that "No scene is continually and untiringly loved, but one rich by joyful human labour."[22] Ruskin felt a nostalgia for the parochial system of preindustrial England, dependent on agriculture and domestic manufacture of cloth with surpluses for nearby towns, helpers from neighboring localities, and high standards of goods. He criticizes industrialization, as did Carlyle, on grounds of its mechanization of human life, its association with a competitive economic system, and its creation of technological unemployment. In *The Crown of Wild Olive,* in particular, he notes that agricultural machinery puts men out of work and he expresses preference for the use of human and animal labor in farming. His attacks on industrialization differ from Gandhi's, however, in that they do not mention the menace of centralized power or lay great stress upon the personal and national self-reliance that

was so important to Gandhi.

The fulminations of a Western author against the Western technological civilization deeply impressed Gandhi as a member of an Eastern nation subject to Britain's colonial government. To those struggling to gain Indian freedom from Britain and establish Indian industrial power like Britain's, Gandhi felt that Ruskin brought a message already barely suggested by his study of Carlyle's *French Revolution:* the knowledge that the citizens of free and powerful Western nations were still the victims and the perpetrators of exploitation, injurious competition, and violence. British citizens suffered nearly the same economic ills as Indian subjects. In Gandhi's "Conclusion" to his paraphrase of *Unto This Last,* he claims that Ruskin has "proved to the hilt" that a hundred years of Western civilization have ruined Europe. Covetousness and mass production are responsible for its exploitation of colored races and for the coming explosion that will turn it into a "veritable hell on earth." Exploitation of the poor and violence in the form of assassinations will not end in India with the expulsion of the foreigner. India must reject industrialization; she must indeed attain home rule, but true home rule depends upon self-control in the individual citizen. In his introduction to the English retranslation thirty-three years later,Gandhi adopts a milder tone, but retains his extension of Ruskin's criticism of the classical economists to a generalized condemnation of Western materialism:

> People in the West generally hold that the whole duty of man is to promote the happiness of the majority of mankind, and happiness is supposed to mean only physical happiness and economic prosperity. If the laws of morality are broken in the conquest of this happiness, it does not matter very much. The consequences of this line of thinking are writ large on the face

of Europe.

> This exclusive search for physical and economic well-being
> prosecuted in disregard of morality is contrary to divine law,
> as some wise men in the West have shown. One of these was
> John Ruskin who contends in *Unto This Last* that men can be
> happy only if they obey the moral law.[23]

Ruskin's indictment of England—"I know of no nation
in history which has established so systematic a disobedi-
ence to the first principles of its professed
religion"—reinforced in Gandhi's thinking the habitual
association of morality with nationalism and
traditionalism in underdeveloped nations. Especially in
his earlier years, he tended to identify India with virtue
and religion, the West with godlessness. Bolshevism he
regarded as the "necessary result of modern materialistic
civilization" with its "insensate worship of matter." As for
the laissez-faire economy, he did not forget Carlyle's pic-
ture of a "nation of shopkeepers" and the references to
Mammon worship and the goddess of somebody's getting-
on: "Many problems can be solved by remembering that
money is their God." He contrasted these British and
American attitudes with the ancient Indian ideal, "the
limitation of activities promoting wealth"; and opposed
"Indian" self-suffering to "Western" violence or brute
force. He humbly refused opportunities to preach nonviol-
ence in the West, however, because he had not yet suc-
ceeded in wholly convincing India: "I am a mere
Asiatic...But Jesus was an Asiatic also."[24] As he con-
demned some Indians' neglect of their native tongue, so he
condemned throughout his life indiscriminate imitation
of Western ways, and encouraged the prevalent conviction
that the Western politician tends to seek power and gold
without regard for human values. He might well have
agreed, for example, with Nehru's estimate of this sen-

tence as typically American: "The statesman can concern himself with the values of justice, fairness, and tolerance only to the extent that they contribute to, or do not interfere with, the power objective."[25] Nonetheless, Gandhi knew that "underlying the fever [of the West]. . .there is a restless search for truth"; and that, whatever Kipling may have said of East and West, "there is no inherent barrier between European and Indian anywhere."[26]

Ruskin's view of British colonialism differs from Carlyle's. Although he opposed the Jamaica Committee and denounced as bestial disloyalty the Indian mutiny of 1858, he declares elsewhere that "every mutiny. . .arises directly out of our national desire to live on the loot of India," and reproduces with approbation penetrating letters to the *Monetary Gazette* condemning the export of corn from that famished land, the village practice of usury there, and the English failure to maintain ancient irrigation systems and to renew the ever-normal granary of the Sultan Ala-ud-din. In *The Crown of Wild Olive,* he attacks "the notion of patriotism as requiring. . .[men] to limit their effort to the good of their own country," and suggests that England help foreign nations out of self-interest as well as duty. "Only that nation gains true territory, which gains itself," he says; whether Britain's "apparent increase of majesty and of wealth. . .prove to us ultimately power or weakness depends wholly on the degree in which our influence on the native race shall be benevolent and exalting."[27] As Graham points out, Gandhi often repeated these remarks during the early years; but the dispute over the Khilafat and the Amritsar massacre of 1919 made him feel that India's only hope lay in freedom from Britain.

Probably Gandhi was not acquainted with Ruskin's account of the career of Sir Herbert Edwardes, a British officer in India. *A Knight's Faith* illustrates some of the

reasons for the difficulty experienced by many tolerant Hindus in sharing Gandhi's perception of the essential spirit of Christianity. Ruskin's Christian hero and Happy Warrior sets up a "Proclamation of Law and Justice for Bunnoo" after forcibly substituting a single British fort for all the small native ones. This "missionary" soldier who did not hate his enemies Ruskin regarded as the ideal son of "Sacred England, who went forth for her, not only conquering, and to conquer, but saving, and to save"; a crusader to bring other nations to say to Mother England, "Thy people shall be my people, and thy God, my God." Gandhi's comment on colonialism of this stamp is a denial that India is a sick child needing nursing: "If God almighty has given the humblest of His creatures the freedom to err, it passes my comprehension how human beings, be they ever so experienced and able, can delight in depriving other human beings of that precious right."[28]

While emphasizing primarily the role of colonial exploitation in creating India's plight, Gandhi is also aware of the fundamental question as to the adequacy of her land to feed all her people. *Unto This Last* cavalierly dismisses the three remedies for overpopulation: colonization, bringing in of waste lands, and discouragement of birth. Although later Ruskin, like Plato, advocates state regulation of childbearing, here he declares that man's increase, unlike animal's, "is limited only by the limits of his courage and his love."[29] Faced with a different situation, Gandhi adopts a less positive tone, although he believes that an improved India could provide the bare essentials of life for a population even greater than the present one. He rarely mentions irrigation (though his interpreter Sitaramayya points out its necessity for the forty-seven percent of arable land still not under cultivation); and he disapproves of contraceptives as unnecessary; but he re-

gards as desirable alternatives the sterilization of some men and the Malthusian proposal of population control through self-restraint. Again at this point religious and economic attitudes reinforce one another. He advocates chastity for social workers in any case, partly as a means of avoiding the distraction of family responsibilities, and partly because of the spiritual value he attributes to chastity. The votaries of *ahimsā* "cannot marry"; "the larger their family, the farther are they from universal love." For others, he recognized the sacramental nature of procreative marital sex, while recommending its renunciation on grounds of the national welfare.[30]

The population problem obtains for both agricultural and industrialized nations today, since the amount of food produced from a given area of land is not affected by improvements in farm machinery, and even the "green revolution" cannot produce sufficient food everywhere. For Gandhi, however, the central problem of modern economics was less the basic inadequacy of the food supply than the choice between the alternatives of, on the one hand, centralized power, industrialization, the search for resources and markets, and military might; or, on the other hand, a decentralized, economically self-sufficient, simple community life. "Centralization as a system is inconsistent with nonviolent structure of society." An urbanized, centralized India would require defense by armaments; capitalism might bring a "bloody class war." Ruskin believes that *unjust* wars are paid for by capitalists and caused by greed; in a letter to the editor of the penny edition of *Unto This Last* he asks workers to unite to abolish "Armaments. . . , of which the real root cause is simply the gain of manufacturers of instruments of death." Likewise, Gandhi considers war the inevitable result of industrial power:

> You cannot build non-violence on a factory civilization, but it
> can be built on self-contained villages. Rural economics, as I
> have conceived it, eschews exploitation altogether, and ex-
> ploitation is the essence of violence. You have, therefore, to
> be rural-minded before you can be non-violent, and to be
> rural-minded you have to have faith in the spinning wheel.

"Handicrafts," he says, "exclude exploitation and
slavery."[31]

Thus his chief objection to machinery is that "It concen-
trates production and distribution in the hands of the
few." If one man could farm all India by a machine and
control all produce, millions might starve. Technological
unemployment, a renewed problem even in America
today, is especially menacing in overpopulated India. Un-
aware that it could eventually be absorbed by an expand-
ing economy, Gandhi sees no value in "labor-saving"
machinery when thousands are without work. He does not
share the Englishmen's disapproval of division of labor,
since to him all labor is worthy; but he seeks "to deliver
human beings from the indignity of being mere machine
tools"; he objects to the ugliness of factory and city, the
factory's influence on family life, and the breakdown of
personal ties in industrial bureaucracy. As the machine
brings suffering to the producer, so, he believes, it creates
greed in the consumer, who does not need such a plethora
of machinemade things—"cheap and nasty," as Carlyle
calls the products of competition for lower prices. Gandhi
preaches contentment with one's present stock of posses-
sions; he cannot understand the urge to "speed up produc-
tion, indefinitely and at any price."[32]

Self-sufficiency

Even had he thought technological development desir-

able for India, Gandhi would not have been willing to pay
its price. India could not replace British mills by native
mills without capital. As Djilas has pointed out, the only
means of forcing from an impoverished people the sac-
rifices required for industrialization without foreign help
is severe regimentation; modern Communism, he shows,
develops less often as the end-product of capitalistic
class-conflict than as a means to nationalistic industriali-
zation of underdeveloped countries. Gandhi was opposed
to state violence and equally opposed to the investment of
private foreign capital, which to him meant exploitation.
Indeed, one of the chief distinctions between his economic
thought and Ruskin's lay in his view of any dependence on
foreign money, machinery, or technical skill as undesira-
ble. India was to avoid not only dependence on foreign
nations, but also competition with them. Successful in-
dustrialism, he said, "depends entirely on your capacity to
exploit, on foreign markets being open to you, and on the
absence of competitors." Production for export, he
thought, required military superiority to markets. Thus
for India he recommended not industrialization, but self-
sufficiency and tariff protection. In his eyes, economic de-
velopment was not worth the sacrifice of *swadeshi,* which
he regarded as a religious principle and defined as "that
spirit in us which restricts us to the use and service of our
immediate surroundings, to the exclusion of the more
remote," the refusal to "serve. . . [the] distant neighbour at
the expense of the nearest."[33] Like Plato in the *Laws,*
Gandhi wished to avoid the immoral results of commercial
interchange. Perhaps he also recalled Ruskin's insistence
on the costliness of exchange—across oceans even more
than between towns.

Villagism was essential to *swadeshi.* As Anjaria points
out, one phrase sums up the essence of Gandhi's economic

program: "Regeneration of the Village."[34] Gandhi sought
to revive the Indian village of the past, which he thought
had exemplified Engels's theory of primitive communism.
Like Kropotkin, he stressed the ethical value of that vil-
lage cooperation which Marx attacked. "From the Indian
tradition of 'village communism without communism's
violence' Gandhi drew his inspiration for *sarvodaya* or the
ideal social order, although immediately it was from a
reading of Ruskin's *Unto This Last*." Admitting the lack of
historical proof, he believed that "there was a time in
India when village economics were organized on the basis
of. . .non-violent occupations, not on the basis of the rights
of man but on the duties of man." Certainly Plato's vision
of the self-sufficient city contributed to his thought;
perhaps he had read an 1814 account of the Indian village
as "a kind of little Republic": "My idea of Village Swaraj is
that it is a complete republic, independent of its neighbors
for its vital wants, and yet interdependent for many
others."[35] Ruskin's theory of the self-sufficient coopera-
tive town was not specifically presented in *Unto This Last*
or in the other books we know Gandhi to have read; but
some of his ideas recall the institutions of ancient India as
well as those of medieval Europe. The similarities be-
tween the caste and the guild, the mutual cooperation of
villagers as a corporate, self-reliant unit, and the produc-
tive enterprises of the Hindu joint family offer instances of
how deeply the notion of "the welfare of all" was rooted in
Indian psychology. The crafts that busied farmer and
herder in the winter months and filled the trader's spare
hours were regarded in the Hindu scriptures as art and
sacrament. When British mills rendered homespinning
unprofitable, the farmer was reduced to idleness as well as
penury during six months of the year. The spinning wheel
and *khadi,* the homespun cotton clothing substituted for

boycotted British goods, came to symbolize self-help, economic independence, and nationalism; but the village crafts movement did not end with the achievement of home rule, for it answered many of India's needs. A nation of small farms with a large population required diversified agriculture, spare-time employment, and cooperative marketing.

In India home industry was essential to make the farmer self-sufficient. For Gandhi it was also a means of avoiding "life-corroding competition" and of finding the "real happiness," which consists in a "proper use of our hands and feet." In Ruskinian language, Gandhi noted that while "hand-spinning does not claim to satisfy the economics of 'getting rich,'" it gives work to those idle half the year, helps to distribute wealth, and counteracts famine because it is independent of climate and monsoon.[36] An economic ethic is after all geographically and historically as well as religiously determined.

To Gandhi Communism in the best sense of the term meant the mutual sharing of workers in self-sufficient villages. All activities were to be cooperative, with perfect democracy based upon individual freedom; education centered on crafts was to be compulsory; guards were to be selected by compulsory rotation; sanitation was to be simple but conscientious; legislative, judicial, and executive functions were no longer to be performed according to British law, but to be united in the traditional village *panchayat,* with five members elected for one-year terms.

Villagism exemplified *swadeshi* on the local scale, providing work, tools, and food for all from nearby sources; permitting equity of distribution, impossible to regulate if production is centralized; contributing to the cities after local needs are met. On the individual scale, *swadeshi* meant bread labor, the reduction of wants to a minimum,

and the duty to employ one's neighbor rather than some-
one from afar. On the national scale, *swadeshi,* a means of
protecting village industries, began as part of the resis-
tance against the British.

It was essential to India's well-being that she stop ex-
porting food and importing cloth. Although Gandhi at
first condemned the boycott of British goods, he later came
to think of *swadeshi* as nonviolent noncooperation, never
vindictive or punitive, but helpful to the English mill
owners by freeing them from the sin of theft. As did Rus-
kin, Gandhi felt that in the end the exploiter suffers more
than the exploited. At first he advocated complete
economic self-sufficiency for India; but eventually he saw
the folly, pointed out in *Unto This Last,* of attempting
inappropriate manufactures and of excluding foreign-
made goods that filled national needs. He continued, how-
ever, to oppose the import of readily producible com-
modities. His approval of tariff barriers and of relative
regional self-sufficiency contrasts with Ruskin's advocacy
of one-world free trade as eventually ending all competi-
tion, a view that Fain regards as a basic inconsistency in
Ruskin's thought. Ruskin did not, like Gandhi, extend his
conception of village self-sufficiency to the national level.

Mutual Responsibility

Gandhi connects even national *swadeshi* with Ruskin's
idea of consumer responsibility: "the economics that per-
mit one country to prey upon another are immoral. It is
sinful to buy and use articles made by sweated labor."
Like every member of society, the consumer, in Ruskin's
view, has a duty to sacrifice selfish desires to the good of
the whole. Ruskin points out the buyer's influence on
production methods and thus on men's souls and his con-

sequent responsibility to give up "such convenience, or beauty, or cheapness as is to be got only by the degradation of the workman." In *A Joy for Ever* he exhorts the consumer to employ people usefully and to be mindful of the cost of rich clothing in terms of human suffering: "as long as there are cold and nakedness in the land around you. . . splendour of dress is a crime." The duty of the buyer, as defined in *Unto This Last,* is to consider the effect of the product on laborers' lives; the justice of its price and the proportion received by the laborer; its usefulness; and the methods by which it is distributed.[37]

These principles are suggested in the vow of *swadeshi* required of every member of Gandhi's *ashram* or religious community:

> It is inconsistent with Truth to use articles about which or about whose makers there is a possibility of deception. . .Use of fire in the mills causes enormous destruction of life besides killing labourers before their time. Foreign goods and goods made by means of complicated machinery are, therefore, tabooed to a votary of Ahimsa.

To this definition Gandhi adds:

> I buy from every part of the world what is needed for my growth. I refuse to buy from anybody anything however nice or beautiful, if it interferes with my growth or injures those whom Nature has made my first care. I buy useful healthy literature from every part of the world. I buy surgical instruments from England, pins and pencils from Australia and watches from Switzerland. But I will not buy an inch of the finest cotton fabric from England or Japan or any other part of the world because it has injured and increasingly injures the millions of the inhabitants of India. I hold it to be sinful for me to refuse to buy the cloth spun and woven by the needy millions of India's paupers and to buy foreign cloth although it may be superior in quality to the Indian hand-

spun. My *swadeshi,* therefore, chiefly centers round the
hand-spun khaddar and extends to everything that can be
and is produced in India.

He uses Ruskin's metaphor of the plague for the mis-
directed flow of wealth in his remark on the burning of
rich cloth: "[it is] the most economical use you could have
made of it, even as the destruction of plague-infected arti-
cles is their most economic and best use." As Ruskin sug-
gested that English women wear mourning for war, so
Gandhi asked Indian women to wear white *khadi* as a
sacrifice, and himself in the days of his Western garb had
temporarily worn the *dhoti,* costume of the indentured
South African Indians, as mourning for some who were
shot.[38]

The economics of *khadi* are Ruskinian economics,
where the welfare of the producer counts more than the
gratification of the consumer; "life is more than money."
Gandhi pierces to the heart of Ruskin's thought when he
replies to the critics of national subsidies for "uneconomi-
cal industries": "The so-called economic character of fac-
tory production as compared to home production today is
not an inherent quality, but only a conferred attribute
depending on the standard of values which society has
adopted or considers desirable to adopt. The only inaltera-
ble and rock bottom test of whether an occupation or
method of production is economical or otherwise, is how
far it answers life's vital needs, what the making of it
means to the producer." Gandhi adopts Ruskin's redefini-
tion of wealth as life and the concept, though not the term,
of "illth"—goods not truly useful in the sense that they
avail toward the life of the consumer, or not produced in
ways conducive to human happiness. With Carlyle and
Ruskin, Gandhi refused to accept Adam Smith's first de-

finition of a nation's wealth as the total amount of money divided by the total number of people; statistics told him India was rich, but he could see the difference between Delhi and the peasant cottages. Like Ruskin, he disagreed with the classical economists that the object of the economy is to increase the national supply of capital and goods: "It is health which is real wealth," he wrote, "not pieces of gold and silver." Vinoba Bhave similarly makes an emphatic distinction between money and "wealth" in human happiness, and Mashruwala declares that "The development of India means, primarily, healthy and all-round development of the life and personality of India's living beings, human as well as animal."[39]

"*Khadi*-wearers should know," Gandhi said, "that the economics of *khadi* are different from the ordinary economics, which are based on competition in which patriotism, sentiment and humanity play little or no part. *Khadi* economics are based on patriotism, sentiment, and humanity." The appeal to such motives was essential because handspun cloth was twice as expensive as millcloth, less varied, and sometimes inferior, although Gandhi argued that the mill-treated Dacca fiber gave far less satisfactory results than handspun muslin. *Khadi* was not only higher in price, but required government subsidy by advertising, a central marketing organization, and the government allocation of yarn through cooperatives. Gandhi pointed out, however, that because of the prevalent taste for modern conveniences, the government was already subsidizing factory production by providing transportation, banks, and city facilities. He regarded subsidy of *khadi* as unemployment insurance or an alternative to relief, for a mill producing five thousand square yards threw one thousand weavers out of work. While the price of *khadi* was double that of mill goods, the wages distri-

buted were more than doubled, since wages are sixty per-
cent of the price of *khadi* and only twenty-two percent of
the price of mill cloth, which includes profit and rent.
Since *khadi* wages are lower, they pay more workers,
while providing a fifth or a sixth of total living costs in the
village.[40] Ruskin felt wages should represent a large
proportion of price.

Not only the consumer, but even the merchant was
asked to help to achieve *swaraj* by patriotic support of
swadeshi, which of course operated to keep his role to a
minimum. Trade and transportation, which Ruskin arbit-
rarily and erroneously labeled unprofitable, have little
importance in an economy of self-sufficient villages. But
Ghandi makes demands on the merchant that are a logical
extension of those made in *Unto This Last,* where Ruskin
writes that "The market may have its martyrdoms as well
as the pulpit; and trade its heroisms, as well as war."
Plato, too, believes that if more good men became mer-
chants the occupation would be honored. According to
Gandhi, "A merchant, who operates in the sacrificial
spirit, will have crores passing through his hands, but he
will, if he follows the law, use his abilities for service. He
will therefore not cheat or speculate, will lead a simple
life, will not injure a living soul and will lose millions
rather than harm anybody." Above all he emphasizes the
merchant's duty to avoid spreading illth. As he asked the
British Government to give up its "sin money" of taxes on
opium and liquor (as well as on that vital necessity, salt)
and to cut military expenditures in half, so he suggested
that merchants consider the buyer's and the producer's
welfare and refuse to sell liquor to alcoholics or to trade in
grain or cloth that create poverty and idleness. Gandhi
agrees with Ruskin that the laws of supply and demand
are not immutable, but may be influenced by human

effort,[41] as contemporary advertisers well know.

As among landlord, capitalist, and laborer, Gandhi applies Ruskin's concept of social responsibility to all three groups, but advocates government discrimination in favor of the have-nots. While recognizing that "the violence of private ownership is less injurious than the violence of the State," he believes that the division of wealth should gradually and voluntarily be rendered more equitable. Inequality is a central assumption of Ruskin; Gandhi, too, recognizes inequality of capacity, while insisting on equality of opportunity. By equality of possession, Gandhi and Vinoba Bhave mean only an irreducible minimum for all: "economic equality must never be supposed to mean possession of an equal amount of worldly goods by everyone." Gandhi's "central aim," however, is "equal treatment for the whole of humanity and that equal treatment means equality of service."[42] Only rarely have religious groups like the Levellers advocated secular as well as spiritual equality.

Stewardship, a time-honored Hindu and Christian economic concept, is to be the means of narrowing the gulf between rich and poor. In *A Joy for Ever* Ruskin uses the parable of the talents as an illustration of the responsibility of those able to create wealth; Gandhi, too, suggests the use of talents to serve rather than to earn, and the benevolent expenditure of wealth by the man who does earn more, as the son who earns more gives his income to the family fund. The Wesleyan ideal of acting as God's steward and dying poor is united in Gandhian thought with the concept of trusteeship, which he encountered in his legal training. His economic chivalry, like Ruskin's, treats the rich man as the servant of society and the guardian of the poor.[43]

Although Gandhi's essential attitude thus agrees with

Ruskin's, his use of the word *trustee* may represent a misreading or a contradiction of an ironic passage in *Munera Pulveris*. Ruskin, antagonistic to saving and intent on persuading the wealthy to spend their money wisely before they die, is ridiculing the ordinary capitalist who devotes his life to the acquisition and preservation of riches he himself does not need and never uses:

> . . .with multitudes of rich men, administration degenerates into curatorship; they merely hold their property in charge, as trustees, for the benefit of some person or persons to whom it is to be delivered upon their death. . . .What would be the probable decision of a youth on his entrance into life, to whom the career hoped for him was proposed in terms such as these: "You must work unremittingly, and with your utmost intelligence, during all your available years; you will thus accumulate wealth to a large amount; but you must touch none of it, beyond what is needful for your support. . . .And on your death-bed you shall have the power of determining to whom. . .[it] shall belong, or to what purposes be applied."[44]

To Gandhi a trustee is one who not only spends money beneficially during his lifetime, but also may leave it for fruitful use after his death. Wealth in excess of elementary needs or beyond that of one's neighbors is to be expended for public purposes in "a voluntary abdication of riches." The trusteeship of the wealthy is to be coerced by the nonviolence of the poor, for "The rich cannot accumulate wealth without the cooperation of the poor in society." Gandhi regards noncooperation as an alternative to class conflict, although both mean striking. The government is to exact high taxes and death duties, like Plato's severe restrictions on private fortunes and Ruskin's graduated income tax and capital levy; and it approves the trustee's nomination of his heir; occasional passages in Gandhi's works support Dhawan's statement that "a trustee has no

heir except the public." Gandhi's position on the confisca-
tion of misused property also varies; sometimes he per-
mits confiscation with minimum violence. He hopes that
eventually the capitalist will exist only as a trustee.[45]

Absentee landlordism was one of the most serious
economic inequities in India. Gandhi may not have read
the works in which Ruskin advocated ownership of land
by those who could use it, community tenure by the
laborer's purchase, redistribution under severe state con-
trol. Gandhi, too, however, believes that "land and all
property are his who will work it"; that since it belongs to
God, it belongs to the people as much as to the landlords.
He exhorts the landlords to avoid expropriation by
friendly cooperation as heads of families or benevolent
trustees choosing poverty for themselves. His followers
believe that his delay in insisting upon land reform was
partly due to the impossibility of effecting it under British
rule; they seek either to plan village cooperative farming
as in the *gramdan* movement, or to persuade the agricul-
turalist to share with the villagers all his income from all
sources according to what they consider "the way of justice
and Sarvodaya."[46] Inheriting Gandhi's mantle, Vinoba
Bhave has obtained incredibly large voluntary land gifts
for village cooperative farming, to which he added re-
quests for wealth gifts and labor gifts.

Capital and labor, as well as every other social group,
are committed to the service of the common welfare in
Ruskinian and Gandhian economics, with industrialists
fixing an established price rather than competing with
one another. Ruskin believes that fixed salaries for all
workers and part interest of labor in the company would
contribute to the reconciliation of the two groups. He
recommends the establishment of cooperative guilds to
regulate methods of production, quality of goods, and

prices, and to compete with employers by independent production. Government, too, is to compete with private enterprise in some industries as well as to operate public utilities. Gandhi advocates not only government ownership of utilities but also a predominant voice for the State in the few industries he regards as necessary. As Anjaria points out, he fails to realize that such centralized power would render impossible the attainment of his moral objectives.

Like Ruskin, Gandhi demands responsibility from laborers as well as from capitalists. He notes the similarity of the medieval guild to the Indian caste, which similarly prescribed set work, taught skills, protected against competition, gave each the fruits of his labor, and worked for God, not for Mammon. While condemning the inequalities of caste, he favors nonviolent unions. Suggesting that workers might be part proprietors, he nonetheless advises them against believing that they know how to run a mill alone and killing the goose that lays the golden eggs by seeking to own it. The interdependence between capital and labor, he believes, can be used either destructively or creatively. Labor and capital are co-trustees. The duty of capital is to serve labor; the duty of labor is to work well in order to earn its rights: a minimum wage, a union shop, the same dignity and status as capital, and full knowledge of the mill's affairs. Gandhi stresses the need to work during strikes and advocates free adult and child education and workers' hospitals with maternity facilities and nurseries. Unlike the political economists whom Ruskin criticizes in *Unto This Last* for their inadequacy in labor crises, Gandhi was not helpless in the face of a strike. He introduced arbitration in labor relations to India and influenced the first establishment there of a workers' union. His work in the historic Ahmedabad strike was based on a

Ruskinian attempt to determine a just wage rather than a bargained wage, and on his belief that "the ideal relationship between master and man should be based not on self-interest but on 'mutual regard' in the spirit of Ruskin's *Unto This Last.*"[47]

The second principle that Gandhi thought he found in this book and had previously only "dimly realized" was "that a lawyer's work has the same value as the barber's, inasmuch as all have the same right of earning their livelihood from their work." He was mistaken in reading into Ruskin's work the concept that the "economic [as well as the] social and spiritual value of every work should be equal," as Vinoba Bhave put it. Gandhi himself advocated a uniform wage for all occupations, time for time. The parable of Ruskin's title, taken literally, implies equality of wages without regard even to time. Ruskin mentions time for time in *Unto This Last,* but explains in a footnote (perhaps not in Gandhi's edition) that this has been misunderstood. Actually he had several theories of the means of determining the ideal just wage, including the laborer's basic needs as decided by doctors and the intrinsic value of the product plus the cost in human suffering. He recommends that wages for each occupation be scaled in a "descending series of offices or grades of labor." Although having "ultimate reference to the presumed difficulty of the work, or number of candidates," they are not to be influenced by the fluctuations of the immediate demand for labor and should take into account the worker's needs rather than the quality of his work.[48]

In Ruskin's view, according to which type is as important as amount of work, mill cloth would have a higher labor cost than *khadi*. Gandhi adopts this idea when he points out sorrowfully that actual prices of mill cloth and *khadi* in India do not reflect the cost in terms of artisans'

lives. According to Ruskin's concept, elaborated in *Munera Pulveris,* cost is human rather than financial, involving three elements: the quality and kind of human effort, the capacities of the workman, and the distribution of the effort. Many types of work contribute to the happiness and growth of the workman; thus the cost should be estimated according to the degree of suffering involved. In these terms, cloth spun at home in leisure time in rural surroundings has a far lower cost than millcloth, requiring an automatic, mechanical type of labor in the city, where poverty means deprivation of sun and fresh air. The fact that the monetary price of millcloth is lower is regarded as less significant by Ruskin, who quotes Carlyle on the undesirability of competing to undersell other nations in cotton, and criticizes that tyranny of the consumer which makes cheapness a decisive factor.[49] Ruskin's emphasis on consumption as the goal of all production never implies neglect of the producer's welfare.

For Ruskin, utility as well as cost is estimated in human rather than financial terms: it can be determined by the kind of satisfaction an article provides, by the "acceptant capacity" of the consumer (his ability to utilize or appreciate it), and by the distribution of articles among consumers. Ruskin's position on the third question, as expressed by Hobson, supports his and Gandhi's condemnation of wasteful luxury:

> The greatest effectual utility is got from any article when it goes to satisfy the intensest human need. . . .A given quantity of commercial goods will attain their maximum value according as they are distributed so as to satisfy the greatest needs.[50]

"Possession," to Ruskin, "is in use only, which for each man is sternly limited."

In *Unto This Last* Ruskin declared that the whole trouble with commerce is that men's minds are on the "vital (or rather mortal) question of profits." *The Crown of Wild Olive* fully states "the fallacy of profit as the motive of industry." As Hobson says, "his insistence that all. . .money income must be estimated in relation to the vital cost of its production and the vital utility of its consumption, is the evidently accurate standpoint for a human valuation of industry." Although in one passage Ruskin accepts Mill's definition of wealth as the possession of useful articles, the reinterpretation of it which he immediately adds reconciles it with his own concept of wealth as life.[51]

The Meaning of Money

The concept of money as a claim on labor is also common to Ruskin and to Gandhi, who writes:

> Ruskin taught in his age that labour has unrivalled opportunities. But he spoke above our heads. At the present moment there is an Englishman, Sir Daniel Hamilton, who is really making the experiment. . .he has come to the same conclusion as Ruskin has arrived at intuitively. . .it is wrong to think that a piece of metal constitutes capital. . .even to think that so much produce is capital. . .it is labour that is capital, and that living capital is inexhaustible.

For Ruskin, money usually represents the suffering and work of the earner, creating a claim on the labor of others and on the commodities they produce—a claim fluctuating according to their relative poverty. As Ruskin's dislike of monetary fluctuations leads him to suggest a food standard rather than a gold standard and to condemn credit, so the Gandhians prefer local exchanges of labor or

barter to the vicissitudes of currency and coinage. Vinoba
Bhave, remarking like Ruskin that money is power to
control the lives of others, seeks in his *ashram* to elimi-
nate as far as possible the use of money, the source of all
evil.[52]

Gandhi frequently insists, as do Ruskin and Carlyle,
that industrial capitalism inevitably makes the rich
richer and the poor poorer. They object to every operation
that makes mere having the source of more having. Just
as Plato dislikes usury and credit, Gandhi condemns cre-
dit as "the cooperation of scoundrels" which "Ruskin
rightly dreaded." Ruskin advocates the limitation of pro-
fits and refuses to accept the justification of interest as a
reward of abstention from the use of money. Although he
appears to change from a condemnation of excessive in-
terest as usury in *Munera Pulveris* to the medieval view of
all interest as usury in *Fors Clavigera,* actually he con-
demns interest as early as *A Joy for Ever,* where he de-
clares it unfair that "to him that hath, shall more be
given" and calls it a "singular arrangement" that "to
every man with a hundred pounds in his pocket there shall
annually be given three; to every man with a thousand,
three hundred; to every man with nothing, none." The
chief indications of Gandhi's attitude are his refusal to
accept interest from spinners on yarn and his condemna-
tion of the endowment of public organizations on grounds
that they should continue to deserve annual contribu-
tions. Vinoba Bhave complains of the Gandhians' lack of
integrity in investing donations to their social welfare
funds in banks making loans to profitable industries. His
remarks, too, reveal a Ruskinian distaste for saving and
underconsumption. Arguing hopefully that "if that
amount is really necessary, it should be possible to spend
it in one or two years," he deplores others' inability to see

the evil of interest, as in modern society "not to earn interest is regarded as folly." Interest from industrial investment differs from interest on loans to the poor, as Hobson points out, and there is no evidence that Gandhi himself condemned the former except through his attack on credit.[53]

Experiments in Living

All Ruskin's enthusiasm could not make the revival of village handicrafts an important factor in the British economy. He did, however, start a movement that produced a large number of cottage industries, undertook a publishing experiment, and revived the homespinning of wool and the homespinning and homeweaving of linen in the Ruskin industry at Langdale in Westmoreland, later removed to Keswick. Eventually a British Home Arts and Industries Association was founded to fill idle hours, revive crafts, and unite the educated and the poor. The Arts and Crafts Movement, which eventually spread to the Continent and to America, was primarily esthetic rather than economic in its significance. Originating in the influence of William Morris and the Pre-Raphaelites as well as Ruskin, and remaining always the work of a few for the few, it stressed the creativity of the individual and the superior beauty of the handmade product. Relating the fine arts to the applied arts, it improved popular taste in printing, illustration, design, weaving, sculpture, architecture, and other fields. It expressed social concern through its rejection of competition in favor of the cooperation characteristic of the medieval guild; its emphasis upon the life of the worker and the beauty of cities and of useful objects; and its insistence upon use rather than profit as the goal of production.

Gandhi's handicraft movement, economically and politically rather than esthetically motivated, gained far wider influence because of its appropriateness to Indian conditions and its value in the independence movement. The villager was advised to grow cotton in his own yard; gin and card it; spin it on the wheel that Gandhi himself had improved mechanically; weave it on the handloom; and dye it. The latter processes were regarded as less satisfactory than spinning because they were separate occupations rather than auxiliaries to farming and because if not accompanied by handspinning they required yarn from mills. Among the other cottage industry products were handpounded rice, hand-ground flour, hand-made jaggery, hand-pressed ghani oil, hand-prepared paper, soaps, matches, and tanned leather. As usual, Gandhi discovered the methods of his "Constructive Programme" before fully developing the theory, began it with individuals in a small area and gradually enlarged its scope. After 1934, when he settled near Wardha in a small village to devote himself to practical experiments and organization, many associations sprang up under his leadership—chief among them the All-India Village Industries Association and the All-India Spinners' Association. The cooperative spinning centers were the heart of the program. Indians of every rank worked at their spinning wheels for loyalty to Gandhi; and on Gandhi's annual day his followers still observe the "dedication of one hand of self-spun yarn. . .symbolical of respect for Gandhi, faith in the Sarvodaya ideal, faith in personal service, faith in the performance of physical labor, faith in a non-violent and non-exploiting order, and of the equal status of the rich and the poor."[54]

The experimental communities in which Ruskin and Gandhi sought to demonstrate their beliefs were amaz-

ingly similar in conception, yet very different in execution. While still teaching at the Working-Men's College, even before writing *Unto This Last,* Ruskin had conceived of founding a "Protestant Convent," a community of craftsmen. But it was not until the 1870s that he actually established St. George's Guild, a land-owning company the members of which were to take vows and contribute one-tenth of their income. The peasants of St. George's Company were to be paid wages until they owned their own land. As Master, Ruskin exacted complete obedience but never intended to offer immediate personal supervision or participation.

The St. George vows included belief in God and in human nature; bread labor; the refusal to deceive, hurt, or rob any human being; the refusal to "kill or hurt any living creature needlessly, nor destroy any beautiful thing"; the attempt to improve oneself in body and soul; and the obedience to law and St. George. Ruskin, in a surprising anticipation of Gandhian attitudes, permitted his guild members to offer "loyal," nonviolent opposition to laws contrary to God's will and needing change. Intending that all should work on the land for a living, he commanded the renunciation of the machine if the hand could do it, and of coal unless no other means was available.[55] Among his group were assiduous handspinners. Although the Guild was intended eventually to expand over Europe as the Society of Mont Rose, it remained a small group with a few scattered properties. Its principal achievement was the founding in Sheffield of a small museum to which Ruskin gave considerable attention.

There is no reason to be sure that Gandhi had ever heard of the Guild. His friend Polak owned *Fors Clavigera,* the series of "Letters to the Workmen and Labourers of Great Britain" in which Ruskin proposed and explained

the idea; but he did not recall ever having discussed it with Gandhi.[56] Yet Gandhi leapt from the first to an understanding of Ruskin's ideals, and later he had read at least *The Crown of Wild Olive,* which Hobson considers a draft of Ruskin's educational and agricultural reform experiments.[57] Godfrey Blount's Ruskinian *New Crusade,* reviewed in *Indian Opinion,* advocated vows similar to those of St. George's Guild. Parallels in the requirements for total dedication in many religions and in Ruskin's and Gandhi's habits of mind may also help to explain the similarity in the conceptions of their intentional communities. The Ruskinian community Gandhi established immediately after reading *Unto This Last* bore startling resemblances to St. George's Guild. It was a small settlement of Indians and Europeans at Phoenix to farm the land and to publish *Indian Opinion* chiefly by hand press—a settlement that provided the model for his "Tolstoy Farm" and for the *ashram* he later founded in India. Gandhi's farm was conceived even more as an experiment in community living rather than as a solution to the newpaper's financial difficulties. Its principles were "the welfare of all," poverty, equality, and manual labor. Having bought the land, Gandhi offered every worker two acres and a house, to be paid for at his convenience; a subsistence wage of three pounds a month; and an equal share of the profits of the move. Gandhi believed that town conditions compelled wastefulness, inhibited originality, and prevented "the realization of his dearest desire to so infuse the columns of the paper with a spirit of tolerance and persuasiveness as to bring together all that was best in the European and Indian communities, whose fate it was to dwell side by side, either mutually hostile to or suspicious of each other, or amicably cooperating in the securing of the welfare of the State and the building up of a

wise administration of its assets." The "vow of poverty," as Polak calls it, the profit-sharing, and the manual labor were continued in the Ahmedabad *satyagraha ashram* of 1915, which had the similar purpose "to train up from childhood public servants upon a basis of austerity of life and personal subordination to common good." The hand loom or other manual labor was to be the means of support, and each member cared for his personal needs, including the "scavenging."[58]

The vows of the *ashram* formulate Gandhi's moral ideals; the first five follow closely the five restraints of Hinduism, and most of the others are Hindu maxims as well. Besides truth, nonviolence, celibacy, palate control, nonthieving, and nonpossession, they included use of neighborhood products, fearlessness, the vow regarding untouchables, the vow of education through the vernacular, the vow to respect the dignity of labor, and the vow as to the religious use of politics.[59] The influence of Gandhi's reading and misreading of *Unto This Last* is especially evident in the last vow and in that concerning manual labor, the use of *khadi*, and the respect to be accorded barber and shoemaker equally with physician. It is remarkable that the vows of St. George's Guild are so much like those of the Hindu *ashram* with the exception of those concerning celibacy, palate control, *swadeshi*, the untouchables, and the vernacular. The fundamental difference between Ruskin's project and Gandhi's lay in Ruskin's proclamation of no liberty and no equality. Gandhi demanded of his associates not obedience, but an uncompromising self-denial; and he had none of Ruskin's interest in beautiful objects or in self-improvement for its own sake. Just as Ruskin's household represented his ideal of the state and the community—no competition, no equality, responsibility of masters, and obedience of

servants—so Gandhi's exemplified a different ideal. But
the principal contrast lay in the practical realities; for by
participating in his *ashrams* Gandhi created in them cen-
ters of spiritual power.

Both Ruskin and Gandhi undertook minor as well as
major experiments. Ruskin wished to form a "Benedic-
tine brotherhood" of Hincksey Diggers among the Oxford
students, who were to build roads, cultivate wasteland,
and improve cities. Gandhi founded an order of service
with a *sarvodaya* motto: "To the common minds, *this* is kin
and *that* is stranger. Those with a generous impulse make
the world their home."[60] Some of Ruskin's other enter-
prises, unknown to Polak as well as Gandhi, again bear a
striking resemblance to Gandhi's experiments because of
being the logical outcome of their system of economic
thought. Both men had a lively sense of propaganda value,
which Gandhi expressed in his bonfires of foreign cloth,
his *hartals* (or strikes), and even in his salt march; Ruskin,
in the Hincksey project, his teashop for the poor, and so
forth. Carlyle had worn Annandale homemade cloth and
even shoes out of preference as Indians were to wear *khadi*
out of patriotism. As Gandhi printed his own newspaper,
Ruskin undertook the publication of his own *Fors Clavig-
era* according to his principles of economic justice, al-
though he chose a sumptuous and costly format. But the
English experiments appeared impractical and ludicrous
to most of the public, as Gandhi's did not. While Ruskin
was ridiculed for his demonstration of street-sweeping,
Gandhi succeeded as part of the sanitation campaign of
All-India Village Industries in beginning a custom on
Ekadashi Day that Indian city dwellers, sometimes ac-
companied by villagers, sweep village streets as evidence
of humility and social concern.

Life as Wealth

A number of scholars who have represented Gandhian economics as unique and original have overlooked its dependence upon the thought of Ruskin. Anjaria, for example, declares that Gandhian economics comprise an entire system like capitalism or Marxism: a system with an ideology, a method, and a programme; a system practical but founded on basic human values. According to Sitaramayya, "no single item of Gandhi's programme of construction reform is a new discovery except the revival of hand-spinning. But it is the assemblage of an economic, a social, and an ethical item that makes the politics the discovery of the age."[61] Whether Ruskin's and Gandhi's economics can properly be called systems may be debated; certainly Hobson has built a system on Ruskin's foundations. But Ruskin anticipated almost all the characteristic features of Gandhian economics, including the emphasis on handicrafts, the unification of several fields of human thought, and the radical departure from the materialistic assumptions of conventional economics. The chief differences lay in Gandhi's advocacy of *swadeshi* and his dislike of government regulation as opposed to Ruskin's recommendation of enforced obedience. Their theories were peculiarly well adapted to Indian conditions in Gandhi's time. Sadleir in 1931 commented upon the lack of any national experiment testing Ruskin's theory as Smith's and Marx's ideas have been tested. Yet actually, both the British welfare state and the American New Deal carried out many of Ruskin's proposals. A majority of the Labour Party members of Parliament in 1906 named *Unto This Last* as the book most influential in their thinking.[62] It is in India, however, that Ruskin's insistence on the signifi-

cance of religion for economics and on the value of manual labor and handicrafts has borne most fruit. The impact of Gandhian thought upon the political economy of present-day India has been considerable, despite Gandhi's own renunciation of office and recommendation that the welfare associations formed under his leadership also refrain from competition for power and spoils and remain free to serve the villages. The true inheritors of the Gandhian tradition are of course Vinoba Bhave and his fellows; the contributors to the *Sarvodaya* volume with its frequent quotations from Gandhi's Ruskin; the advocates of moral reform within the heart of the individual, trusteeship of wealth for the good of all, village cooperation, barter in preference to the use of currency, and voluntary gifts of land and other goods from the haves to the have-nots.

The ideas of Ruskin and Gandhi, though inadequate to deal fully with the world's chief future economic problems, are relevant in many ways to the present situations of both underdeveloped and powerful countries. Among the major dilemmas facing all nations in the future —dilemmas that Ruskin did not envisage fully—will be the disparity between food supply and population and the difficulty of reconciling any degree of human freedom with the extreme concentration of power necessitated by modern technology. Irrigation, the "green revolution," and mechanical cultivation of marginal land will not suffice to feed the world's people unless birth control is extensively practiced or science finds new sources of food. But certainly meanwhile underdeveloped countries should place central emphasis where Ruskin would have placed it—upon increasing the productivity of land, improving agricultural techniques and distribution (as distinct from mechanizing farming), rather than upon industrializing too rapidly at terrible human cost. When totalitarian na-

tions are deliberately sacrificing human life to the increase of industrial and military power, Ruskin's words gain added meaning: "there is no wealth but life." But the machine that throws men out of work may eventually create new jobs for them; the machine that dehumanizes labor may eventually eliminate even assembly-line tasks. The Gandhian emphasis on handicrafts is a judicious means of easing the transition to industrialization rather than a permanent solution to the problem of poverty. Even assuming popular acceptance of the Gandhian renunciation of modern conveniences, the bare necessities of food, clothing, and shelter are more readily provided for all by modern methods, and an adequate defense system requires modernization of the entire economy. A nation permanently committed to the Gandhian system would rely upon friendliness as the most effective deterrent to military invasion.

Many of the problems Ruskin and Gandhi attacked have been at least partially solved in some of the fully industrialized countries; the graduated income tax, free compulsory education, minimum wage laws, and social security are no longer novel concepts. Yet the questions of decentralization and of man's need to work challenge the most technologically advanced cultures. Ruskin was concerned with the equalization of wealth and the dangers of urbanization; Gandhi saw as the main problem of economics that of "how to tame Power"—physical power over nature and other men; "how we can decentralize and democratize the ownership and control of power economic, political, and social."[63] Centralized government regulation becomes increasingly inevitable as technology progresses; the invention of the automobile, for example, made necessary numerous new limitations on individual freedom. Many restrictions, perhaps eventually including

even government regulation of birth control, are the price of social justice. Other sacrifices of liberty are made by the organization man enslaved by greed. Concentration of capital is required for such major plants as those producing nuclear energy, although decentralized stock ownership is a possibility. The optimum size for most industrial plants is by no means necessarily the largest, especially in countries with more labor than capital; electrical machinery is highly adaptable to small separate shops, and several of the larger American corporations prefer to establish such plants.

To what extent such changes are desirable and possible may be debated. Although Gandhi was far more interested than was Ruskin in decentralization, both insisted upon their preference of manual labor to artificial sources of power. But production through human and animal muscle, using energy ultimately derived from vegetation, is coming to an end; nuclear and solar energy will supply the deficiencies of coal and oil. Human physical strength is becoming less and less economically useful, less and less militarily significant. Assembly-line tasks and even tedious and repetitious mental work can eventually be delegated largely to machines. Thus technology itself will eliminate the problem of the factory worker's monotonous life; but it will present to increasing numbers of men, as the work week is cut to twenty hours, the question Ruskin and Gandhi answered so negatively: is idleness good?

Ideally, of course, active sports might replace manual labor in preventing the deterioration of health for lack of exercise; active cultural life and closer family ties might develop as the result of freedom and leisure. Certainly the trend represented in a recent *Punch* cartoon of a do-it-yourself kit emerging from an assembly line suggests not

only standardization submerging the individuality Ruskin and Gandhi valued so highly, but also a tendency to satisfy the needs they saw for personal creativity, manual labor, and self-reliance. Although the latter is narrowly limited in an age of machinery, it might be increased if public schools gave the elementary technological instruction now being offered in some adult education courses. The pursuit of such self-sufficiency as is possible today might provide part of the answer to the developing problem of the "leisure-stricken," which has been considered by a committee of the American Psychiatric Association, by the Twentieth Century Fund, and by the Center for the Study of Leisure. Rubber-plant workers in Akron, Ohio, when granted a six-hour day, chose for the most part to use their free time neither for pleasurable physical and intellectual activity nor for socially motivated endeavors, but rather for pursuit of extra income. Often such inability to relax is attributed to guilt feelings induced by just such puritanical teachings as those of Ruskin and Gandhi—irrational guilt feelings that do not apply to the supposedly laudable accumulation of money, whether or not it results from genuine achievement. Yet, with three-fourths of the world's population on the verge of starvation, there may be reason for guilt feelings on the part of those who are idle as well as those who are busy making money in unproductive ways. Advertising creates false wants and products are deliberately made perishable so that they may soon require replacement. The present imbalance between wasteful private consumption and pressing public needs makes relevant Ruskin's and Gandhi's appeals to the consumer for responsibility and simplicity.

It is a commonplace that a political and economic philosophy stressing the rights of man and the pursuit of happiness fails to evoke sacrificial dedication in time of

peace. The appeal of Marxism lies not only in dogma providing escape from the responsibilities of freedom, but also in the uncompromising demand for selflessness in the individual—a demand strangely incongruous with the interpretation of historical conflict in terms of clashing selfish economic interests. Totalitarianism—whether remotely related to Hegelian idealism or stemming from its contrasting offshoot, dialectical materialism—resembles the social theory of Carlyle, Ruskin, and Gandhi in that it requires sacrifices, demands almost religious allegiance, and promises to revive the past.[64] The parallels between Carlyle's ideas and Nazism have been recognized more widely than the influence of Carlyle and Ruskin upon Gandhian socialism. Even Carlyle, however, had insisted upon the sincerity of his heroes, while Gandhi's thought completely contrasts with totalitarianism in its ethical and religious basis of truth and nonviolence.

Today Ruskin and Gandhi challenge us to substitute idealism for materialism. East and West are not so different as they sometimes appear. The East is following the lead of the West in technological development. Perhaps the West can rediscover its own religious tradition through the Indian insistence on the primacy of spiritual values. Heretofore we have idealized less the saint than the technician, man the omnipotent ruler of nature rather than man sacrificing self to humanitarian purposes. It was Einstein who saw that the world needs material progress less than "great and pure characters."[65] Ultimately the very perfection of scientific means will cast man in the sole role of chooser of purposes for his machines.

4

THE NATURE OF PROPHECY:

SCHIZOPHRENIA AND CHARISMA

"In heaven," said Socrates, "there is laid up a pattern of
the Ideal City which he who desires may behold, and
beholding, may set his own house in order. Whether such a
city now exists, or ever will exist, does not matter. The
good man will always live after the manner of this Ideal
City, having nothing to do with any other."

One who sees a discrepancy between his own concep-
tion of justice and the practice of society may denounce
society, withdraw from it as did Tolstoy, or work to
change it by means partly evil, as Carlyle recom-
mended. Usually, even among religious leaders, says
Weber, there is a clear-cut distinction between the
emissary prophet believing himself the bearer of God's
message to mankind, and the exemplary prophet re-
treating from a sinful world.[1] Certainly few have com-
bined, as Gandhi did, the rejection of evil means with
active participation in social affairs. Whether Gandhi
was a saint turned politician or, as he said, a politician
trying to be a saint, certainly he was the agent of re-
ligious influence on social change, an influence that
has rarely been effected through organized churches, so
well aware of the dilemma posed by contradictions be-

tween demands of morality and the need to maintain their membership.[2] Gandhi's life reveals what Ruskin's might have been had he found converts for his social gospel or strength of will to rule himself. As it was, Ruskin went mad.

Ruskin's economic convictions; the sense of mission in which he resembled Gandhi; the failure of his mission, in which he differed from Gandhi, were directly related to his insanity. Just as the two shared some ideas, so they shared certain qualities of character, for men's ideas are often intellectual formulations of emotional experience. Gandhi's personal consistency and sense of unity with his nation represented his successful expression of the same moral preoccupations that resulted in Ruskin's morbid inconsistency and isolation: the religious as against the materialistic view of life; self-denial as against the pleasure principle; subordination of egotistic demands to the welfare of all. The idea of self-sacrifice unified Gandhi's personality and vitalized his relationship to society, while it destroyed Ruskin's self-respect and popularity because he and his nation could not live by it. For both men *Unto This Last* marked a turning point in thought and in life. Had Ruskin been able to conquer his self-indulgence and had he found a substantial following among the Victorian public, the emotional crisis accompanying the composition of *Unto This Last* might have eventuated as fruitfully as did Gandhi's transformation when he read it.

Carl Jung and Anton Boisen argue that some emotional disturbances are essentially therapeutic in nature, and tend to reorganize the personality on a higher level.[3] Furthermore, Boisen believes that conversions of great religious leaders have much in com-

mon with schizophrenic attacks, and differ primarily in outcome. The success or failure of the individual's reintegration after such an experience depends in large part upon his capacity for self-discipline and his ability to win external social validation for his ideas. If he can regulate his conduct according to the demands of his conscience, he recovers; if not, he relapses. If he finds followers to agree with his rational ideas, he modifies his more fantastic notions; if not, his isolation leads him back into insanity. The personalities of Ruskin and Gandhi provide further illustrations of Boisen's theory. Ruskin's illness may have been at least partially schizophrenic, rather than manic-depressive. Inter-relationships between religion, national leadership, and psychosis are suggested by a comparison between the lives of the hero of a nation struggling to be born and a would-be prophet who remained without much social influence on his own country in his own lifetime, and who died insane.

An isolated, precocious child of strict parents, Ruskin did not win the Catholic girl, Adèle Domecq, who was the object of his first affections. He became depressed after her marriage, but shortly thereafter published the first volume of *Modern Painters*. His studies of art continued during his unhappy marriage with Effie Gray, a union that was never consummated and ended in divorce. *Unto This Last,* published in 1860 when he was forty-one, first fully expressed the deep social concern that he developed at about the same time when he fell in love with Rose La Touche, a child thirty years younger than he. The inner conflict of the two preceding years culminated in a deep depression after the unfavorable reception of the book. Despite the unpopularity of his ideas, Ruskin continued to write about economics and later initiated social experi-

ments such as St. George's Guild. At fifty-nine, three years after the death of Rose, he experienced the first attack of an insanity that was to recur periodically before the final years of peaceful retirement at Brantwood. Ruskin died in 1900.

Born in 1869, trained in England as a lawyer, Gandhi failed to establish a practice either in Bombay or in Rajkot, where the local British Political Agent disliked him. Although he had been married at the age of thirteen and already had two of his four children, he left his family to go to South Africa, where he attained success as an out-of-court negotiator. His profound concern for the problems of the Indian population there was evident even before his reading of *Unto This Last* induced him to adopt the simple life by moving his newspaper to an experimental settlement. Two years later, in 1906, he initiated the *satyagraha* campaign and took personal vows of poverty and chastity. A year after his return home in 1915, he began to utilize nonviolence in the struggle for India's freedom. Independence in 1947 was accompanied by partition and communal strife that led to Gandhi's death less than a year later at the hands of a Hindu assassin.

For all the differences in the lives of Ruskin and Gandhi there were similarities in their psychological development. Although these are best illuminated by Boisen's Jungian views, Freud's and Adler's theories of the genesis of mental illness are also relevant because they involve the concepts of pleasure and power, toward which Ruskin and Gandhi held partially similar attitudes.

The Pleasure Principle

The materialistic view of man as essentially little different from other animals, the view that Ruskin and Gan-

dhi attacked, may lead to the mechanistic psychology of behaviorism and the conditioned response to pleasure and pain, or to the dynamic Freudian view of character as usually determined by complex unconscious forces rather than by the rational compromise between selfish hedonism and the demands of society which is regarded as the goal of therapy. For Freud, men's basic unconscious strivings are dominated by the pleasure principle and, secondarily, the death wish. He always interprets as pleasure-in-pain, masochism or sadism, the choices of men in conflict between suffering themselves or imposing suffering on others. Since for him the material is the real, love is "in reality" sexuality; he commits the fallacy of the "nothing but," of seeing a phenomenon in terms of its origins rather than its goals. His concept of sublimation differs from Plato's primarily in this judgment of the nature of reality. For Plato, the world of true being is the ideal world; thus the ultimate goal of love is more significant than its earliest objects. Plato omits and Freud neglects the possibility of transforming *eros,* the selfish wish, into *agape,* the selfless gift. Gandhi's choice of abstinence after sex within a normal marriage enabled him to combine the Platonic with the humanitarian sublimation; but Ruskin, though probably a virgin throughout his life, never ceased to suffer from the need of a woman's love.

Control over physical desires as well as the egotistic will to power was regarded by Gandhi as vitally related to attainment of the spirit of *ahimsa.* Gandhi never developed Ruskin's faults of self-righteousness and self-indulgence—characteristics that Boisen regards as significant in foreshadowing the unfavorable outcome of schizophrenic illness. Like Ruskin, Gandhi was physically unattractive, yet drew women and children irresistibly in later years by his gentleness and warmth. Like

Ruskin, he experienced an early emotional awakening;
but while Ruskin's romantic attachment to Adèle was
never fulfilled, Gandhi's intense sexuality was gratified
in child-marriage to a beautiful wife. Perhaps his later
self-denial was influenced by his sense of guilt at having
been with her when his father died. With her ready con-
sent, he abandoned earlier than usual the sexual aspect of
the householder stage of Hindu life, in order to free him-
self of further family responsibilities and give himself
more wholeheartedly to his work. Gandhi's vow of
brahmacharya or chastity in marriage, perhaps influ-
enced by Tolstoy, was not thought abnormal, as was
Ruskin's virginity during marriage; Gandhi's wife,
though self-assertive, accepted his renunciations, while
Ruskin's Effie rebelled. Although Gandhi was not re-
garded as an ascetic, he thought rational self-denial good
for the soul. Perhaps it was not merely coincidence that
his final vow of *brahmacharya* and poverty in 1906 pre-
ceded by only a few days his unpremeditated initiation of
the passive resistance movement in South Africa. He ex-
perienced a sudden sense of revelation and release when
another speaker vowed in the name of God never to submit
to the Asiatic Registration Law—as Gandhi had just
vowed in the name of God never to submit to the law of his
members. *Satyagraha* was a means of emotional sublima-
tion for Gandhi, although he consistently prefers the term
nonviolence to *love* in order to avoid ambiguity and reiter-
ates that *ahimsā* is not a personal feeling, but an identifi-
cation with all that lives.[4]

Ruskin was not without the capacity for love, which he
partially sublimated first in nature mysticism and later in
humanitarian efforts. After the loneliness of his child-
hood, his passion for Adèle had come "with violence ut-
terly rampant and unmanageable." Not only the intensity

of his unfulfilled and eventually abnormal erotic involvements, but also his inordinate love of esthetic pleasure and his frequent sense of guilt in the most innocent satisfactions, were undoubtedly reactions to the puritanism of a mother who denied him candy and toys. His parents' disapproval and Adèle's indifference combined to thwart his earliest romantic feelings. Again in the courtship of Effie Gray and in their marriage, parental supervision, criticism, and advice continued ceaselessly, with Ruskin so immature as to follow dutifully the family leads. Too, the woman herself took him lightly: Effie at first regarded as ludicrous the very idea that she and John might be in love. In his letters of this period he expressed to others well-founded doubts of her suitability and especially of her love for him, and addressed her as a dangerous siren, dangerous because she might prove cold at heart. His fears concerning her response to his wooing received confirmation when shortly before the wedding he learned that her father, beset by financial reverses, had compelled her to marry him for his money.

Ruskin's failure to consummate his marriage he attributed variously to the unsatisfactory nature of the personal relationship, his reluctance to have children, and religious motives. However unnatural the latter reasons appeared to Effie, still more so to modern Western biographers, they would have been understood by Gandhi. For all the tenderness to little children that Gandhi shared with Christ and Ruskin, he once in blessing a newly married couple expressed the hope that they might have no children. His own vow of chastity was explained by his view, similar to that of the Roman Catholic Church, that this is the only morally acceptable form of birth control. While Gandhi wished to free himself for political work, Ruskin wished to enjoy the pleasures of travel, so neces-

sary for his art criticism. Yet both set more than a practical value on chastity. Gandhi regarded it as spiritually rewarding and vital in genuine *ahimsā*. Ruskin, too, pointed out that virginity within marriage has its religious spokesmen, but at this period in his life, perhaps there was more significance in the fear he expressed before marriage that he might lose his delight in nature, since the sea was beginning to appear to him as mere salt water, rather than as teacher and friend. Both Ruskin and Gandhi knew the *Symposium,* where other kinds of creativity are preferred to physical fatherhood.

Ruskin's abstinence cost him his wife and later Rose, whose mother's decision was based on Effie's letter and on mistaken legal advice. That he needed both sexual pleasure and affection is suggested by the auto-erotism that he did not overcome until well into manhood and by his own view of woman's love as a panacea for all his woes. He had written Effie before their marriage that she would cure his nervousness, which he attributed to his unwed state and to his doubts of the value of all earthly pleasure. Rose he regarded as his only possible savior; later Kathleen Olander appeared to be the one who might cure the madness due, he said, to lack of a wife. That emotional deprivation did indeed contribute its share to his illness is evident in the fact that his earliest depression followed close upon Adèle's marriage, his last destructive insanity upon Kathleen's rejection, and that it was not long between Rose's death and the first attack.

Ruskin's unconventional choice of young girls as the love objects of his later life may be partially attributed to his need to teach and mould the women he loved—a need to which Effie did not accommodate herself. Gandhi, whose relationship with women contained the same element, failed in his efforts as a young boy to raise the

untutored Kasturba to his own educational level, and provoked serious quarrels by his insistence that she share his simplicity and his service of untouchables. Indeed, he declared that he had learned *satyagraha* from Kasturba's quiet determination. In later years he tolerated but disciplined severely the love of Mira (Madeleine Slade) and permitted *ashram* girls to compete for the privilege of serving him personally. Occasional nights sleeping beside these girls permitted him to test his chastity as Alcibiades had tested the virtue of the more personally involved Socrates. Like Gandhi's feminine admirers, Ruskin's Rose and Kathleen were idealists, Rose with a tendency toward religious mysticism and a guilt-laden concern for the poor, which she had learned from Ruskin and which isolated her as it had isolated him. In this sense she would have been more suitable than Effie as Ruskin's wife.

Both Ruskin and Gandhi were devoted to highly religious mothers, observed chastity while married, and found feminine disciples, including young girls, as they grew older. Ruskin was clearly disturbed in the sexual sphere. But while Gandhi's emphasis on the value of chastity may seem abnormal to some Western commentators, his life and character may seem to many others to demonstrate the successful total sublimation of sexuality that Freud declared impossible.

The Will to Power

Not only Freud, but Adler too might have observed psychological affinities between Ruskin and Gandhi. For Adler, the fundamental fact of human nature is not the sexuality it shares with the animal world, but man's awareness of himself as a separate ego differentiated from the rest of nature and determined to dominate it. Focusing

on man's external social relationships rather than upon his inner problems, Adler stressed his assertion of the individual ego in competition with his fellows. Freud himself had recognized the intelligence of Nietzsche's discussion of the sublimation of pleasure-pain motivation in the will to power. As Ruskin saw, the quest of wealth is a quest less of pleasure than of power over others. Ruskin and Gandhi attacked social theories based upon acceptance of this competitive egotism in the individual; yet on occasion both could themselves manifest tyrannical and dictatorial characteristics, Gandhi for noble ends.

The attitudes of Ruskin and Gandhi toward dominating others were less dissimilar than appeared on the surface. Like Ruskin, Gandhi had been a sensitive, lonely child with a demanding conscience derived from a severely pious mother; but Gandhi's mother was more gentle and less dominating than Ruskin's. Like Ruskin, Gandhi was exceptionally devoted and reverently obedient to his parents; but while Ruskin remained enslaved to his family during much of his adult life, Gandhi's parents died in his youth, leaving him with a deep sense of bereavement for his mother. Both men early developed a preceptorial attitude toward their companions that perhaps reflected their parents' personalities. Neither was completely successful in the early part of his career. In spite of his moderate reputation, Ruskin felt that he was failing to persuade Englishmen to enjoy art. Gandhi broke down ignominiously during his first cross-examination of a witness, and also experienced racial humiliation as an Indian in South Africa. Ruskin's arrogance is not entirely without its Gandhian parallel, for Gandhi's gentleness and humility were united with a steel will that imposed compliance with his ethical standards. He treated his wife tyrannically and awoke in Nehru at their first encounter a

sense of terrifying dictatorial potentialities. Never, however, did he share Ruskin's authoritarian political views or refer to God as a despot.

The Collective Unconscious

However relevant may be the views of Freud and Adler, Ruskin and Gandhi can be fully understood only in the light of a third view of the purpose of the ego—not as reconciliation of id with superego, nor as self-preservation in the usual sense, but as preservation of the "ego itself" or "the coherence of experience," as in heroism. It may seek fulfillment of "the universal capacities as contraposed to unique individualistic things."[5] Such a view is more compatible with religious thought. For Toynbee the difference between the unconverted and the converted man lies precisely in the quest of the first for power over himself and others, and the effort of the latter to cope with the problem of human suffering, usually by participation and alleviation.[6] Yinger similarly points out that although a religious prophet may, like Tolstoy, have suffered few personal misfortunes, he is usually one especially sensitive to human misery and frustration and especially eager to find permanence behind a mutable world.[7] The religious man transcends his personal limitations and endures the pain so widely predominating over pleasure by uniting himself with a larger life. As Erich Fromm says:

> Beyond the attitude of wonder and of concern, there is a third element in religious experience, the one which is most clearly exhibited and described by the mystics. It is an attitude of oneness not only in oneself, not only with one's fellow men, but with all life and, beyond that, with the universe. It comprises both the sharp and even painful awareness of one's self as a separate and unique entity and the longing to break through the confines of this individual or-

ganization and to be one with the All. The religious attitude
in this sense is simultaneously the fullest experience of the
individuality and of its opposite; it is not so much a blending
of the two as a polarity from whose tension religious experi-
ence springs. It is an attitude of pride and integrity and at the
same time of a humility which stems from experiencing one-
self as but a thread in the texture of the universe.[8]

Man needs profoundly to escape from his separate iden-
tity, to sacrifice his individual self, to merge with the rest
of humanity. Divided from nature, alone among living
creatures in his capacity to distinguish self from not-self,
subject from object, he longs to return to a state of undif-
ferentiated oneness—perhaps childishly through a symbi-
otic relationship with another individual, perhaps
through identification with a limited group, perhaps ma-
turely through religious experience of unity with all other
life. In an individualistic, competitive society this impulse
is often thwarted or confined to romantic sexual expres-
sion; in a totalitarian society it is utilized to destroy indi-
vidual human dignity. The social theories of Ruskin and
Gandhi recognized this impulse. Gandhi's character ful-
filled it; Ruskin's regressed toward childishness through
failure to fulfill it.

Among recent interpreters of the human psyche, it is
Carl Jung who has most adequately recognized and
analyzed the religious impulse, while carefully avoiding
problems of a purely philosophical rather than psycholog-
ical kind. Jung reinterpreted the libido as psychic energy
not exclusively sexual in nature and rooted not only in the
individual unconscious, but also in a collective uncon-
scious replete with archetypal symbols universally valid
from a psychological point of view, however they may be
related to objective truth. In his view and in that of Boisen,
there is a kinship between the conversion experience,

described as the death of the personal self and the rebirth in Christ; the mystic's prayer experience of annihilation of self in union with the divine; and the schizophrenic regression from logical thought processes to the symbolism of the subconscious. Jung sees each as a reunion with the collective unconscious; a quest of the mother who is man's original physical link with other life; a possibility of renewal of strength as when Antaeus touched his mother earth. Schizophrenia thus represents a constructive effort of the psyche to reorganize itself on a higher level, and to achieve a harmony between the individual ego and the collective interest—an effort distinguished from conversion experiences accepted by society as "genuine" not by its essential nature but by the success or failure of the outcome. Psychotics or mystics who have temporarily abandoned the processes of logic in favor of intuition must next subject their new insights to their own and others' rational criticism. Psychiatrists judge a man's normality not according to the abstract truth of his ideas, but according to whether at least a few others agree with him.[9]

Among crises of visionaries who later found followers, Boisen studies the sojourn of Jesus in the wilderness, the conversion of Paul, and certain episodes in the life of George Fox, the founder of the Quaker faith, which influenced Ruskin slightly and Gandhi considerably. Such "twice-born" men tried to face life's fundamental issues, emerged from the struggle with a sense of personal responsibility for human welfare, and identified their own salvation with the attempt to establish the kingdom of God on earth. After their searching exploration of inner realities, they achieved integration with the external world by submerging selfish urges and lesser loyalties to this effort. Fox's eccentricities diminished as his ideas found hearers; his only relapse occurred when his follow-

ers were imprisoned while he remained free. The ability of
the charismatic leader to express the common identity of
the group, to unite men through his own personality, is
the product of his capacity for identification with them.
The paranoid dictator who evokes the psychopathic rather
than the heroic in mass man is one in whom the destruc-
tive subconscious forces have won over the creative, one
who has identified himself with the power urge of a merely
national group rather than the genuine welfare of all
humanity or even of all life. The Hebrew prophets were
national leaders of a different kind and Jesus himself had
a choice to make between earthly kingship of the Jews and
a solely spiritual messiahship. His longing for unity with
other life, for a world of peace and love, drove him to act to
reduce the discrepancy between the real world and the
ideal. Since most men need to change themselves as well,
such crises have been explained as "nature's way. . .to
heal the breach between the ideal self and the actual self
not by lessening the conflict but by heightening it."[10]

Like the patients Boisen studied, Ruskin had a sense of
mission, felt acute division within himself, and identified
his own problems with those of his country and with dis-
turbances of the natural world. Like them, he was isolated
in childhood and thereafter felt inwardly lonely. The de-
pression preceding the composition of *Modern Painters*
and the more significant inner conflicts over *Unto This
Last* may be viewed as potentially creative in nature. The
years between 1858 and 1860 are well described by
Sullivan's account of the history often preceding a
schizophrenic episode: a developing awareness of "ten-
dencies which manifestly involve the patient in rather
durable integrations incongruous with his past experi-
ence and foreign to his at least dimly formulated
career-line."[11] *Unto This Last,* the sanest book Ruskin

ever wrote, expressed such tendencies. We cannot know what Ruskin might have become had he yielded wholly to his new impulses and had the world accepted them. As it was, his discouragement over the failure of his writings to influence England's economic situation led to episodes of actual insanity in later life, periods of deep regression into a primitive, infantile world of archaic symbolism. These emotional crises ended in failure.

Ruskin always viewed himself as a man with a mission, often as a saint *manqué*. His mother's ambition for him to be a minister was fulfilled by his preaching on art and economics. Editorially calling himself St. George (a national as well as a religious hero), he suggested from time to time similarities between himself, St. Francis, St. Anthony, and even Christ.[12] The notion was shared by many women and children and some men as well. Those who knew him frequently stressed his gentleness, sometimes his holiness. His tenderness to animals and anti-vivisectionism would have harmonized even more with Eastern than with Western religious sensibility. Greville MacDonald compared him to Christ and wrote, "Simply to have looked into Ruskin's face and felt the grasp of his hand was to believe in him utterly."[13] Frederic Harrison, who knew a number of eminent men, was impressed by the unique "inexplicable light of genius" in Ruskin, and with his gentleness and humility in private life, which contrasted so puzzlingly with his fulminations in print: "he talked like an angel and wrote as if he were one of the Major Prophets."[14]

Yet this gentle angel was unsuccessful in establishing real shared intimacy with others. Like schizophrenics, he combined a longing for human relatedness with a fear of it. Despite his intense interest in the world of phenomena, despite his gaiety in company and his prolific letter-

writing, Ruskin was inwardly isolated from childhood on, "solitary in thoughts though social in habits," as Collingwood puts it.[15] He felt himself unlovable and unloving, admitted indifference to the feelings of others, and often revealed a sense of unreality and a lack of emotional response called "depersonalization," a common schizophrenic sympton. Joan Evans notes that "I *felt* nothing" "comes as a refrain in the diaries";[16] Collingwood, that one of Ruskin's most curious gifts was his "power of detaching himself from his surroundings."[17] He alternated between praise of peaceful solitude and complaints of loneliness. He spoke of a heart "broken ages ago, when I was a boy," and in later years, with childish dependency, of the deprivation of father, mother, and nurse. The increased isolation brought about by his attacks on contemporary society ended in regression to childhood during the episodes of insanity, which he described as "part of one and the same system of constant thought, far out of sight to the people about me, and of course, getting more and more separated from them as *they* go on in the ways of the modern world, and *I* go back to live with my Father and Mother and my nurse, and one more—all waiting for me in the Land of the Leal."[18]

Before learning (despite Rose's disapproval) to love her more than God, Ruskin had loved nature better than man. For many years the power of his emotions expressed itself primarily in his religious sense of natural and artistic beauty. His repression of his disappointment over Adèle's marriage produced a "want of. . . [feeling], in all wholesome directions but one: magnetic pointing to all presence of natural beauty, and to the poles of such art and science as interpreted it." The redirection of emotion for a girl whom he had compared to mountain snow contributed to the Wordsworthian feeling behind *Modern Painters,*

written shortly after his depression. In his childhood, mountains had represented to him freedom from his mother's restrictions; later they gave him a sense of "help and peace," a vision of "seemingly immutable good in this mutable world," like "the seen walls of lost Eden." As Tolstoy found religious experience in the mountains, so Ruskin continued to seek there spiritual release and resolution of conflict, although he came to perceive mountain gloom as well as mountain glory, to contrast Vesuvius, "visible Hell," with the Alps, "visible Paradise." The humanitarian mysticism of his later years was not unrelated to his feeling for the Alps as "a direct revelation of the benevolent will in creation," since his concern for the Alpine peasants was the origin of the plan for St. George's Guild—the end of his "youthful happiness" and the beginning of his "true work in the world." His imagination associated the beauty of nature unspoiled by industry with the peace of a golden age unmarred by conflict. In 1887 in England

> the skies of Turner were still bright above the foulness of smoke-cloud or the flight of plague cloud; and the forms. . . [of clouds] unmingled with volcanic exhalation. . .were infinite, lovely, and marvellous beyond any that I had ever seen from moor or alp. . . .What might the coasts of France and England have been now, if. . .the Christian faith had been held by both nations in peace, in this pure air of heaven?[19]

The redirection of Ruskin's interest from the mountains to the inhabitants of the mountains, from art to political economy, coincided with an emotional upheaval.

Ruskin's inner ambivalence between esthetic and social concerns suggests a schizophrenic split between conflicting trends in the personality. Ruskin's life altered its direction in the years immediately preceding the publica-

tion of *Unto This Last*. Comparing his trip to the mountains in 1858 with the going of a religious man into the wilderness, he asserts firmly: "the claim of being able to find among the rock-shadows thoughts such as hermits of old found in the desert, whether it seems immodest or not, was wholly true."[20] Two years after an experience occurred that he himself compares to a conversion, "in 1860 people saw a change come over me which they highly disapproved"—the change from esthetic to social preoccupations. Harrison suggests a parallel between this experience and Dante's spiritual crisis in middle age.[21] Ruskin's secretary-biographer says his first serious mental breakdown occurred in 1860 at the age of forty-one. This was neither his first emotional disturbance nor an episode of actual insanity, but he himself regarded it as the "heaviest depression" he had ever experienced. In 1858 he mentioned a "cloud upon me this year":

> I am not able to write as I used to do, nor to feel, and can only make up my mind to the state as one that has to be gone through, and from which I hope some day to come out on the other side.

The spring and summer of 1860 marked a deeper upheaval, but it was not until November that he reached a "general state of collapse." At this time he gave two years as the duration of his melancholy. By March, 1861, everyone commented on his "jaded, bilious look" and inquired whether he had heart disease. In December he wrote that he had been "somewhat seriously ill" for a year, and in July of 1862 that his anger and unhappiness had persisted for three or four years. The letters suggest not so much swings of mood as a prolonged conflict beginning shortly after Ruskin began to relate art to social problems in the Manchester lecture later called *A Joy for Ever;* a

conflict steadily deepening and attaining a climax about the time when the publication of *Unto This Last* was broken off.[22]

In 1862 Ruskin himself stated with his usual vehemence a connection between his own illness and England's:

> My change from what I was once. . .is merely. . .an infinitely small part of the wreck which is taking place everywhere through the baseness of the national feeling of England.

And again, years later:

> I have no hope for any of us but in a change in the discipline and framework of all society, which may not come to pass yet, nor perhaps at all in our days.[23]

Ruskin's spiritual turmoil in fact coincided with England's, as the title of a recent collection suggests: *1859: Entering an Age of Crisis.*[24] That the relationship was more than coincidence seems undeniable when we take into account the mental and physical ills of Carlyle and the other Victorian critics of democracy, as well as the periods of profound spiritual upheaval described by Carlyle and Tolstoy, whose ideas were so similar to Ruskin's. Arnold in 1859 moved from art criticism to political criticism, as Ruskin was doing, and with the same interest in England's attitude toward the conflict in Italy. The 1859 essays stress among other matters the problem of the relationship between art and social concern, the significance for religion of the *Origin of Species,* the conflict between Evangelicalism and positivism, and the prevalence of profound anxiety over such questions. "The primary agent in provoking this sensibility in 1859. . ." says Madden, "was the quiet erosion of Christian faith" and the

consequent feeling of alienation at a time when technolog-
ical change rendered the sense of mutuality increasingly
imperative.[25] Ruskin's problems were not unlike those of
his educated contemporaries, although the answers he
found were such as they could not accept.

Between 1858 and 1860, Ruskin underwent several
simultaneous and interrelated transitions: a renewal of
amorous feeling, a personal emancipation from his par-
ents' authority, a religious emancipation from
Evangelicalism, and an evolution from esthetic to
economic interests, The real Ruskin was trying to emerge
from the dutiful son. As Henry Ladd puts it, the escapist
was beginning to face facts: the Wordsworthian transcen-
dentalist was turning toward a humanitarian
mysticism.[26]

The impulses that led him in 1860 to consider imitating
the life of Veronese (but instead expressed themselves less
unconventionally in his relationship with Rosie) must
have helped him in 1858 to see the power of Veronese's
painting and to reverse his own previous convictions as to
the relative value of "Worldly visible Truth" and "visio-
nary Truth." A mystical meditation in Turin, accom-
panied by an experience of "perfect color and sound," per-
suaded him to adopt "the old article of Jewish faith, that
things done delightfully and rightly, were always done by
the help and in the Spirit of God."[27]

It was then that he rejected forever Evangelicalism
—his "mother-law of Protestantism"—as the culmination
of a process that had been continuing for some time and
was completed in the summer of 1860 during his argu-
ments with his friend Stillman. He was gradually aban-
doning his belief in the mandatory observation of the
Sabbath and becoming convinced that the Bible was not a
revelation uniquely divine, but one among many. The

beginnings of tolerance had been evident as early as 1857, when in *Notes on the Construction of Sheepfolds* he had appealed for unity among Protestant sects. In the Waldensian chapel at Turin in 1858 he suddenly perceived the folly and narrow egoism of imagining that a particular set of beliefs would procure salvation for a small band of the elect alone among the whole human race. This revulsion from the dogmatic, exclusive Evangelicalism of his mother was followed later by attacks on the hypocrisies of all organized religions. It cost him some pain, especially in the relinquishment of his belief in immortality. Norton said that he never recovered from his loss of faith.[28]

Yet in a sense Ruskin's change of belief was actually a conversion. It was accompanied by an intensified sense of the urgency of Christ's essential message: "If ye love me, feed my sheep." With a desperate effort toward existential commitment in a cruelly exploitative society, he sought literally to feed the hungry and to clothe the naked by means of words. From this time on, he felt it his duty to devote himself wholly to teaching "peace and justice," although his gifts, he thought, lay in other directions.[29] Just as he outgrew his mother's narrow sectarianism, so he outgrew the tendency of his father to value his artistic sensibility above all his other qualities. Factors in this development had been his recent tour of the industrial north of England and his teaching at the Working-Men's College, where he eventually resigned because men overladen with labor and pressed by the competitive drive for power could not devote themselves to the contemplation of the beauty he sought to show them. In spite of his disillusionment with his efforts to inculcate art appreciation, which is already evident in *A Joy for Ever*, he nevertheless completed *Modern Painters*, in the spring of 1860, chiefly to please his father: "On the strength of this piece of filial

duty, I am cruel enough to go away to St. Martin's again, by myself, to meditate on what is to be done next. Thence I go up to Chamouni—where a new epoch of life and death begins."[30]

The epoch was new, he explained, in that "my father and mother could travel with me no more, but Rose, in heart, was with me always, and all I did was for her sake."[31] Until this period, his father and mother had dominated him completely, even in his marriage. As a child, he said he had developed no power of independent *action*, as distinct from independent thought. At his father's death in 1864 he expressed a certain relief that he would no longer be compelled to sacrifice his own welfare to his father's wishes—indeed, Fain believes that Ruskin's economic thinking would have begun ten years earlier had it not been for his father's negative influence. Between 1860 and his mother's death in 1871 Ruskin remained independent in spirit from her, even during the two years after his father's death, which he dutifully spent with her although she tyrannized over him and frequently called him a fool. As he wrote to a friend,

> The 'Wist ye not that I must be about my Father's business?' has to be spoken. . .to all parents, some day or other.

When Ruskin spoke it, belatedly indeed, he was forced to seek from others the praise and support that he had hitherto found at home; but he chose a road that would deny him this affirmation, too. With his emancipation from his parents in the spring of 1860 had come "terrible doubt as to what to do" with himself, "almost unendurable solitude" while still at home, and intense scorn of himself and others.[32] Thereafter he complained of a sense of homelessness. His fact-facing had indeed partially alien-

ated him from his parents and from others as well.

Ruskin found the facts—the facts about religion, art, and society—very hard to face. As he put it much later, "men who know the truth are like to go mad from isolation. . .it is impossible for us, except in the labor of our hands, not to go mad." Nonetheless, he was surprised that he did so, for he had been taking pride in his "peculiar sanity."

In 1858 his realism was already torturing him: he was shocked by the recognition of how few people "have striven to do God's will, not their own. . . .The truth as far as I can make it out seems too terrible to be the truth." Of Bishop Colenso's book he wrote:

> For the last four years I've been working in the same direction alone. . . .And the solitude was terrible—and the discoveries and darknesses terriblest—and all to be done alone.

His "depreciation of the purist and elevation of the material school" of art were also "painful pieces of new light." In economics he felt that Carlyle had led the way, yet feared from the beginning that the public would not accept the truth he could offer: "It is often impossible, often dangerous, to inform people of great truths before their own time has come for approaching them." His political economy

> is founded on principles which it will take the world still another 100 years to understand the eternity of. . . .You will see it gravely stated as a great and recent discovery, in a Russian journal, that the interests of a nation are not to be sacrificed to those of an individual. In another hundred years England may discover that human beings have got souls, which are the eminently Motive part of the Animal.

Besides, to change his subject was difficult: "I've to turn myself quite upside down, I'm half broken-backed and

can't manage it." Thus, when he considered God's laws for men's life together, he wrote:

> I am stunned—palsied—utterly helpless—under the weight of the finding out the myriad errors that I have been taught about these things; every reed that I have leant on shattering itself joint from joint—I stand, not so much melancholy as amazed—I am not hopeless, but I don't know what to hope for.[33]

Above all, he had grown more aware of the human suffering that surrounded him. Medicine was "almost the only thing in the world *worth* knowing. . . .To know how to stop pain must be wonderful." Or, perhaps, "to fill starved people's bellies is the only thing a man can do in this generation." "The vastness of the horror of this world's blindness and misery opens upon me—as unto dying eyes the glimmering square." He described his pain in a metaphor reminiscent of the ocean of darkness and death that George Fox saw as vanquished by an ocean of light: "I am tormented between the longing for rest and for lovely life, and the sense of the terrific call of human crime for resistance, and of human misery for help—though it seems to me as the voice of a river of blood which can but sweep me down in the midst of its black clots, helpless." Perhaps, he concluded, "dying is the only thing possible." Only compassion sustained him later.[34]

Ruskin was indeed helpless against the tide of human misery; his writings accomplished little. The hostile reception of *Unto This Last* and of his later social writings might account in large measure for his periods of despondency and inertia. The prosperous subscribers to *Cornhill's Magazine* indignantly forced Thackeray to discontinue after the fourth essay the protest against economic injustice; only nine hundred copies of the first

edition were sold. In a later edition this book sold many copies; in a penny edition still more; in Gandhi's four-anna Guiarati paraphrase it was widely circulated in India. Yet at first Ruskin's own opinion of *Unto This Last* as "the best and truest thing I ever wrote" found external validation only from Carlyle, just as his own opinion of his change in character was diametrically opposite to his father's: "I am an incomparably nobler and worthier person now, when you disapprove of nearly all I say and do, that I was when I was everything you and my mother desired me."[35] In order fully to appreciate Ruskin's frustration in the new work he had undertaken, one must recall the difficulties with his three letters on the Italian question published in the *Scotsman* in 1859, the cessation of publication of his "Essays on Political Economy" (*Munera Pulveris*) in *Fraser's* in 1862, and the suppression by his father of his dialogue on the gold standard, written for *Fraser's* in the same year after an exchange of letters in the *Times* with J. E. Cairnes.

Fron 1860 on Ruskin often complained of "the continual provocation I receive from the universal assumption that I know nothing of political economics, and am a fool—so far—for talking of it." He reacted both with flight and with fight. In Switzerland in 1861 he isolated himself from his unappreciative contemporaries because "I do not believe in their religion, disdain their politics, and cannot return their affection—how should I talk to them?"[36] Against his opponents he entered the lists wrathfully, abusing them with increasing vehemence. Fain points out, for example, that Ruskin made no personal attack upon Mill until the fourth essay of *Unto This Last,* which was written after Thackeray had informed him the series would be discontinued.[37] More and more, he saw himself as "howling and bawling the right road to a generation of

drunken cabmen"[38]—instead of walking the right road himself and quietly asking others to follow, as did Gandhi.

Some of those who loved him undermined him more subtly than his attackers. His father and the devoted Charles Eliot Norton discouraged his new interests and sought to direct him again toward the study of art; had not his gloom begun with his economic studies? Indeed, about the time *Unto This Last* was discontinued, he had half agreed with them:

> I am divided in thought. . . .Whenever I work selfishly. . .I am happy and well; but when I deny myself, and give all my money away, and work at what seems useful, I get miserable and unwell. The things I most regret in all my past life are great pieces of virtuous and quite heroical self-denial; which have issued in all kinds of catastrophe and disappointments, instead of victories. . .It upsets all one's moral principles so.

More often, however, he asked these well-intentioned men to promote his mental health in a different way. He wrote his father that the postponement of the second *Fraser's* article depressed him, as had the difficulties over the letters on the Italian question. Arguing that only the achievement of his purposes could diminish his melancholy, he implored him: "Let me follow out my work in my own way and in peace. All interference with me torments me." Similarly he frantically appealed to Norton to help him in the only possible way by understanding and supporting his economic concepts; till Norton did so, he said, "You are a seeker of my good in your way, not in mine."[39] But it was for the most part in vain that Ruskin asked comprehension from members of his own class, or even later from the workmen of England. He might perhaps have found it by making himself, as Gandhi did, one among the poor he defended.

After the period of crisis, Ruskin often expressed his sense of a division both within himself and between good and evil cosmic forces—feelings often considered typically schizophrenic. He was frequently preoccupied with ideas similar to those of the patients Boisen studied: ideas of his own death, which he extended, with a feeling of urgent personal responsibility, to a notion of coming world catastrophe. He alternated between a "happy sense of direct relation with Heaven" and a sinking "into the faintness and darkness of the Under-world"; he wondered in 1869 "whether to think of these ten years as Divine or Diabolical." He experienced a "sense of loveliness in life, and of overbrooding death, like winter"; he spoke as from a deathbed of a coming Revolution. Regressing to the primitive mythmaker's identification of human life with nature, he declared that because of men's failure to love justice and truth, nature was developing "conditions of storm and of physical darkness, such as never were before in Christian times,. . .in connection also with forms of loathsome insanity, multiplying through the whole genesis of modern brains." The sinful nations were to be "punished by the withdrawal of spiritual guidance from them, and the especial paralysis of efforts intelligently made for their good"; not as of old by "plagues of the body; but now, by plagues of the soul, and widely infectious insanities, making every true physician of souls helpless and every false effort triumphant. Nor are we without great and terrible signs of supernatural calamity, no less in grievous changes and deterioration of climate, than in forms of mental disease."[40]

These notions emerge in full force during the attacks of actual insanity, which, ironically, began only shortly before his social theories attained popularity, about 1880. Among the events leading up to the first attack in 1878

might be mentioned not only the death of Rose, but also the dispute with Octavia Hill over the tenements and the resignation of Acland and Cowper-Temple as trustees of St. George's Guild. Even Carlyle thought the Guild a little mad and quarreled with him, yet the second attack he himself attributed partly to "the sense of loneliness and greater responsibility brought on me by Carlyle's death" a week or two before. His madness was due not to overwork, he said, but to the humiliation, solitude, and frustration of finding no one to believe in his work. During the onset of the first illness, he felt a "strong mystical conviction of religious truth."[41] He described his illusion of terrible battle with the Devil who compelled him to do a wrong he could not resist; his auditory hallucination of a peacock's voice croaking triumphantly of rain each time he failed; and his refusal to eat during the first stages of recovery.[42] These experiences might be contrasted with Gandhi's wakening in the middle of the night, sensing a profound inner struggle, and hearing a voice commanding him to fast. As Luther threw his inkpot at the Devil, as Fox saw visions of fierce beasts, so Ruskin finally fancied his cat to be the Devil and sought to strangle it. The birds that he befriended as a lonely child had always been killed by the cats; even more noteworthy, all the creatures in whom he saw the Devil (cat, peacock, and crowing cock) were creatures with whom Ruskin sometimes identified himself. He experienced a sense of split personality, of being "one beside myself. . .a double, or even treble, creature." Again he expressed apocalyptic ideas; he thought the Day of Judgment was near; he "saw the stars rushing at each other—and thought the lamps of London were gliding through the night into a World Collision."[43]

Ruskin himself and others as well interpreted his mental illness in terms of religious experience. His secretary

Collingwood compared it to Jacob's struggle with the angel and Savonarola's effort to reconcile God and man; of the delirium he remembers "the vision of a great soul in torment, and through purgatorial fires the ineffable tenderness of the real man emerging, with his passionate appeal to justice and baffled desire for truth."[44] In *Fors Clavigera* Ruskin criticized the doctors for failing to see that dreams are prophetic, that insanity is an experience given by God, and that it began for him as a "brain action. . .simply curative. . .of the wounded nature in [him]." Only Dr. Parsons, who brought him through, realized "that there *were* any mental wounds to be healed."[45] His madness, like his mountain meditations, appeared to him to be imbued with deep meaning: "It taught me much, as these serious dreams do always." The illness of 1871 had encouraged his work and had led him to say to himself, *"Tu ne cede malis, sed contra fortior ito."* Although he thought the 1878 attack did "nothing but humiliate and terrify him," he admitted that it gave him perspective on his own selfishness and failure and showed him all his efforts to help others "as the mere foaming out of my own vanity." This awareness of his arrogance had been expressed earlier in a prayer for humility and charity composed on Mont Blanc, which he said revealed "the temper in which I composed the best work of my life." He recognized inwardly that "all worst madness, nearly, begins in pride, from Nebuchadnezzar downwards."[46]

During his attacks, he became unable to distinguish reality from vision, inner from outer world, sleep from waking. He described "grotesque, terrific, inevitable" dreams—"false visions (whether in sleep, or trance, or walking, in broad daylight with perfect knowledge of the real things in the room, while yet I saw others that were not there)." Again, he says, "The periods of delirious im-

agining through which I have myself passed are simply states of prolonged dream—sometimes of actual trance, unconscious of surrounding objects, sometimes of walking fantasy, disguising or associating itself with the immediate realities both of substance and sound; but, whatever its character, recognized afterwards as a dream or vision."[47] After "climbing that hill of the voices," he felt "regret to have come back to the world. . . [from] the scenic majesty of delusion. . .so awful—sometimes so beautiful."[48] Between the 1889 attack and his death in 1900, he secluded himself from the world, sometimes hostile, usually silent.

Ruskin's earlier crusades against the world from which he finally retreated did not justify his designation of himself as the "Don Quixote of Denmark Hill." For all his eagerness to right wrongs; for all his valour, his tenderness, and his childish rage at the uncooperative; for all his idealization of the medieval past; for all his futility in an unsympathetic world, Ruskin differed from Don Quixote in that originally and essentially he saw contemporary society as it was. His perception of facts was accurate, however incomplete his understanding of the classical economists and however slight his interest in practical financial detail. Yet his deepest sanity was regarded as sheer folly. He grieved over Don Quixote because "all true chivalry is thus by implication accused of madness and involved in shame."[49] Society's inability to accept his true and chivalrous insights, its accusations of madness helped to drive him mad; for he had chosen to make his personal salvation dependent on the immediate salvation of society.

If these aspects of his illness make tempting an interpretation of his personality in the light of Boisen's work, a difficulty immediately presents itself. Wilenski's

brilliant analysis develops a tentative diagnosis of manic-depressive psychosis rather than schizophrenia. This problem is not, however, insuperable. Modern psychiatry regards the classification of syndromes as less significant than the study of the characteristics and social relationships of the individual; moreover, it is sometimes so difficult to differentiate between manic-depression and schizophrenia that two psychiatrists interviewing the same patient may arrive at different diagnoses. There are "cases in which the symptoms are entirely schizophrenic but run in cycles," cases of "schizophrenia with depressive elements or cyclic mood changes," cases that must be considered "schizo-affective," neither one nor the other. Often cases originally considered manic-depressive eventually develop into clear-cut schizophrenia, although the reverse rarely occurs. It has been suggested that although typical cases of the two psychoses are easily distinguished, they are "variants of one general disease. . .the extremes of a continuous series of variables."[50]

Many of the specific symptoms analyzed by Wilenski might equally be well regarded as schizophrenic. The mood swings he observes might represent the alternation of catatonic excitement with hypochondria; the disturbances in communication have some manic and some schizophrenic characteristics; the manic schemes might be the unrealistic, vague plans of the schizophrenic; the manic euphoria might be schizophrenic religious ecstasy; the manic impulse to preach, which Wilenski tries mistakenly to differentiate from Ruskin's social conscience, is part of a sense of divine mission typical of schizophrenia! Ruskin was regarded as consumptive in his youth and frequently during his depressions had coughs and colds, which were twice cured by faith, as he believed;[51] tuberculosis often coincides with schizophrenia. We might also

note that Ruskin experienced his first depression in college when he lost Adèle, and his first actual insanity at fifty-nine, about the age of appearance of the involutional illness that Boisen does not differentiate from schizophrenia and that Sullivan also regards as often related to the schizophrenic world-disaster psychosis, and "frequently the outcome of a lifetime career of interpersonal frustration through the instrumentality of a rigid moral system acquired in the early years but energized in adolescence by the coming of lust."[52]

Certainly some of the criteria for differential diagnosis would suggest schizophrenic tendencies. One essential difference between the manic-depressive and schizophrenic types is the difference between the extravert and the introvert. The manic-depressive flees into "reality"—that is, into action in the external world. Schizophrenia, on the other hand, is "a form of adjustment characterized by a withdrawal into an autistic state accompanied by delusional preoccupations" and sometimes by a "flight into intellectualism": a breakup of a former synthesis of the personality through the introversion of the libido. If the normal personality is extraverted, objective, and realistic, manic-depressive psychosis is the likely diagnosis; if it is introverted and subjective, schizophrenia. Hallucinations are rare for the manic-depressive, but typical of the schizophrenic, who descends into a dream-world of autistic fantasy in which he cannot distinguish the subjective from the objective, the figurative "voice of conscience" from its audible perception. The more grotesque the delusions, the more schizophrenic; the more illogical, the more schizophrenic.[53]

Ruskin's uncertainty as to the limits of his own ego and the schizophrenic spread of meaning are reflected in his habit of transferring to himself his mother's failing

eyesight and old-age; his preternatural sensitivity and attribution of significance to minor detail; his hallucinatory interpretations of ceiling stains and light on bedpost; his belief in "signs that seem to multiply around us"[54] when he was abstracting the Book of Revelations; and especially his identification of his own tragedy with the pollution of nature and approaching world catastrophe. He was well qualified to explain the role of projection in the pathetic fallacy.

Ruskin's illness shows other schizophrenic characteristics as well. Schizophrenic patients have the same tendency as Ruskin to diverge sporadically from logical communicative discourse into passages meaningful or relevant only in terms of the writer's private preoccupations. Ruskin also invented new heraldic terms for St. George's Guild and ingeniously symbolic mineralogical accounts that he himself could not later decipher. Perhaps these instances of autistic use of words are not wholly unrelated to his explicit and rational attack in *Unto This Last* on the consensually valid meaning of economic terms and his attempt to substitute and to justify his private definitions and even his neologism "illth." His insistence on private insight influences both his least intelligible meanderings and his sanest thought. Thus in many ways Boisen's study seems applicable to his personality.

Boisen recognizes that the inner spiritual evolution he describes may well be gradual and peaceful rather than stormy. So it was with Gandhi, whose life developed continuously in the direction of combined spiritual and political leadership. His effectiveness as a charismatic hero sprang from impulses much like those that tortured and isolated Ruskin: impulses to subordinate his drives for pleasure and power to his need for identification with his nation and with humanity. He was deeply sane, full of

good humor, affectionately related to his people. Despite his eccentric notions about diet and health, he was never irrational; the "voice" that he heard as audible gave commands that, like the prohibitions of Socrates's daemon, were in perfect accord with the reasoned decisions of his conscious mind.

Yet Gandhi's constant underlying anxiety, his sense of maintaining a precarious balance, is suggested in his remarks that one breach of his vow of chastity would have destroyed him and that without prayer he would have been a lunatic. In his emotional development there were significant parallels to that of the patients Boisen studied, many of whom had had strict parents, had failed socially and professionally, and had experienced sexual fears. Although he underwent no episode of cataclysmic inner turmoil, he crucially transformed his way of life when he read *Unto This Last* in 1904.

Both Ruskin and Gandhi were profoundly convinced of the force of example, of the priority of moral self-reform over political agitation. Both attempted the establishment of utopian settlements and made other practical experiments with their social theories. The similarities between their efforts are striking. Ruskin's failed because he could not yield himself wholly to his new impulse to self-sacrifice, and because most of his contemporaries ridiculed his undertakings; but Gandhi's succeeded.

In his efforts to improve the economic lot of his countrymen on a national scale, Ruskin met only frustration during his lifetime.

The changes wrought in Gandhi by Ruskin's words meant more than the initiation of an experimental community, more than the adoption of a simple way of life. Simplicity was Gandhi's means of identifying himself completely with the fellow-countrymen he had already

begun to help; it was his way of asserting that in his own life Ruskin's "first principle" held true: the welfare of this one, at least, was contained in the welfare of all. For Ruskin, too, the perception of this principle had marked a turning point in his life. Yet because he was unable to renounce the luxury he disapproved or to find listeners for his message, he reinforced with his own projected guilt feelings his vehement denunciations of others who were far guiltier, while Gandhi, avoiding so far as possible every occasion of personal guilt, accepted the guilt of his followers as his own, fasting in vicarious penance even for the sexual misconduct of *ashram* boys and girls as well as for acts of violence reducing the effectiveness of the *satyagrahi*. So differently did Ruskin and Gandhi express their deep concern for the suffering and guilt of their nations.

Gandhi's experiments were not sporadic; his all-encompassing drive for personal consistency led him to choose poverty and simplicity as a permanent way of life. He took quite seriously Ruskin's peroration: "Raise the veil boldly; face the light; and if, as yet, the light of the eye can only be through tears, and the light of the body through sackcloth, go thou forth weeping, bearing precious seed, until the time come, and the kingdom, when Christ's gift of bread and bequest of peace shall be Unto this Last as to thee; and when, for earth's severed multitudes of the wicked and the weary, there shall be holier reconciliation than that of the narrow home, and calm economy, where the Wicked cease. . .from troubling—and the Weary are at rest."

"I will not wait till I have converted the whole society to my view," remarks Gandhi less eloquently, "but will straight away make a beginning with myself. It goes without saying that I cannot hope to bring about economic

equality of my conception, if I am the owner of fifty motor cars or even often Bighas of land. For that I have to reduce myself to the level of the poorest of the poor."[55] Considering as the most difficult task of his life the effort to hold himself to the severe moral standards he preached, he once told the Christian missionaries of Ceylon: "We do not need to proselytize either by our speech or by our writing. We can only do so with our lives."[56]

When Gandhi was not living in his *ashrams,* his household became an *ashram* observing the laws of poverty, manual labor, and defiance of untouchability. Calling himself a "farmer and weaver by profession," reducing his personal possessions to the barest minimum, sacrificing his wife's inclinations and his sons' education, he contributed all his own money to *Indian Opinion,* the home rule movement, and such less significant causes as vegetarianism. After his unfortunate initial experience with the financial manager for *Indian Opinion,* he kept scrupulous account of contributions and expenditures in the projects he supervised. He, and after him Vinoba Bhave, insisted in word and deed upon careful attention to detail as an expression of religious attitude. It is in the light of their lives, and of a Platonic statement which Ruskin quotes on the dependence of great matters on little ones, that we must interpret Ruskin's verbal insistence on taking even the smallest matters to God. Gandhi's refusal of interest on the Phoenix mortgages and the handspinner's yarn was accompanied by the requirement of similar integrity from others, like the "Gandhian capitalist" whom he advised against buying a mill. Despite his care, there is no evidence that he ever made this kind of honesty pay. The contrary is suggested by the failure of the vegetarian restaurants in which he invested; the difficulties of *Indian Opinion* even after the move to

Phoenix Farm and especially after the refusal to accept advertising; and the remark of a friendly *ashram* contributor that "it costs a great deal to keep Gandhi in poverty." Unable to finance his own projects as Ruskin could, he enlisted the support and confidence of others far more readily than Ruskin.

Gandhi's severe wholeheartedness illuminates by contrast Ruskin's sense of guilt in self-indulgence. Inwardly he demanded of himself the sacrifices of a Gandhi; yet he could not compel his weak nature even to rational moderation. He dissipated his inheritance party through charity, but also largely through excessive selfish expenditures. His fortune was such that he could afford to give and lend generously to relatives, finance social and artistic experiments, live extravagantly, and make bad investments as well. He attributed his cessation of indiscriminate charity, perhaps quite truthfully, to his inability to endure the pain of refusing some requests.[57] He followed his principles in his practices as a consumer and employer;[58] but not as a landlord or an investor, for he accepted rent for his model tenements and interest on his investments, although St. Anthony's Bank on the basis of his principles offered interest-free loans to the poor. Hobson accepts as logical Ruskin's defense of the latter inconsistency: " 'though taking interest is, in the abstract, as wrong as war, the entire fabric of society is at present so connected with both usury and war that it is not possible violently to withdraw, nor wisely to set example of withdrawing, from either evil.' "[59] But such a denial of the possibility of individual remedy for a supposed social evil brings into question the value of all the limited experimentation that Ruskin attempted as a desultory and casual stonebreaker, road digger, crossing-sweeper, carpenter, and house painter; or as a guest who set his fellow

visitors at Broadlands to manual work. In these edifying examples Ruskin acted much more the mentor than the participant. By far his most successful demonstration of his principles was his support of the slum improvement schemes of Octavia Hill, a practical woman who administered them herself. His inefficiency, inaccurate accounting, confusion of esthetic with social purposes, and inability to resist artistic purchases contributed to the failure of the St. George's experiment; but in this case, too, his fundamental failure was his failure to commit his own life.

It was a perceptive subscriber who wrote to *Fors* that Ruskin's travels made her feel like a soldier at Sebastopol under orders from a general in London, and that she would join St. George's Company when he did. He himself recognized the validity of her criticism in a remark politely contradicted by his admirers:

> 'As head of a Society that preaches economy and simplicity of life I ought to practise it myself or I cannot expect others to follow. But I am founder not Master.' Mr. Wedderburn suggested that to preach economy to others would have more effect on the world than to practise it silently.
>
> 'It would not,' answered the Master. 'Nothing can equal the force of personal example.'

"I believe," he wrote, ". . .the reason my voice has an uncertain sound, the reason that this design of mine stays unhelped, and that only a little group of men and women, moved chiefly by personal regard, stand with me in a course so plain and true, is that I have not yet given myself to it wholly, but have halted between good and evil, and sit still at the receipt of custom, and am always looking back from the plough." Even his lack of complete intellectual conviction he attributed with circular reasoning to his

failure to act. Truth, he said, was concealed in parables from all save the disciples, "of whom the sign is one and unmistakable: 'They have forsaken all that they have.' " "Compromise with Christ. . . [is] visited always with spiritual death," but ecstasy may be bought by complete renunciation. "If I had lived in a garret," he once wrote, "then I could have preached that Queen Victoria should do the same." (Gandhi so lived and so preached.) Ruskin's constant resolutions to give up buying pictures were constantly broken; but at heart he believed that camel's hair pencils were inadequate weapons, while "camel's hair raiment might do something." Wilenski points out his frequent rationalizations of his self-indulgence, his habit of blaming his parents for the luxurious upbringing that made it so difficult for him "to harden. . . [himself] into daily common service." But the demands he made on himself were as stringent as Gandhi's: "Men ought to be severely disciplined and exercised in the sternest way in daily life—they should learn to lie on stone beds and eat black soup, but they should never have their hearts broken." Although he was also capable of inconsistent laxity in his attitude toward others, as when in true Gandhian fashion he helped a forger of his name despite his belief in the stern repression of crime, most of his practical deviations from theoretical positions were less admirable. He asked others to obey him when he could not obey himself. Not wholly inaccurately, Ruskin considered himself "at one with the wisest men of all ages" "in matters of *abstract* principle (I don't mean impractical! but as distinguished from the subjects of debate in one's own conduct.)"[60]

Social and individual salvation are interrelated. The ancient parallel between justice in the Republic and justice in the citizen was woven into the texture of the

thought of Ruskin and Gandhi. for whom individual vir-
tue held eternal primacy. Thus it is not surprising that
their social and ethical theories are intimately related to
their own personalities. The correspondence between in-
trapsychic and interpersonal attitudes is a commonplace
today: emotional health and religious commitment cannot
exist in a vacuum. One's feelings toward others reflect
one's feelings toward oneself: the figures in a dream or in a
work of art represent parts of the dreamer's psyche as well
as people in his environment. Thus, beyond all the inter-
nal and external conflicts Gandhi knew, the inner har-
mony of his spirit corresponded to his sense of identifica-
tion with his people; while Ruskin's inability to achieve
personal wholeness of heart was both cause and product of
his inability to gain the cooperation of others.

Gandhi himself exemplified the belief, which he shared
with Plato, Carlyle, and Ruskin, that development of in-
dividual character is the key to social change. In many
ways Gandhi illustrates Weber's definition of the charis-
matic leader, although this concept contains no moral
implications and includes both national and religious
leaders, saints and sinners. Charismatic authority, that
which depends on the attribution of exceptional qualities
to an individual, is a revolutionary force emerging in time
of national suffering and crisis; demanding from its fol-
lowers new attitudes, new kinds of sacrifice; yet depend-
ing wholly upon their free and voluntary allegiance. Inde-
pendent of the influence of economic factors, it has a
characteristic economic structure: the leader and his chief
followers abandon the earning of livelihoods and the es-
tablishment of families in order to form a purposeful
community dependent on charity or on plunder. Like most
charismatic authority, Gandhi's existed only during its
origination. His refusal to accept political power after his

country's liberation initiated the period of bureaucratic routinization that Weber describes as the inevitable sequel of charisma—a period for India that Frank Moraes compares to the establishment of the New Class in Communist countries.[61] Gandhi's withdrawal allowed the inheritors of power to adopt only those parts of his philosophy with which they felt an "elective affinity." Yinger suggests that the selectivity of the followers may, despite Weber's denial, have its inverse parallel in the early development of the leader's thought, which he believes may be partially affected by environmental social forces.[62] The appropriateness of Gandhi's ideas to the Indian situation supports such a compromise between Marxist materialism, according to which the economic system determines men's patterns of value, and the point of view of Plato, Carlyle, Ruskin, and Gandhi himself, that reformation of society begins in the individual soul.

Gandhi had not created the city of his dreams: India was tragically divided and imperfectly governed. Yet he had accomplished many of his purposes and achieved enduring influence. There were many reasons for the vast difference between his effectiveness and the failure of Ruskin. Both had declared a preference for practical over verbal expression of truth. Gandhi was able to find in his personal life as well as in political action ways of fulfilling their mutual convictions; but Ruskin failed not only to reorganize English society, but also to establish the miniature Utopia he projected, and finally to bring about the reign of justice and affection in his own spirit. One of the chief differences between the experimental communities of Ruskin and Gandhi lay in Gandhi's personal participation. One of the chief differences between their lives lay in Gandhi's stern consistency in following their precepts—a consistency exemplifying the dicta of Carlyle's mentors

Fichte and Goethe that knowing must be followed by doing, that the self may be discovered not by speculation, but only by action. Gandhi changed first himself, next the oppressed, and last of all the oppressors. Ruskin, however, agreeing with Plato that reforms start with the upper classes, began by addressing appeals and denunciations to the stewards of England's wealth. Gandhi became one among suffering millions who had been readied for his message by a tradition of valuing spiritual dedication above the conquest of nature, while Ruskin was seeking to alter the attitudes of a Western nation habituated to materialism and competitive individualism and well along the road of industrial progress. Gandhi's fame among his own people grew as his thoughts and achievements developed, while Ruskin experienced after the publication of *Unto This Last* a shift from acclamation of his art criticism to opprobrium for his economic ideas. Gandhi found wide support for beliefs that antagonized British businessmen. Ruskin's isolation increased when he expressed his central convictions; Gandhi's diminished. The difference between them was partly the difference between the Victorian and the Indian environments.

Ruskin perhaps exemplifies Plato's description in the *Republic* of the dangers of the philosopher in the unjust state, where the best becomes the most defective. He is well described in his own words about others:

> I see creatures so full of all power and beauty, with none to understand or teach or save them. The making in them of miracles, and all cast away, for ever lost, as far as we can trace.[63]

Concerning great men, he laments:

> In the kindliest and most reverent view which can justly be

taken of them, they were but poor mistaken creatures, struggling with a world more profoundly mistaken than they;—assuredly sinned against or sinning in thousands of ways, and bringing out at last a maimed result—not what they might or ought to have done, but all that could be done against the world's resistance, and in spite of their own sorrowful falsehood to themselves.[64]

But Ruskin's voice in the wilderness had prepared the way for a greater leader, had baptized him into complete dedication. Gandhi's near-fulfillment of the Christlike potentialities of every man gave new meaning to the inscription on the funeral wreath from Ruskin's village tailor:

There was a man sent from God, and his name was John.

GLOSSARY

This glossary, intended for the convenience of the reader, includes definitions of Indian words and identifications of Indian religious, philosophical, and literary figures, writings, and concepts; political events; places; lesser-known Western thinkers; projects of Ruskin; and those works of Ruskin which are mentioned in the text. It excludes major Western figures; scholars whose work has not been outstandingly original; and, except for Polak, persons whose sole claim to distinction lies in their relationship with Ruskin or Gandhi.

advaita. The denial of dualism. According to the *Vedānta* the distinction between thought and being, between self and world, is an illusion (*maya*) and all is *brahman.* Found in the last of the six Indian philosophic systems, the *advaita* is more religious than critically philosophical.

ahimsa. The doctrine of noninjury to all living things, leading to vegetarianism. First advanced in the *Upanishads* seven centuries before Christ, it has been accepted by all Hindu sects and in a limited degree by Buddhists, and has been carried to extremes by Jainists.

Ahmedabad. An industrial city in Gujarat. Half of its population depends on the cotton industry, and there are numerous other major plants, as well as handicrafts. In 1915 Gandhi founded his *satyagraha ashram* in Kochrab, a nearby village, and in 1918 moved it to Sabarmati, a suburb. At this time he assumed the leadership of Ahmedabad textile workers in a

three-week peaceful strike for a thirty-five percent increase. After he had fasted for three days, the strike was settled by an agreement to arbitration which eventually awarded the full increase to the workers.

Amritsar. A city of Punjab. In its park in 1919 British troops under Brigadier General Reginald Dyer killed and wounded hundreds of people by firing on a political meeting. Indians became embittered. The site of the massacre is now a national monument.

ashram. A place for austerities on the part of an individual or a group. The word also refers to the traditional four stages in the spiritual development of twice-born men. It implies ascetic training.

Asoka. Emperor of India (273–231 B.C.), whose conversion to Buddhism made it a dominant faith. He taught reverence for all life, respect for elders, and truthfulness. He engraved on rocks his remorse for war and his ethical edicts, emphasizing *ahimsa.* He constructed notable edifices and governed benevolently in accordance with his precepts.

atman. The self, in its philosophical meaning. The inner essence of the individual and of the whole world. According to the *Upanishads,* man may progress from awareness of the bodily self to knowledge of the incorporeal Self. The *atman* or soul of the individual entering the world is identical with the *Atman* that creates the world and with *Brahman,* the prinicple of the world or God: "that art thou."

avatar. Descent or incarnation of deity when evil threatens humanity. In popular Hinduism animals may be *avatars* and the objects of cults. See Vishnu for his principal *avatars.*

Bhagavad-Gita. The "Song of the Blessed," a religious poem forming part of the sixth book of the *Mahabharata (q.v.)* On a battlefield Krishna, an incarnation of the god Vishnu in the form of a charioteer, gives advice and spiritual instruction to the archer Arjuna. He advocates both love of himself as a personal deity and transcendent unity with the impersonal *Brahman,* both meditation and right action as alternative paths to salvation.

Bhave, Vinoba (1895–). A disciple of Gandhi and member of his *ashram,* who sought to achieve land reform by the non-violent means of changing hearts. Beginning in 1951 to walk

from village to village asking for gifts of land (*bhoodan*) for the landless, he had received four million acres by 1956. When he suggested *gramdan*, the pooling of all the land of the village for a cooperative reorganization, more than 2,500 villages agreed to the plan before 1957.

bhoodan. See Bhave.

bigha. A land measure varying in different parts of India from one-third to five-eighths or all of an acre.

Blount, Godfrey. English founder of the Simple Life Press and Peasant Arts Society, author of *The Gospel of Simplicity* (1903), *The New Crusade* (1903), and other works on country life and handicrafts.

Boisen, Anton (1876–). American clergyman, author of *Exploration of the Inner World* (1936), *Problems in Religion and Life* (1946), and *Religion in Crisis and Custom: a social and psychological study* (1955). After his own recovery from schizophrenia, he became a researcher, a chaplain in a psychiatric hospital, and a leader in the movement for clinical training for ministers. He correlated the work of other thinkers, interviewed individuals, and made field studies of entire communities. He believed in the influence of social crisis upon individual psychology and in a religion of experience arising from personal crisis which may eventuate in a favorable or an unfavorable outcome.

Bose, Sir Jagadis Chandra (1858–1937). An outstanding though controversial Indian animal and plant physiologist and physicist. He taught at the Presidency College in Calcutta, founded and directed the Bose Research Institute, and wrote numerous books. He demonstrated similarities in the responses of plant and animal tissues.

brahmacharya. Chastity. It also refers to the first of the four stages of life during which one practices chastity and devotes oneself to study.

Brahman. In the abstract sense, a neuter force acting as the supreme unifying principle of the universe. The object of *Vedānta (q.v.)*, as expressed in the *Upanishads (q.v.)*, is the search for *Brahman*.

Brantwood. A house overlooking Coniston Lake, purchased and renovated by Ruskin when he was fifty-two.

Broadlands. A Georgian estate near Romney Marsh belonging

to close friends of Ruskin, the Cowper-Temples, a couple both socially prominent and socially concerned.

Cārvāka. A heterodox Indian philosophical system variously expressing skepticism and fatalism, mentioned in the *Rig Veda* and the Epics and fully formulated about 600 B.C. It proclaims that matter is the only reality and denies a future life and the existence of consciousness and the soul apart from the body. Its ethic is hedonistic, asserting that virtue and vice are mere conventions.

Chauri Chaura. A village in the United Provinces. On February 4, 1922, the murder there of twenty-one police officers by a mob caused Gandhi to suspend civil disobedience because India was not ready for a nonviolent campaign.

Colenso, John (1814-83). Anglican bishop of Natal, author of *The Pentateuch Critically Examined* (1862-79), a mathematical argument against the historical accuracy of the Pentateuch. He was convicted of heresy; the decision was reversed; he was deposed from his bishropic; but he remained at his post. The controversy was famous and significant.

darshan. Literally sight, metaphorically intuition or vision, and hence a term for the six systems of Indian philosophy. Crowds follow a *mahatma* seeking *darshan.*

Denmark Hill. Ruskin's home from the age of twenty-three until after his parents' death, located in the suburbs outside London.

dharma. Sacred duty, action leading to *moksha* or the behavior expected of any caste or community. According to the *Bhagavad-Gīta,* each one must follow his own *dharma.*

dhoti. The unsewn garment with which Hindu men have clothed the lower part of their persons for over two thousand years.

Djilas, Milovan (1911–). Yugoslav writer, former Vice-President and Communist party official. Once considered the potential successor to Tito, he was thrice imprisoned for denunciation of officials and for the publication of two books in the United States, *The New Class* (1957) and *Conversations with Stalin* (1962). The former work argues that the establishment of a Communist government necessarily leads to the development of a new bureaucratic ruling class.

Edwardes, Sir Herbert (1819–68). See Ruskin, *A Knight's Faith.*

Ekadashi Day. The eleventh day of the moon's increase or de-
crease, a Hindu fast day.

Erikson, Erik H. (1902–). Psychoanalyst, professor at Har-
vard, and author of several books, including two distin-
guished examples of psychoanalytic biography. Partly
through his work with children and adolescents, he has
evolved a theory of the stages of human development and the
identity crisis.

Froebel, Friedrich W. A. (1782–1852). German educational re-
former who originated the kindergarten, wrote several
books, and influenced John Dewey. He stressed the educa-
tional value of activity and particularly of play, and advo-
cated the union of headwork and handwork.

Fromm, Erich (1900–). Neo-Freudian psychoanalyst and
author of numerous books that relate sociology, ethics, and
religion to psychoanalysis and stress, freedom and other
humanistic values.

Froude, James Anthony (1818–94). Prolific English historian,
biographer, and professor, particularly known for a twelve-
volume history of Tudor England. Inaccurate and anti-
Catholic, he accepted Carlyle's theory of the hero in history
and applied it to Henry VIII. Eventually he wrote a bio-
graphy of Carlyle and compiled an edition of his papers.

Gita. See *Bhagavad-Gita*.

Gokhale, Gopal Krishna (1866–1915). A political leader of the
moderate Indian nationalists, advocating constitutional
methods and practicing honesty. He was president of the
Congress party, a champion of untouchables and of the In-
dians in South Africa, and the founder of the Servants of
India Society, whose members vowed poverty and service of
the nation.

gramdan. See Bhave.

Gujarati. An Indo-Aryan language spoken by about twenty
million people in the present states of Gujarat and
Maharashtra and nearby areas. Gandhi was born in Porban-
dar, one of about three hundred states of Kathiawar Gujarat.

guru. In general, a spiritual teacher. In particular, during the
first of the four traditional stages of upper-caste Hindu life, a
student learns the *Veda* from a *guru,* who is regarded as a

second father and sometimes as an incarnation of God. Some sects recommend great care in the selection of a *guru* and complete obedience to him throughout life.

Harrison, Frederic (1831–1923). English jurist, author, and positivist. A follower of Auguste Comte, he spoke and wrote on Comte's sociology and on the religion of humanity. Among his many books was an admiring biography of Ruskin (1902).

hartal. Closing of business as a measure of protest or civil disobedience; strike.

Hill, Octavia (1838–1912). Philanthropist. She was influenced by the Christian Socialists and by Ruskin. After meeting him in 1853, she became his friend and protégée, copied pictures for his *Modern Painters,* served as secretary to the women's classes at the Working-Men's College, where he taught, and persuaded him to finance her housing schemes for the poor. She came to manage more and more property, attracted many investments, and developed a system that spread not only in Great Britain but also abroad. Her methods combined efficiency with helpfulness. She also worked for the preservation of natural beauty and for legislative reform.

Hincksey Diggers. A group of Oxford students who at Ruskin's suggestion sought to beautify the countryside and to enjoy manual labor through transforming a lane near the village of Ferry Hincksey into a flower-bordered road. The project was unsuccessful.

Hobson, John A. (1858–1940). British economist and publicist. Although never offered an academic post, he was praised as a pioneer by Keynes. Influenced by Ruskin, he adopted a humanistic but logical approach to economics in books on the dangers of oversaving, inequalities in the distribution of income, imperialism, and such remedies as the graduated income tax, social services, and the nationalization of monopolies. He worked for the causes he believed in and was interested in the Ethical Society. He combined the disciplines of ethics, politics, and economics.

Jamaica Committee. A committee formed by John Stuart Mill and others to prosecute Governor Eyre of Jamaica for his execution of George Gordon after an uprising of natives in October, 1865. Ruskin sent a hundred pounds to Carlyle's

Eyre Defence and Aid Fund, wrote a letter to the *Daily Telegraph,* made a speech on the subject, and otherwise supported Eyre.

Jainism. A heterodox theory denying the authority of the *Vedas* and following its own religious literature, based partly on the teachings of Mahavira. Jainists believe in the indefiniteness of being or changeability of matter and the distinction between lifeless things and souls. Mundane souls are subject to reincarnation, but liberated souls have attained *moksha* and will be embodied no more. *Ahimsa,* the highest duty, is carried to the extreme of not killing even insects. The five Jain vows are nonviolence, truthfulness, nonstealing, chastity, and poverty. Austerities, especially fasting, are practiced.

karma yoga. As described in the *Bhagavad-Gita,* the path to salvation through right action performed with detachment from the results.

khadi or *khaddar.* A form of handwoven cloth.

Khilafat movement. The effort to preserve the Turkish empire and to restore a supreme Muslim authority. After Turkey's entry into World War I all Muslims were summoned to aid the "holy war" against the Allies. Much discontent and agitation resulted among Indian Muslims. In 1920, many thousands sought unsuccessfully to leave India for Afghanistan, and others in late 1921 and early 1922 made war upon British and Hindus in an effort to establish an independent Khilafat kingdom in Malabar. The caliphate was abolished by Turkey in 1924 and suspended by an international congress in 1926.

Kropotkin, Peter A., Prince (1842–1921). Russian geographer, anarchist, and author of numerous books. In *Mutual Aid, a Factor of Evolution* (1902), he used his observation of higher animals to refute social Darwinism by showing that they aid other members of their own species rather than engage in war, as does man. Elsewhere he argued for the transformation of the state through voluntary societies and decentralization and for the value of agricultural labor during the leisure created by machines.

Mahabharata. An epic of eighteen books written in western India from 400 B.C. to A.D. 400 and including much didactic ethical and religious material with stories of ancient India

and the descendants of the great king Bhārata. The *Bhagavad-Gītā* forms part of the sixth book.

Mahātma. Great soul, a title of respect for exceptional spirituality and high-mindedness.

Mahavira. An epithet used as the name of the last prophet of Jainism, a contemporary of Buddha who lived about the end of the sixth century B.C. After marriage and fatherhood he became a Jain monk, was said to have eventually attained omniscience, and instructed eleven disciples. Some Jainist canonical books are said to be his discourses.

maitrī. The bond of human relationship.

Marshall, Alfred (1842–1924). British economist and one of the originators of neoclassical economics. A Cambridge professor and an author, he introduced many new concepts in his *Principles of Economics* (1890), and represented economics as a method rather than a body of knowledge.

maya. The illusion of the multiplicity of the universe, produced by ignorance of the truth that Brahman is all in all. Salvation (*moksha*) is gained through overcoming *maya* and recognizing one's unity with the *atman*. The doctrine was the first established in the *Upanishads* and developed in the later *Vedānta.*

moksha. Liberation from suffering and from rebirth. Recommended in the *Upanishads,* in the *Bhagavad-Gītā,* and in the later *Vedānta,* emancipation means not only release from the power of the body but release from illusion, from ignorance of the identity between Brahman and the self.

Norton, Charles Eliot (1827–1908). American scholar, man of letters, and reformer. He worked with a night school, a housing experiment, the *North American Review,* and the *Nation;* taught art at Harvard; and wrote and edited many books, including a prose translation of the *Divine Comedy.* He knew and wrote to many great authors, edited the American editions of Ruskin and Carlyle, and was a particularly beloved friend and correspondent of Ruskin.

panchayat. Locally elected village governing body. Limited judicial functions of arbitration in the village are exercised by a separate body known as the *nyaya panchayat.*

Pigou, Arthur Cecil (1877–1959). A British economist, Cambridge professor, and author of *The Economics of Welfare*

(1920). Although this work is based on utilitarian principles, it argues that state intervention may remedy the dangers of unbridled pursuit of economic self-interest.

Polak, H. S. L. (1882–). An English assistant editor and attorney who made the acquaintance of Gandhi in a vegetarian restaurant in Johannesburg, gave him *Unto This Last,* worked with him on *Indian Opinion,* and lived in his household. Both Polak and his wife Millie wrote books about Gandhi and eventually followed him to India.

Raychandbhai. Gandhi's name for Rajchandra, a diamond merchant and well-known Jain spiritual leader who deeply influenced Gandhi, especially in his decision for *brahmacharya,* sent him Hindu books, and corresponded with him until his own death at the age of thirty-one, perhaps from self-neglect.

Rig Veda. The oldest and most important of the *Vedas,* or collections of sacred hymns, offering verses, and spells, composed about 1500–1200 B.C. It contains metrical hymns invoking the gods and intended to accompany sacrifices, but implying henotheism and even monism in some passages.

Rowlatt Act. Bills passed in March, 1919, occasioned by the report of a sedition committee under Sir Sidney Rowlatt. Besides the prohibition of certain literature, the Act provided for trial without jury and internment of political suspects. Gandhi began his Indian *satyagraha* campaign by announcing on March 30 a *hartal* directed against the Rowlatt Act.

Ruskin, John (1819–1900). Works written by him or published under his sponsorship:

The Cestus of Aglaia. Nine papers on the laws of art that appeared in the *Art Journal* in 1865 and 1866 and were reprinted in parts in other volumes, and in their entirety in the collected *Works.* The title refers to "The Girdle of the Grace," "in which all things are wrought." Focusing upon engraving, the essays deal with the virtues that give art its value.

The Crown of Wild Olive. A collection of lectures on industry and war. Three lectures, "Work," "Traffic," and "War," delivered in 1864 and 1865, were included in the 1866 edition, and a fourth on "The Future of England" was added in the 1873 edition. The title-page quotes Aristophanes' *Plutus,*

"And indeed it should have been of gold, had not Jupiter been so poor." Stressing honor rather than riches, denying the after-life, and advocating Gothic architecture, the book reiterates Ruskin's earlier social teaching and introduces a new discussion of the ethics of war.

The Economist of Xenophon, translated into English by Alexander D.O. Wedderburn and W.G. Collingwood. Ruskin suggested this translation, wrote a preface for it, and included it in 1876 as volume I of his series of classics, *Bibliotheca Pastorum*. It is a Socratic dialogue concerning a country gentleman who shares his wealth cooperatively. The idea that "things are only property to the man who knows how to use them" seemed to Ruskin "a faultless definition of wealth," the "foundation of all true Political Economy among nations."

Fors Clavigera: Letters to the Workmen and Labourers of Great Britain, first printed as separate octavo pamphlets from 1871 to 1884, then appearing in eight volumes and then, in 1896, in four. The title refers to "Fortune, the Nail-Bearer," its inevitability yet justice. Addressed to *all* laborers in God's vineyard, the imprudent, ironic letters deal with a wide range of subjects: personal confessions, religious faith, readings including Plato and the Bible, education, social economy, Utopianism, and in particular St. George's Guild.

Frondes Agrestes, Readings in "Modern Painters," chosen at her pleasure, by the author's friend, the Younger Lady of the Thwaite, Coniston. "Rustic Leaves," selected by Susanna Beever at Ruskin's request and prefaced by him, was first published in 1875 and went through many editions.

A Joy for Ever: The Political Economy of Art. Two lectures given at the Art Treasures Exhibition in Manchester, published as *The Political Economy of Art* in 1857, and republished as *A Joy for Ever* in 1880 with three other lectures given in 1858, 1873 and 1875. The title comes from Keats's *Endymion:* "A thing of beauty is a joy for ever." Besides the preservation of ancient buildings, the improvement of taste, and increased patronage of the arts, Ruskin here for the first time advocates social justice; cooperation rather than competition; government responsibility for students, old people, and employees; and the development of "Soldiers of the

Ploughshare as well as Soldiers of the Sword."

A Knight's Faith. Ruskin's condensation with commentary of Sir Herbert Edwardes's *A Year on the Punjab Frontier, 1848–1849* (1851). During the British protectorate of the Punjab, Edwardes subdued the Afghan district of Bunnoo without firing a shot and planned a successful administration there. Later he distinguished himself in military operations against rebels. Ruskin believed that Edwardes, his personal friend, had subdued treachery through justice and love.

Modern Painters. Five volumes on art and beauty that appeared from 1843 to 1860 and were published in a complete edition in 1873. This work, which made Ruskin's reputation, originated in the impulse to defend the later manner of J.M.W. Turner as superior to the painting of the ancient masters. Ruskin said that the books test man's work by its concurrence with the beauty of God's work. The parts were entitled "Of General Principles and of Truth," "Of Mountain Beauty," "Of Leaf Beauty," "Of Cloud Beauty," "Of Ideas of Relation," including "Of Invention Formal" and "Of Invention Spiritual."

Munera Pulveris. Six essays published in 1872 in book form which had first appeared in 1862–63 in *Fraser's Magazine* as "Essays on Political Economy, Being A Sequel to Papers which appeared in the 'Cornhill Magazine,' " that is, to *Unto This Last.* The title, "Gifts of the Dust," denigrates the wrong kind of riches; the system here outlined develops the idea that the wealth of a state consists in the happiness and the numbers of its population, hence also in things inherently useful owned by those with the capacity to use them. Money, riches, cost, and price are defined; a theory of commerce and principles of government are developed.

Notes on the Construction of Sheepfolds. A shilling pamphlet published in 1857, criticizing Church schism and undue emphasis upon the outward sacrament of baptism and contending that faith in Christ and ethical conduct are the only true criteria of an individual's membership in the Christian Church.

Sesame and Lilies. Two lectures in the editions of 1865, 1866, 1867, and 1882, to which "The Mystery of Life and its Arts"

was added in the 1871 edition. "Of Kings' Treasuries" dealt with libraries, or sesame; "Of Queens' Gardens" concerned women's purifying influence, or lilies. Perhaps because the book reiterates that true wealth is life, Ruskin asked that it be read "in connection with *Unto This Last*."

Unto This Last. Four essays that appeared in 1860 in the *Cornhill Magazine* and in *Harper's New Monthly Magazine*, New York, and were published in 1862 in book form. The preface announces a redefinition of wealth, its moral preconditions, and the necessity of practical reforms, which are enumerated. "The Roots of Honour" attacks the conception of the economic man, insists upon the motivating power of affection in employees, and suggests a sacrificial concept of vocation for the captains of industry. "The Veins of Wealth" defines wealth as life and distinguishes political economics from mercantile economics, the economics of getting rich. "Qui Judicatis Terram" defines political economics as the method of getting rich by just means, explores the concept of the just wage, and attacks the law of supply and demand as unjust. "Ad Valorem" defines value as "that which avails toward life," denies that there is profit in exchange, defines price in terms of labor, asserts that consumption is the end of production, and disputes Mill's opinion that "a demand for commodities is not a demand for labor."

ryot. A cultivator or subject, more especially a member of the agricultural population.

Salter, Reverend William Mackintire (1853–1931). Early member of the Society for Ethical Culture in America, lecturer, and author. His numerous works include a scholarly book on *Nietzche the Thinker*, two books in German, *Ethical Religion* (1889), and the article "Morality as a Religion" (1902), which Gandhi translated without acknowledgment as *Ethical Religion*.

samaj. Society.

sarvodaya. The welfare of all.

satyagraha. Firmness in the truth or soul-force, power derived from truth and love or nonviolence.

Sullivan, Harry Stack (1892–1949). American psychiatrist, military medical officer, and professor, Director of Clinical Research at Shepard and Enoch Pratt Hospital, and a foun-

der of the William Alanson White Psychiatric Foundation, its offshoot the Washington School of Psychiatry, and the journal *Psychiatry*. Emphasizing the significance of interpersonal relationships in emotional illness, he studied infantile and childhood experience as well as schizophrenia. He believed that schizophrenia is an attempt to reintegrate the total experience of an individual and that it can have a constructive outcome.

swaraj. Self-rule, self-government.

swadeshi. Pertaining to one's own native country; a movement supporting and buying goods produced in the native country.

Tulsidas. A sixteenth-century northern Indian poet devoted to the merciful Rāmachandra as an incarnation of the Supreme, who narrated his life in a formal epic using the same subject as the Sanskrit *Rāmāyana* but differing in its treatment.

Upanishads. The concluding parts of the *Vedas,* dealing with the knowledge of God, composed over many centuries, but primarily from the eighth to the sixth century B.C. The literal meaning of the title of these philosophical treatises in prose and verse is "sitting near devotedly." In the dialogues, the teacher answers and may occasionally pose questions. An idealistic monism superseding polytheism proclaims that Brahman or the *atman* alone is real and all else is *maya*. The *Upanishads* also include secondary cosmological and psychological doctrines for those incapable of the higher knowledge, ascetic ethical teachings, discussions of transmigration, and recommendation of meditation on the sacred syllable OM.

Vaishnava. A Hindu sect worshipping Vishnu as a monotheistic god rather than one of the supreme trinity of the Hindu pantheon. In all forms, it stresses reverence for life. Gandhi's mother regularly attended a Vaishnava temple.

Vedas. The oldest and most important Hindu scriptures, composed over many centuries. Each is divided into two parts: Work, or hymns, ceremonial instructions, and rules of conduct; and Knowledge, or religious truth, the *Upanishads*.

Vedānta. Final aim of the *Veda*. It may refer to the older *Upanishads* or to the most widespread of the six Indian philosophical systems, based upon the *Upanishads,* formerly presented by Badarayana, and interpreted by Sankara about

A.D. 800. Besides the higher knowledge of the nondualistic Brahman there is also a lower knowledge accepting a personal god, the transmigration of souls, and the ceremonial law of the *Veda*.

Vishnu. With Brahmā and Siva, a member of the triad elevated above other Hindu gods. He encompassed the universe in three strides. Among his human *avatars* were Rāma, a brave hero with a faithful wife Sita celebrated in the epic *Rāmāyana,* composed in the sixth and second century; Krishna, originating as a cowherd god, developed through syncretism, and appearing in the *Bhagavad-Gītā*; and Buddha.

Weber, Max (1864-1920). German sociologist, political economist, professor, and author. In *The Protestant Ethic and the Spirit of Capitalism* (1930), he argued that economic developments can be crucially influenced by religious beliefs. A scholar in the religious and social history of India, China, and the Jews, he stressed the significance of values in the study of men.

BIBLIOGRAPHY

I. Works by Gandhi and Ruskin cited
Gandhi, Mohandas K. *Autobiography: The Story of My Experiments with Truth.* Translated by Mahadev Desai. Washington, D.C.: Public Affairs Press, 1954.
———. *Cent per Cent Swadeshi.* Ahmedabad: Navajivan, [1945].
———. *Communal Unity.* Ahmedabad: Navajivan, 1949.
———. *Constructive Programme.* Ahmedabad: Navajivan, 1941.
———. *Economic and Industrial Life and Relations.* Ahmedabad: Navajivan, 1957.
———. *The Gandhi Sutras.* Arranged by D. S. Sarma. New York: Devin-Adair, 1949.
———. *Indian Home Rule.* Madras: Ganesh and Co., [1919?].
———. *Mind of Mahatma Gandhi.* Compiled by R. K. Prabhu and U. R. Rao. London: Oxford University Press, 1945.
———. *Sarvodaya.* Ahmedabad: Navajivan, 1908.
———. *Sarvodaya.* Translated by Mahadev Desai. Ahmedabad: Navajivan, 1951.
———. *Satyagraha in South Africa.* Madras: S. Ganesan, 1928.
———. *Speeches and Writings.* Madras: G. A. Natesan and Co., 1933.
Ruskin, John. "The Late Mr. John Ruskin: Mr. Ruskin's Illness Described by Himself." *British Medical Journal,* January 27, 1900, pp. 225 f.
———. *Praeterita.* Boston: n.p. , 1886–87.
———. *Unto This Last.* New York: John Wiley and Son, 1866.
———. *Unto this Last and Other Essays on Art and Political Economy.* London: Dent, 1932.
———. *Works.* Edited by E. T. Cook and A. Wedderburn. 39 vols. London: G. Allen, 1903–12.

II. Other Sources Consulted

Agarwal, S.N., ed. *Sarvodaya: its principles and programme.* Ahmedabad: Navajivan, 1951.

Anjaria, J. J. *An Essay on Gandhian Economics.* Bombay: Vora and Co., ltd., 1945.

Appleman, Philip; Madden, William A.; and Wolff, Michael, eds. *1859: Entering an Age of Crisis.* Bloomington, Ind.: Indiana University Press, 1959.

Barker, Ernest. *Reflections on Government.* Oxford: Oxford University Press, 1942.

Beard, Charles. "Ruskin and the Babble of Tongues." *New Republic* 87 (August, 1936): 370-72.

Benson, Arthur C. *Ruskin.* New York: G. P. Putnam's Sons, 1911.

Blount, Godfrey. *The New Crusade.* London: Simple Life Press and Peasant Arts Society, 1903.

Boisen, Anton. *Exploration of the Inner World.* New York: Willett, Clark and Co., 1936.

————. *Religion in Crisis and Custom.* New York: Harper, 1955.

Broome, Isaac. *The Last Days of the Ruskin Cooperative Association.* Chicago: C. A. Kerr and Co., 1902.

Carlyle, Thomas. *The French Revolution.* New York: Modern Library, 1934.

————. *On Heroes and Hero-Worship.* N.p.: A. L. Burt, n.d.

Cassirer, Ernst. *The Myth of the State.* New Haven: Yale University Press, 1946.

Childs, Marquis W., and Carter, Douglas. *Ethics in a Business Society.* New York: Harper, 1954.

Collingwood, Robin G. *Ruskin's Philosophy.* Kendal: T. Wilson & Son, 1922.

Collingwood, William G. *Life and Work of John Ruskin.* 2 vols. Cambridge, Mass.: Riverside Press, 1893.

Datta, Dhirendra M. *Philosophy of Mahatma Gandhi.* Madison, Wisc.: University of Wisconsin Press, 1953.

Dhawan, Gopic N. *Political Philosophy of Mahatma Gandhi.* Bombay: Popular Book Depot, 1946.

Djilas, Milovan. *The New Class.* New York: Praeger, 1957.

Erikson, Erik. *Gandhi's Truth.* New York: Norton, 1969.

Evans. Joan. *John Ruskin.* New York: Oxford University Press, 1954.

Fain, John. *Ruskin and the Economists*. Nashville: Vanderbilt University Press, 1956.

Fischer, Louis. *Gandhi and Stalin*. New York: Harper, 1947.

Fromm, Erich. *Psychoanalysis and Religion*. New Haven: Yale University Press, 1950.

Gilbert, Katherine. "Ruskin's Relation to Aristotle." *Pholosophical Review* 49 (January, 1940): 52–62.

Graham, David. "Gandhi's Debt to Ruskin and to Tolstoy." *B.B.C. Listener* (March 14, 1948).

Harrison, Frederic. *John Ruskin*. New York: The Macmillan Co., 1902.

Hendrick, George. "The Influence of Ruskin's *Unto This Last* on Gandhi." Ball State Teacher's College *Forum* 1 (Spring, 1960): 67–72.

———. "The Influence of Thoreau's Civil Disobedience on Gandhi's Satyagraha." *New England Quarterly* 29 (December, 1956): 462–76.

———. "Thoreau and Gandhi: a study of the development of 'civil disobedience' and satyagraha." Unpublished Ph.D. dissertation, University of Texas, 1954.

Hoblitzelle, Harrison. "The War against War in the Nineteenth Century: A Study of the Western Backgrounds of Gandhian Thought." Unpublished Ph.D. dissertation, Columbia University, 1959.

Hobson, John A. *John Ruskin, Social Reformer*. Boston: D. Estes and Co., [1898].

Indian Opinion, 1905–1907, *passim*.

Jung, Carl. *Psychology of the Unconscious*. New York: Dodd, Mead, 1957.

Kaplan, Alexandre. *Gandhi et Tolstoï*. Nancy: Impr. L. Stoquert, 1949.

Khullar, K. K. "Carlyle and Gandhi—A Study." Ambala *Tribune*, December 28, 1952.

Kumarappa, Bharatan, ed. *Sarvodaya*. Ahmedabad: Navajivan, 1954.

Ladd, Henry. *The Victorian Morality of Art: An Analysis of Ruskin's Esthetic*. New York: Octagon Books, 1932.

Le Roy, Gaylord C. "John Ruskin: An Interpretation of 'His Daily Maddening Rage.' " *Modern Language Quarterly* 10 (March, 1949): 81–88.

Leon, Derrick. *Ruskin, The Great Victorian.* London: Routledge and K. Paul, 1949.

———.*Tolstoy: His Life and Work.* London: Routledge, 1944.

Lippincott, Benjamin. *Victorian Critics of Democracy.* Minneapolis: University of Minnesota Press, 1938.

MacDonald, Greville. *Reminiscences of a Specialist.* London: G. Allen and Unwin, ltd., 1932.

McLaughlin, Elizabeth T. "Thoreau and Gandhi: the Date." *Emerson Society Quarterly* 2 Quarter (1966): 65 f.

Manning, Clarence A. "Thoreau and Tolstoy." *New England Quarterly* 16 (1943): 234–43.

Markovitch, Milan. *Tolstoï et Gandhi.* Paris: A. Champion, 1928.

Moraes, Frank. *India Today.* New York: Macmillan, 1960.

Nag, Kalidas. *Tolstoy and Gandhi.* Patna: Pustak Bhandar, 1950.

Nanda, B. R. *Mahatma Gandhi: A Biography.* Boston: Beacon Publishers, 1958.

Nehru, Jawaharlal.*Discovery of India.* London: Meridian, 1956.

Noyes, Arthur P., and Kolb, Lawrence C. *Modern Clinical Psychiatry.* Philadelphia: Saunders, 1958.

Polak, H. S. L. *Gandhi, The Man and his Mission.* Madras: Natesan and Co., [1931].

Radhakrishman, Sarvepalli, and Moore, Charles A., eds. *A Source Book in Indian Philosophy.* Princeton: Princeton University Press, 1957.

Riesman, David. *Individualism Reconsidered.* Glencoe, Ill.: Glencoe Free Press, 1954.

Rivett, Kenneth. "The Economic Thought of Mahatma Gandhi." *British Journal of Sociology* 10 (March, 1959): 1–13.

Roe, Frederick W. *The Social Philosophy of Carlyle and Ruskin.* New York: Harcourt, Brace & Co., 1921.

Salter, William. *Ethical Religion.* Boston: Roberts Brothers, 1889.

Scott, Edith Hope. *Ruskin's Guild of St. George.* London: Methuen and Co., Ltd., 1931.

Senn, Milton, M.D., ed. *Symposium on the Healthy Personality.* New York: Josiah Macy, Jr., Foundation, 1950.

Sharma, J. S. *Mahatma Gandhi: A Descriptive Bibliography.* Delhi: S. Chand, 1955.

Sitaramayya, B. P. *Gandhi and Gandhism*. Allahabad: B. Pattabhi, 1942.

Smart, William. *A Disciple of Plato: A Critical Study of John Ruskin*. Glasgow: Wilson and McCormick, 1883.

Society of Ethical Propagandists, ed. *Ethics and Religion*. London: S. Sonnenschein & Co., 1900.

Sullivan, Harry S. *Clinical Studies in Psychiatry*. New York: Norton, 1956.

———. *Conceptions of Modern Psychiatry*. Washington: Norton, 1947.

Tendulkar, D. E. *Mahatma*. 8 vols. Bombay: Publications Division, Government of India, 1951–54.

Thoreau, Henry. *Walden. Writings*. Vol. II. Boston: Houghton, Mifflin, and Co., 1894–95.

Tolstoy, Leo. *Recollections and Essays*. Translated by Aylmer Maude. London: Oxford University Press, 1937.

Townsend, Francis G. *Ruskin and the Landscape Feeling*. Urbana, Ill.: University of Illinois Press, 1951.

Toynbee, Arnold J. *An Historian's Approach to Religion*. London: Oxford University Press, 1956.

Weber, Max. *From Max Weber: Essays in Sociology*. Translated and edited by Hans Heinrich Gerth and Charles Wright Mills. New York: Oxford University Press, 1946.

Whitehouse, J. H., ed. *Ruskin the Prophet*. New York: E. P. Dutton and Co., 1920.

Wilenski, R. H. *John Ruskin: An Introduction to Further Study of His Life and Work*. New York: Stokes, 1933.

Yinger, J. Milton. *Religion, Society, and the Individual*. Part I. New York: Macmillan, 1957.

NOTES

Chapter 1

1. Thomas Carlyle, *On Heroes and Hero-Worship* (A. L. Burt, n.p., n.d.), p. 194.

2. Mohandas K. Gandhi, *Autobiography: The Story of My Experiments with Truth,* tr. Mahadev Desai (Washington, D. C.: Public Affairs Press, 1954), pp. 363–65.

3. Ibid., p. 348.

4. Ibid., p. 365.

5. Ibid.

6. John Ruskin, *Unto This Last* (New York: John Wiley and Son, 1866), p. 138.

7. Unpublished letter to author, April 7, 1958.

8. Pp. 376, 379.

9. (New York: Norton, 1969).

10. Gandhi, cited ibid., p. 259.

11. Ibid., p. 47.

12. Ibid., p. 265 f. and n.

13. Cited by Frederick W. Roe, *The Social Philosophy of Carlyle and Ruskin* (New York: Harcourt, Brace & Co., 1921), p. 139; Ruskin, preface, *Unto This Last,* p. vii.

14. Cited by R. H. Wilenski, *John Ruskin: An Introduction to Further Study of His Life and Work* (New York: Stokes, 1933), p. 363.

15. Gandhi, *Speeches and Writings* (Madras: G. A. Natesan and Co., 1933), p. 226.

16. Unpublished letter to the author, April 7, 1958.

17. The "Essays on Political Economy" are chapters one to four of *Munera Pulveris.* David Graham suggests this possibility. Such a theory would be supported by the fact the Oliver Lodge's introduction to the Everyman edition stresses the very ideas which Gandhi in his autobiography lists as central in *Unto This Last:* equal pay and the advantages of rural life. Although the misconception that Ruskin advocated equality of wages was shared by a number of subscribers to the *Cornhill Magazine,* and although there is a brief passage giving ground for Gandhi's third principle, the selection of these points as

187

significant represents such an unusual interpretation as to suggest Gandhi's having seen Lodge's preface. Remarks by Lodge on "The Roots of Honour" are quoted from *Public Opinion,* July 6, 1907, in *Indian Opinion.*

18. John Fain, *Ruskin and the Economists* (Nashville: Vanderbilt University Press, 1956), p. 100.

19. May 27, p. 333. The booklet was published in London in 1903 by the Simple Life Press and Peasant Arts Society, which was founded by Blount.

20. P. xiii.

21. *Indian Opinion* at various times recommended to its readers Charles Wagner's *The Simple Life;* George H. Allen's "The Need for Simplicity"; Mrs. Oscar Beringer on "The Simple Life"; books by Kropotkin and Christian mystics; Blount's own *Gospel of Simplicity;* and the American series *Ethics,* which included *Walden, Civil Disobedience, Life without Principle,* Emerson's *Man the Reformer,* and works by and about Tolstoy. Gandhi's knowledge of William Salter may have come from the periodical *Ethical Addresses,* which published "Morality as a Religion" in November, 1902, pp. 33–46.

22. *Sarvodaya* (Ahmedabad: Navajivan, 1908); tr. Mahadev Desai (Ahmedabad: Navajivan, 1951). As Desai's translation of Gandhi's paraphrase is not paginated, references to it will not be footnoted.

23. Future footnotes to *Sarvodaya* will refer to this anthology, ed. Bharatan Kumarappa (Ahmedabad: Navajivan, 1954). The earlier version was *Sarvodaya: Its Principles and Programme,* ed. S. N. Agarwal (Ahmedabad: Navajivan, 1951).

24. His reading, usually of a religious or biographical character, also included the scriptures of the world's great faiths, especially the *Bhagavad-Gita* and the New Testament; and of Western literature Emerson, Bacon's essays, Huxley's speeches, biographies of Garibaldi and Mazzini, British books on India, Butler's *Analogy,* and other works of Christian apologetics. See Gandhi, *Autobiography: The Story of My Experiments with Truth,* p. 114; *Speeches and Writings,* pp. 218, 226, 238. On occasion he could quote Goldsmith, Tennyson, Macaulay, Shaw, or Shelley's "Masque of Anarchy." *Indian Opinion* quoted Shaw on nationalism and race dominance, W. J. Bryan on "British Rule of India," Upton Sinclair on the Chicago stockyards, Rolland on Booker T. Washington, William Penn's *No Cross No Crown,* H. Fielding Hall's *The Inward Light,* Raleigh's *History of the World,* Longfellow, Charles Edward Russell, *The Friend* of Bloemfontein, Ella Wheeler Wilcox, Mrs. Annie Besant, Hugo de Vries, Herbert Spencer, Max Muller, Anatole France, Goethe, Swift, and others, and various Western books on India. It reprinted Shylock's speech on the humanity of Jews and Clough's "Say not the Struggle Naught Availeth," which Gandhi's opponent Churchill was later to use in a different struggle.

25. See Milan Markovitch, *Tolstoï et Gandhi* (Paris: A. Champion, 1928); Alexandre Kaplan, *Gandhi et Tolstoï* (Nancy: Impr. L. Stoquert, 1949); Kalidas Nag, *Tolstoy and Gandhi* (Patna: Pustak Bhandar, 1950); Derrick Leon, *Tolstoy: His Life and Work* (London: Routledge, 1944), passim.

26. William G. Collingwood, *Life and Work of John Ruskin,* 2 vols. (Cambridge, Mass.: Riverside Press, 1893), 2:564 f.

27. Leo Tolstoy, *Recollections and Essays,* tr. Aylmer Maude (London: Oxford University Press, 1937), p. 188.

28. Ruskiniana, in John Ruskin, *Works,* ed. E. T. Cook and Alexander Wedderburn, 39 vols. (London: G. Allen, 1903–12), 34:729.

29. Henry Thoreau, *Walden, Writings,* (Boston: Houghton, Mifflin, and Co., 1894–95), 2:51, 171.

30. See Harrison Hoblitzelle, "The War against War in the Nineteenth Century: A Study of the Western Backgrounds of Gandhian Thought," unpublished dissertation, Columbia University, 1959, passim. For other studies of these interrelated influences, see Gopic N. Dhawan, *Political Philosophy of Mahatma Gandhi* (Bombay: Popular Book Depot, 1946); David Graham, "Gandhi's Debt to Ruskin and to Tolstoy," *B. B. C. Listener,* March 14, 1948; K. K. Khullar, "Carlyle and Gandhi—A Study," Ambala *Tribune,* December 28, 1952, listed by J. S. Sharma, *Mahatma Gandhi: A Descriptive Bibliography* (Delhi: S. Chand, 1955), p. 467; Roe, op. cit.; Dean Inge, "Ruskin and Plato," *Ruskin the Prophet,* ed. J. H. Whitehouse (New York: E. P. Dutton and Co., 1920), pp. 23–45; William Smart, *A Disciple of Plato: A Critical Study of John Ruskin* (Glasgow: Wilson and McCormick, 1883); George Hendrick, "Thoreau and Gandhi: A study of the development of civil disobedience' and satyagraha", unpublished dissertation, University of Texas, 1954, and "The Influence of Ruskin's *Unto This Last* on Gandhi," Ball State Teachers' College *Forum* 1 (Spring, 1960): 67–72; Clarence A. Manning, "Thoreau and Tolstoy," *New England Quarterly* 16 (1943): 234–43. Emerson on the Over-soul is recommended in *Indian Opinion,* February 18, 1905; James Russell Lowell is discussed on November 25, 1905, pp. 798 f. Sharma summarizes the Khullar article as follows: "Comparing the two personalities the author adds, 'Thus Carlyle and Gandhi stand on the same tradition of intuition and insight. They meet the scientist, the evolutionist, the free trader, the historian, the democrat, the parliamentarian and the intellectualist with a keen edged sound of verbal wit and ivory and challenge than for open duel in the arena of moral law within [sic].' "

31. George Hendrick, "The Influence of Thoreau's Civil Disobedience on Gandhi's Satyagraha," *New England Quarterly* 29 (December, 1956): 462–76; Elizabeth T. McLaughlin, "Thoreau and Gandhi: the Date," *Emerson Society Quarterly,* No. 43 (II Quarter, 1966), Part Two, pp. 65f.

Chapter 2

1. Sarvepalli Radhakrishnan and Charles A. Moore, eds., General Introduction, *A Source Book in Indian Philosophy* (Princeton: Princeton University Press, 1957), pp. xxi–xxviii.

2. Arnold J. Toynbee, *An Historian's Approach to Religion* (London: Oxford University Press, 1956), pp. 263–85.

3. Arthur C. Benson, *John Ruskin* (New York: G. P. Putnam's Sons, 1911), p. 251.

4. *Fors Clavigera, Works,* 28:750.

5. B. P. Sitaramayya, *Gandhi and Gandhism* (Allahabad: B. Pattabhi, 1942), 1:37.

6. B. R. Nanda, *Mahatma Gandhi: A Biography* (Boston: Beacon Publishers, 1958), pp. 66 f.

7. Carlyle, *On Heroes and Hero Worship*, p. 3.

8. *Fors Clavigera, Works*, 29:82–97.

9. *Modern Painters*, cited by Benjamin Lippincott, *Victorian Critics of Democracy* (Minneapolis: University of Minnesota Press, 1938), p. 61; *Sesame and Lilies, Works*, 18:186; *The Crown of Wild Olive*, 18:420; letter to Charles Eliot Norton, June 21, 1869, 36:571.

10. William Salter, "Ethical Religion," *Ethics and Religion*, ed. Society of Ethical Propagandists (London: S. Sonnenschein & Co., 1900), p. 84; "The True Basis of Religious Union," p. 94. (Pp. 74–108 comprise two chapters from his book, *Ethical Religion*.)

11. Sitaramayya, 1:246.

12. Robin G. Collingwood, *Ruskin's Philosophy* (Kendal: T. Wilson & Son, 1922); for "Ruskin's Relation to Aristotle," see Katherine Gilbert in *Philosophical Review*, 49 (January, 1940): 52-62. Ruskin disliked Aristotle's system-making, the idea of the golden mean, and the concept of beauty as composed of order, symmetry, and definiteness. He liked the Aristotelian quest of fact and the doctrines of pleasure and of contemplation.

13. Joan Evans, *John Ruskin* (New York: Oxford University Press, 1954), pp. 411 f.

14. Gandhi, *Communal Unity* (Ahmedabad: Navajivan, 1949), p. 555; Dhirenda M. Datta, *Philosophy of Mahatma Gandhi* (Madison, Wisc.: University of Wisconsin Press, 1953), pp. 73, 76.

15. *Speeches and Writings*, p. 166; Gandhi, *The Gandhi Sutras*, arr. D. S. Sarma (New York: Devin-Adair, 1949), pp. 98, 131.

16. Lippincott, p. 60.

17. *Sutras*, pp. 30 f.; Kumarappa, ed., *Sarvodaya*, p. 68.

18. Wilenski contrasts the two, p. 301.

19. Gandhi, *Indian Home Rule* (Madras: Ganesh and Co., 1919), p. 19.

20. Dhawan, pp. 47 n., 48.

21. *Indian Opinion*, cited in *Speeches and Writings*, p. 189; Gandhi, *Satyagraha in South Africa* (Madras: S. Ganesan, 1928), p. 173. According to the dictionary, "satyagrapha" means simply "firmness in the truth"; but Gandhi's typically Indian interpretative "definition" reveals his thought more clearly than does the literal meaning.

22. *Speeches and Writings*, p. 162; Roe, p. 89.

23. Thomas Carlyle, *The French Revolution* (New York: Modern Library, 1934), pp. 266, 720, 634, 474, 23.

24. Carlyle, *On Heroes and Hero Worship*, pp. 148–50; Nanda, p. 129.

25. *On Heroes and Hero Worship*, p. 137.

26. *Modern Painters*, cited by Fain, p. 38; *Unto This Last*, pp. 77 n., x, 61.

27. *Unto This Last*, pp. 22, 23; *The Cestus of Aglaia*, cited by Wilenski, p. 36 n.; *Fors Clavigera, Works*, 29:85 n.

28. John A. Hobson, *John Ruskin, Social Reformer* (Boston: D. Estes and Co., 1898), p. 325.

29. W. Collingwood, 1:119 f.

30. *Unto This Last*, pp. 59, 71; *Modern Painters*, cited by Hobson, p. 45, and

Evans, p. 422; *A Joy for Ever, Works,* 16:55; *Unto This Last,* p. 87.

31. *Communal Unity,* p. 259; *Speeches and Writings,* pp. 306, 522; Kumarappa, ed., *Sarvodaya,* p. 80; *Speeches and Writings,* p. 105; *Indian Home Rule,* p. 37; *Speeches and Writings,* pp. 165 f.; Gandhi, *Mind of Mahatma Gandhi,* compiled by R. K. Prabhu and U. R. Rao (London: Oxford University Press, 1945), p. 68; *Speeches and Writings,* p. 718; *Autobiography,* p. 616.

32. *Autobiography,* p. 400; *Speeches and Writings,* p. 105; *Constructive Programme* (Ahmedabad: Navajivan, 1941), p. 8.

33. Sitaramayya, p. 368.

34. *Mind of Mahatma Gandhi,* p. 64; *Speeches and Writings,* pp. 405 f.; *Autobiography,* p. 92, and D. G. Tendulkar, *Mahatma,* 8 vols. (Bombay: Publications Division, Government of India, 1951–54), 6:177; *Communal Unity,* p. 552; Kumarappa, ed., *Sarvodaya,* pp. 67 f.

35. *Speeches and Writings,* pp. 1070 f.

36. Carlyle, *The French Revolution* (see above, pp. 43F.); *Speeches and Writings,* pp. 168 f., 503, 191; *Indian Home Rule,* p. 184; Tendulkar, VI, 189; *Mind of Mahatma Gandhi,* p. 68.

37. Introduction, *Works,* 18:lxii; 455 f.

38. *Unto This Last,* pp. 71 n. and 21.

39. Gandhi, *Economic and Industrial Life and Relations* (Ahmedabad: Navajivan, 1957), 1:70.

40. *Unto This Last,* p. 59.

41. Jawaharlal Nehru, *Discovery of India* (London: Meridian, 1956), p. 574.

42. Cited by J. Milton Yinger, *Religion, Society, and the Individual,* Part I (New York: Macmillan, 1957), p. 307.

43. Letter to Mrs. John Simon, July 5, 1859, *Works,* 36:307.

44. Letter to Charles Eliot Norton, July 12, *Works,* 36:339.

45. Francis G. Townsend, *Ruskin and the Landscape Feeling* (Urbana, Ill.: University of Illinois Press, 1951), pp. 15, 23.

46. R. H. Tawney, cited by Marquis W. Childs and Douglas Carter, *Ethics in a Business Society* (New York: Harper, 1954), p. 25.

47. Kumarappa, ed., *Sarvodaya,* p. 149; cited by Dhawan, p. 58.

48. Addenda, *Works,* 16:101, 110; cited by Wilenski, p. 327.

49. *Economic and Industrial Life and Relations,* 2:199; Kumarappa, ed., *Sarvodaya,* p. 128; *Economic and Industrial Life and Relations,* 1:xxviii; *Mind of Mahatma Gandhi,* p. 77; *Sutras,* p. 44.

50. Roe, p. 203; *Unto This Last,* p. 134; Roe, pp. 62–65. Compare *Sutras,* p. 100.

51. Datta, p. 73; Dhawan, p. 58.

52. Cited by Childs, p. 15.

53. *Constructive Programme,* p. 3; Kumarappa, ed., *Sarvodaya,* p. 52.

54. Smart, pp. 11, 38, 47.

55. Letter to the Brownings, March 29, 1858, *Works,* 36:280; Gandhi, cited by Datta, p. 11; *Unto This Last,* p. 38; *Sutras,* p. 99; *Communal Unity,* p. 346; cited by Dhawan, p. 92.

56. Cited by Benson, p. 275; *Unto This Last,* p. 87.

57. *Unto This Last,* p. 200 n. Wilenski and Hoblitzelle discuss Ruskin's conflicts on this subject.

58. *The Crown of Wild Olive, Works,* 18:480; Ruskin, *Praeterita* (Boston: n. p., 1886–87), p. 307; Hobson, p. 343; *Unto This Last,* p. 33; *Speeches and Writings.* p. 173; *Indian Home Rule,* p. 101; *Sutras,* p. 131; *Mind of Mahatma Gandhi,* p. 139; *Speeches and Writings,* pp. 683 f., 348.

59. Tendulkar, 6:177.

60. Roe, pp. 255, 244, 128, 257; Lippincott, p. 65; *The Crown of Wild Olive, Works,* 18:477; Addenda, *A Joy for Ever, Works,* 16:110 n.; *Unto This Last,* p. 129.

61. "Group Psychology and the Analysis of the Ego," cited by David Riesman, *Individualism Reconsidered* (Glencoe, Ill.: Glencoe Free Press, 1954), p. 107.

62. *Economic and Industrial Life and Relations,* 1:ciii; *The Crown of Wild Olive, Works,* 18:495; Kumarappa, ed., *Sarvodaya,* p. 20.

63. Cited by Roe, pp. 71, 83, 86–88, 94 f., 249 n.

64. *Economic and Industrial Life and Relations,* 1:16; *Sutras,* p. 169.

65. Kumarappa, ed., *Sarvodaya,* p. 131; *Speeches and Writings,* p. 891; *Economic and Industrial Life and Relations,* 1:1xxvii; Dhawan, p. 219; *A Joy for Ever, Works,* 16:18 f.; Dhawan, pp. 201, 235 f.

66. Cited by Roe, p. 146 n.; W. Collingwood, 1:103; Wilenski, p. 201.

67. *Praeterita,* p. 335; *Modern Painters, Works,* 4:64.

68. *Sutras,* pp. 104–8; Addenda, *Works,* 16:122; *A Joy for Ever,* p. 35.

69. *A Joy for Ever, Works,* 16:46; Gandhi, cited by Sitaramayya, 2:360.

70. Sitaramayya, 1:22; *Speeches and Writings,* pp. 578 f., 593.

71. Kumarappa, ed., *Sarvodaya,* p. 17; cited by Dhawan, p. 128; *Sutras,* pp. 104–8.

72. Gandhi, cited by Dhawan, p. 210; *Sesame and Lilies, Works,* 18:146.

73. *Fors Clavigera, Works,* 39:228; *Unto This Last,* p. 77; *The Crown of Wild Olive, Works,* 18:502; Hobson, p. 273.

74. Sitaramayya, 1:405; Kumarappa, ed., *Sarvodaya,* pp. 132, 134; *Indian Home Rule,* p. 109; Kumarappa, ed., *Sarvodaya,* pp. 173—76, 134; *Economic and Industrial Life and Relations,* 1:87.

75. Sitaramayya, 1:22; Kumarappa, ed., *Sarvodaya,* p. 133; Sitaramayya, p. 408.

76. Ernst Cassirer, *The Myth of the State* (New Haven: Yale University Press, 1946), pp. 256–61.

Chapter 3

1. Milovan Djilas, *The New Class* (New York: Praeger, 1957).

2. *Fors Clavigera, Works,* 28:85; *Speeches and Writings,* p. 331.

3. *Indian Home Rule,* pp. 30, 26, 67; *Economic and Industrial Life and Relations,* 1:146.

4. Childs and Carter, p. 69; *Speeches and Writings,* p. 354; *Praeterita,* p. 884.

5. Preface, *Unto This Last,* p. xiv.

6. *Speeches and Writings,* pp. 1455, 1000.

7. Dhawan, pp. 7, 122.

8. J. J. Anjaria, *An Essay on Gandhian Economics* (Bombay: Vora and Co., Ltd., 1945), p. 10.

9. Hobson, pp. 99 f.

10. Kumarappa, ed., *Sarvodaya,* p. 32; *Unto This Last,* p. 19; *Speeches and Writings,* pp. 184, 339, 711; Introduction, *Economic and Industrial Life and Relations,* 1:xvi; *Speeches and Writings,* p. 355; *Sutras,* p. 124.

11. Sitaramayya, 1:498.

12. *Speeches and Writings,* p. 351. Ruskin's mother had read him the Bible daily.

13. Addenda, *A Joy for Ever, Works,* 16:134; letter to Dr. Chambers, January 3, 1859, 36:299; *Unto This Last,* pp. 105 f.

14. *Fors Clavigera, Works,* 28:89, *A Joy for Ever,* XVI, 15–17; *Unto This Last,* p. 128 n.; *Sesame and Lilies, Works,* XVIII, 182; *A Joy for Ever,* 16:49 f., Addenda, pp. 123–25; *Unto This Last,* p. 138.

15. Kumarappa, ed., *Sarvodaya,* p. 69.

16. *Speeches and Writings,* pp. 349 f.; *Sutras,* p. 80.

17. *A Joy for Ever, Works,* 16:98–100; Kumarappa, ed., *Sarvodaya,* p. 49.

18. *A Joy for Ever, Works,* 16:23; *Speeches and Writings,* pp. 771, 589.

19. Kumarappa, ed., *Sarvodaya,* p. 18; *The Crown of Wild Olive, Works,* 18:418; *Fors Clavigera, Works,* 28:564; Kumarappa, ed., *Sarvodaya,* pp. 159 f.

20. *Economic and Industrial Life and Relations,* 1:90; *Constructive Programme,* pp. 12, 16; *The Crown of Wild Olive, Works,* 18:, 183.

21. Ch. I, "Work," *The Crown of Wild Olive, Works,* 18; Roe, p. 215; Kumarappa, ed., *Sarvodaya,* pp. 184 f., 161 f.

22. *Autobiography,* p. 365; *Unto This Last,* p. 134.

23. Kumarappa, ed., *Sarvodaya,* p. 7.

24. *Unto This Last,* p. 88; *The Crown of Wild Olive, Works,* 18:448; *Speeches and Writings,* pp. 102 f., 359, 353, 472, 532; cited by Louis Fischer, *Gandhi and Stalin* (New York: Harper, 1947), p. 13.

25. N.J. Spykman, *America's Strategy in World Politics,* cited by Nehru, pp. 552 f.

26. Cited by Dhawan, p. 105 n.; *Speeches and Writings,* pp. 906, 181.

27. Cited by Wilenski, p. 309 n.; *Fors Clavigera, Works,* 29:208–13, 281 f.; *The Crown of Wild Olive, Works,* 18:479 f.

28. *Works,* 31:506; *Speeches and Writings,* p. 781.

29. P. 130.

30. Kumarappa, ed., *Sarvodaya,* pp. 61, 11.

31. Kumarappa, ed., *Sarvodaya,* p. 35; *Sutras,* p. 97; *Unto This Last,* p. 124; Kumarappa, ed., *Sarvodaya,* p. 37.

32. Kumarappa, ed., *Sarvodaya,* pp. 44, 40; cited by Anjaria, p. 16n.; Gandhi, *Cent per Cent Swadeshi* (Ahmedabad: Navajivan, 1945), pp. 165 f.; Kumarappa, ed., *Sarvodaya,* p. 39.

33. Kumarappa, ed., *Sarvodaya,* p. 39; *Speeches and Writings,* p. 336; *Mind of Mahatma Gandhi,* p. 141.

34. P. 10.

35. Kumarappa, ed., *Sarvodaya,* pp. vii, 37; cited by Sitaramayya, 1:324; Kumarappa, ed., *Sarvodaya,* p. 125.

36. *Indian Home Rule,* p. 68; *Economic and Industrial Life and Relations,* 1:lxx; Kumarappa, ed., *Sarvodaya,* pp. 184 f.; *Economic and Industrial Life and Relations,* 1:61.

37. *Speeches and Writings,* p. 591; cited by Roe, p. 200; *A Joy for Ever, Works,* 16:48–51; *Unto This Last,* p. 137.

38. H. S. L. Polak, *Gandhi, The Man and his Mission* (Madras: Natesan and Co., 1931), p. 192; *Unto This Last,* p. 68; *Speeches and Writings,* pp. 577, 69 f.

39. Gandhi, cited by Sitaramayya, 1:364; *Sutras,* p. 103; *Speeches and Writings,* p. 407; Kumarappa, ed., *Sarvodaya,* pp. 21, 162, 181.

40. Kumarappa, ed., *Sarvodaya,* p. 94; Dhawan, p. 223 n.; Sitaramayya, 1:366 f.

41. Kumarappa, ed., *Sarvodaya,* pp. 412, 124 f.; *Mind of Mahatma Gandhi,* p. 77.

43. Kumarappa, ed., *Sarvodaya,* pp. 34, 33.

44. "Essays on Political Economy," in *Unto This Last,* pp. 217 f.

45. *Constructive Programme,* pp. 18–20; Kumarappa, ed., *Sarvodaya,* p. 89; Dhawan, p. 95.

46. *Sutras,* p. 170; Kumarappa, ed., *Sarvodaya,* pp. 49–51, 167–70.

47. Kumarappa, ed., *Sarvodaya,* p. 54; *Speeches and Writings,* pp. 1045–50; *Economic and Industrial Life and Relations,* 1:ciii; Kumarappa, ed., *Sarvodaya,* p. 45; Nanda, p. 164.

48. *Autobiography,* p. 365; Kumarappa, ed., *Sarvodaya,* pp. 153, 34 f.; *Unto This Last,* p. 81.

49. "Essays on Political Economy," *Unto This Last,* pp. 302 f.

50. Fain, pp. 94 f. Although Hobson presents the definition of effectual utility only as a logical development of Ruskin's principles, Fain shows that Ruskin himself made it quite explicit.

51. See Hobson, p. 60; Fain, pp. 10, 90 f.

52. Kumarappa, ed., *Sarvodaya,* p. 45; cited by Sitaramayya, 1:388; Kumarappa, ed., *Sarvodaya,* p. 164.

53. Kumarappa, ed., *Sarvodaya,* p. 164; Addenda, *A Joy for Ever, Works,* 16:166; Kumarappa, ed., *Sarvodaya,* p. 165; Hobson, p. 164.

54. *Fors Clavigera, Works,* 28:419 f. For an American experiment, see Isaac Broome, *The Last Days of the Ruskin Cooperative Association* (Chicago: C. A. Kerr and Co., 1902).

56. Letter to the author, April 7, 1958.

57. Hobson, p. 61.

58. Polak, pp. 12, 24.

59. *Mind of Mahatma Gandhi,* pp. 150–57. The original constitution of the farm at Phoenix had omitted the vow concerning untouchables. See page 96 for Gandhi's definition of theft.

60. Sitaramayya, 1:420 f.

61. Anjaria, p. 9; Sitaramayya, pp. 422 f. See also Kenneth Rivett, "The Economic Thought of Mahatma Gandhi," *British Journal of Sociology,,* 10 (March, 1959): 1–13, where Ruskin's influence is acknowledged.

62. Roe, pp. 313 f; see also Charles Beard, "Ruskin and the Babble of Tongues," *New Republic,* 87 (August, 1936): 371.

63. Anjaria, p. 36.

64. Ernest Barker, *Reflections on Government* (Oxford: Oxford University Press, 1942), p. 167.

65. Toynbee, p. 230; cited by Nehru, p. 574 n.

Chapter 4

1. Max Weber, *From Max Weber: Essays in Sociology,* trans., ed., and with an introduction by Hans Heinrich Gerth and Charles Wright Mills (New York: Oxford University Press, 1946).

2. Yinger, p. 307.

3. Carl Jung, *Psychology of the Unconscious* (New York: Dodd, Mead, 1957); Anton Boisen, *Exploration of the Inner World* (New York: Willett, Clark and Co., 1936).

4. It is difficult to accept Rivett's discussion of Gandhi's virtues as a set of sublimations and reaction-formations of anal eroticism, which Rivett says is not associated with aggression in the East, as it is in the West where toilet training is rigid.

5. Milton Senn, M. D., ed., *Symposium on the Healthy Personality* (New York: Josiah Macy, Jr., Foundation, 1950), pp. 65, 73.

6. Toynbee, p. 76.

8. Erich Fromm, *Psychoanalysis and Religion* (New Haven: Yale Unviersity Press, 1950), p. 95.

9. Anton Boisen, *Religion in Crisis and Custom* (New York: Harper, 1955), p. 119.

10. Edwin D. Starbuck, cited ibid., p. 53.

11. Harry S. Sullivan, *Conceptions of Modern Psychiatry* (Washington: Norton, 1947), p. 70.

12. "I'm getting a little less complex now, only steady headache instead of thorn fillet," he writes in a letter to C. A. Howell, November 3, 1866, *Works,* 36:519.

13. *Reminiscences of a Specialist* (London: G. Allen and Unwin, Ltd., 1932), pp. 98, 100.

14. *John Ruskin* (New York: The Macmillan Co., 1902), p. 95.

15. W. Collingwood, 2:471 f.

16. P. 412.

17. R. Collingwood, p. 31.

18. Pp. 388 f.

19. *Praeterita,* pp. 39, 208–10, 81, 100, 232 f., 354 f., 380.

20. *Praeterita,* pp. 383, 402.

21. Harrison, p. 95.

22. Letters to Carlyle, August 28, 1861, *Works,* 36:382; to Elizabeth Barrett Browning, October 14, 1858, p. 292; to Charles Eliot Norton, February 25, 1861, pp. 356 f., July 12, 1860, pp. 338 f., and November 4, 1860, pp. 346 f.; to Elizabeth Barrett Browning, November 5, 1860, p. 347; to father, March, 1861, p. 360; to Dr. John Brown, December 3, 1861, p. 395; to Lady Naesmyth, July 18, 1862, p.

412. Cf. Gaylord C. Le Roy, "John Ruskin: An Interpretation of 'His Daily Maddening Rage,' " *Modern Language Quarterly,* 10 (March, 1949), 81–88.

23. Letters to Lady Naesmyth, loc. cit.; to Ernest Chesneau, February 13, 1867, *Works,* 36:523.

24. Philip Appleman, William A. Madden, and Michael Wolff, eds., *1859: Entering an Age of Crisis* (Bloomington, Ind., Indiana University Press, 1959).

25. "The Burden of the Artist," ibid, p. 249.

26. Henry Ladd, *The Victorian Morality of Art: An Analysis of Ruskin's Esthetic* (New York: Octagon Books, 1932), p. 165.

27. *Praeterita,* p. 402.

28. See Appleman, Madden and Wolff, pp. 263–67.

29. Wilenski, p. 92.

30. *Praeterita,* p. 394. Smart, p. 33, quotes a passage in *Modern Painters* 5:201, in which Ruskin makes a surprising statement about these volumes: "Arising first not in any desire to explain the principles of art, but in the endeavour to defend an individual painter from injustice, they have been coloured throughout. . .by digressions respecting social questions, which had for me an interest tenfold greater than the work I had been forced into undertaking. Every principle of painting which I have stated is traced to some vital or spiritual fact."

31. Appendix to *Praeterita, Works,* 35:533.

32. Cited by Derrick Leon, *Ruskin, the Great Victorian* (London: Routledge & K. Paul, 1949), p. 470; letter to Charles Eliot Norton, February 25, 1861, *Works,* 36:356.

33. *Fors Clavigera, Works,* 28:206 f.; Evans, p. 379; letters to Brownings, March 29, 1858, 36:280; to Sir John M. Naesmyth, Bart., November 15, 1862, pp. 424 f.; to Charles Eliot Norton, July 12, 1860, pp. 338 f.; to E. S. Dallas, August 18, 1859, pp. 315 f.; to Elizabeth Barrett Browning, November 5, 1860, p. 348, May 13, 1861, p. 364.

34. Letters to Dr. John Simon, July 20, 1858, *Works,* 36:286; to Charles Eliot Norton, July 31, 1859, p. 311, August 28, 1862, p. 423, July 29, 1863, p. 450; *Fors Clavigera, Works,* 28:486.

35. Letter to Ruskin's father, August 10, 1862, *Works,* 36:419.

36. Letters to Charles Eliot Norton, August 30, 1869, *Works,* 36:586; to father, December, 1861, asking that no visitors be permitted when he returned home, 36:401.

37. Pp. 103 f.

38. Letter to Brownings, January 15, 1859, *Works,* 36:303.

39. Letters to Elizabeth Barrett Browning, November, 1860, *Works,* 36:350 f.; to father July 22, 1862, p. 415; to Norton, August 30, 1869, *Works,* 36:587.

40. *Praeterita,* p. 305; letters to Mrs. John Simon, Christmas, 1869, *Works,* 36:600; to father, November 23, 1863, p. 459; to Dr. Henry Acland, September 25, 1869, pp. 592 f.; *Fors Clavigera,* 28:615, 488.

41. Wilenski, p. 163; *Fors Clavigera, Works,* 39:386; Evans, p. 370.

42. "The Late Mr. John Ruskin: Mr. Ruskin's Illness Described by Himself," *British Medical Journal,* January 27, 1900, pp. 225 f.

43. Letters to Mrs. John Simon, May 15, 1878, *Works,* 37:245 f.; to George

Richmond, January 11, 1881, pp. 334 f.; to Charles Eliot Norton, March 15, 1883, pp. 442 f.

44. W. Collingwood, 2:545.

45. *Works,* 28:594 f.; 29:382.

46. Evans, p. 388; Wilenski, pp. 156 f. and n.; letter to Charles Eliot Norton, August 16, 1869, *Works,* 36:582.

47. Evans, pp. 384, 389.

48. Benson, pp. 194 f.

49. Wilenski, p. 176 n.

50. Arthur P. Noyes and Lawrence C. Kolb, *Modern Clinical Psychiatry* (Philadelphia: Saunders, 1958), pp. 413, 412.

51. Wilenski, pp. 331, 337.

52. P. 84. See also his *Clinical Studies in Psychiatry* (New York: Norton, 1956).

53. Noyes and Kolb, pp. 382, 396, 399.

54. *Praeterita,* p. 368.

55. Kumarappa, ed., *Sarvodaya,* p. 144.

56. Sitaramayya, 1:238.

57. Introduction, *Works,* 36:c.

58. Roe, pp. 259 f.

59. Hobson, p. 166.

60. Wilenski, p. 117; Scott, pp. 66 f.; *Fors Clavigera, Works,* 28:84, 320; Wilenski, pp. 88, 249; letter to Mrs. John Simon, Christmas, 1869, *Works,* 36:600; letter to father, December 16, 1863, 36:461; Collingwood, 2:509; Wilenski, p. 159.

61. Frank Moraes, *India Today* (New York: Macmillan, 1960), pp. 89–111.

62. Yinger, p. 304.

63. Letter to Tennyson, September, 1859, *Works,* 36:321.

64. Addenda to *A Joy for Ever, Works,* 16:119 f.

INDEX

199